CITIES AND SAINTS

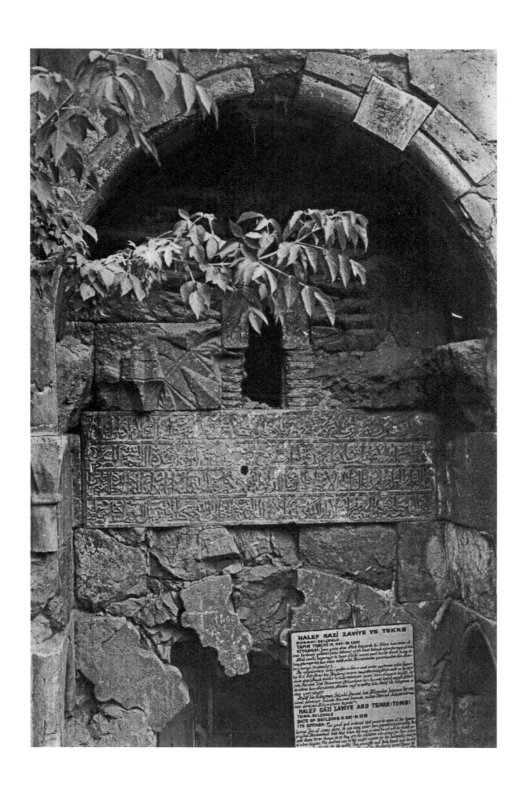

CITIES AND SAINTS

Sufism and the Transformation of Urban Space in Medieval Anatolia

 Ethel Sara Wolper

THE PENNSYLVANIA STATE UNIVERSITY PRESS

UNIVERSITY PARK, PENNSYLVANIA

Library of Congress Cataloging-in-Publication Data

Wolper, Ethel Sara, 1960–
 Cities and saints : Sufism and the transformation of urban space in medieval Anatolia / Ethel Sara Wolper.
 p. cm.

Includes bibliographical references and index.
ISBN 0-271-02256-6 (cloth : alk. paper)

1. Architecture, Medieval—Turkey.
2. Architecture, Islamic—Turkey.
3. Architecture—Turkey.
4. City planning—Turkey—History.
5. Sufism—Turkey.
6. Dervishes—Turkey.
7. Architecture and religion.
8. Architecture and society—Turkey.
I. Title.

NA1363 .W65 2003
726'.9'095610902—dc21 2003004686

Published by *The Pennsylvania State University Press*,
University Park, PA 16802-1003

It is the policy of The Pennsylvania State University Press to use acid-free paper. Publications on uncoated stock satisfy the minimum requirements of American National Standard for Information Sciences—Permanence of Paper for Printed Library Materials, ANSI Z39.48–1992.

Cover illustration: Bodleian Library, Oxford, MS Ouseley Add 24, fol. 78v
Page ii: Author photograph
Page vi: Bakhtiar, *Sufi Expressions,* p. 71
Page 14: Bodleian Library, Oxford, MS Ouseley Add 24, fol. 79v
Page 40: Edhem and Van Berchem, *Matériaux,* © IFAO
Page 72: Bodleian Library, Oxford, MS Ouseley Add 24, fol. 55v

CONTENTS

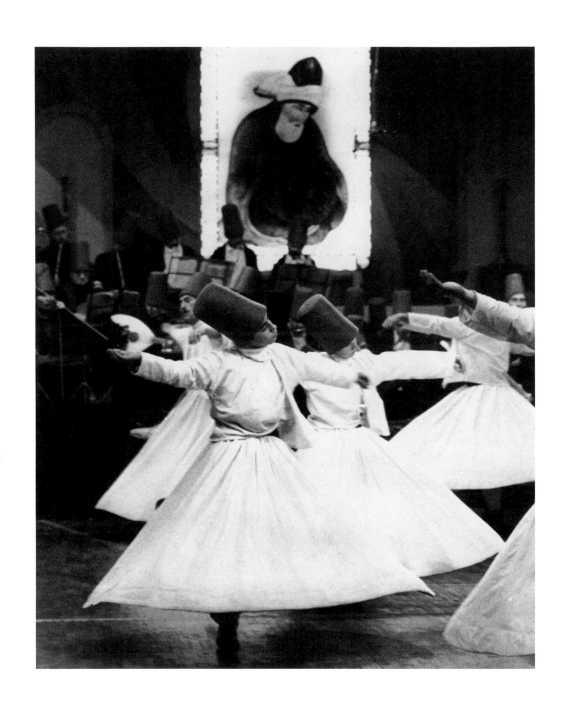

The successive houses in which we have lived have no doubt made our gestures commonplace. But we are very surprised, when we return to the old house, after an odyssey of many years, to find that the most delicate gestures, the earliest gestures suddenly come alive, are still faultless. In short, the house we were born in has engraved within us the hierarchy of the various functions of inhabiting.

— GASTON BACHELARD[1]

IN THE PAST decades, interest in Sufism, Islam's main form of mysticism, and in the thirteenth-century poet and saint Jalāl al-Dīn Rūmī (d. 1273) has reached new heights.[2] In the United States alone, there are two Rūmī festivals per year. A growing portion of his poetry is available in translations and interpretations, many of which are performed live and sold as recordings. As part of this trend, a number of recent publications have shown an interest in illuminating the works of this great Sufi poet. These illuminations often mix poetry and images. The poems are Rūmī, yet the images have been taken from every time period and geographic location. They are meant to evoke the spirit of Rūmī. What we gain from these publications is obvious. I write this book, however, out of a concern with what these books can obscure. As we spend more and more time divorcing Rūmī and other Muslim mystic poets from their historical context, it becomes easy to forget why artistic greatness flourishes in some periods and not in others. We also obscure the influence of other mystics on Rūmī's thoughts, his belief and training in Islam, and the adjustments that he made in his life to the massive changes in the world around him.

This study seeks to recover these historical contexts by focusing on the physical place that produced this influential man. I begin, therefore, with some general definitions of Rūmī's world. He came of age in Anatolia in the late Seljuk and early Beylik period, a period that is understood in this study as beginning in 1240 and ending in 1350. The ruling dynasties of the period were Turkish groups that followed Persianate traditions in government. Their religion was Islam, and their major sultans sought to bring Muslim scholars from all over the Islamic world to their courts in Konya and Sivas. Those that

came found themselves in a land where Muslims were the minority and the Byzantine and Armenian legacy was still strong.

When we understand Rūmī and the whirling dervishes as an intrinsic part of the Islamic world, we help construct a more accurate picture of Islam as a dynamic and multifaceted faith. After this monotheistic faith arose in western Arabia in the seventh century, with the revelations of the prophet Muhammad, it was enriched by a variety of philosophical and intellectual movements, an enrichment that continues to this day. Sufism is one of those movements. Like other mystical movements, the central goal of Sufism is knowledge of God. The methods by which that knowledge is achieved form a main focus of Sufi literature and practice.

Although Rūmī has entered the consciousness of the West as an ecumenical love poet, embraced by New Age movements, he was a devout Muslim. He came from a long line of Muslim clerics and gave legal judgments before his introduction to Sufism. He, and the other religious scholars of his era, lived at a time when the practice of Islam was changed by the proliferation of Sufi communities. These communities tested the outward manifestations of Islam to find new ways of achieving an intimate knowledge of God. Rūmī's ecumenical message, which is so appealing to today's followers in the West, grew out of this search and is reflected and reaffirmed by other Sufi writers of the period.

The Sufis in this study were often called "dervishes," a Turkish variant of a Persian word signifying those who have renounced the world. Although such a term emphasizes poverty, it came to be associated with members of a variety of urban movements. Rūmī's followers, commonly known as the whirling dervishes, are shown in this book's frontispiece, engaged in their ritual whirling. Although this is one of many photographs circulating in the West that have helped create a picture of Sufism as a timeless world of arcane spirituality, Rūmī and the dervishes in the photograph are separated from each other by close to seven centuries, each of which brought major changes to the Islamic world and to the practice of Sufism.

This study focuses on one of these periods of change through an examination of the complex relationship between religious authority and the visual world during Rūmī's lifetime. The careers of Rūmī and other Sufi leaders, such as Bābā Ilyās Khurāsānī and Fakhr al-Dīn ʿIrāqī, are set against the spatial networks—urban, topographical, and spiritual—commanded by the buildings in which they lived and worshiped. Such a focus

allows me to reintroduce Rūmī in the context of the unusual time and place in which he and his disciples lived. Although nothing remains of a portrait of Rūmī that was painted during his lifetime, there are rich source materials and building remains from the large number of Sufi buildings constructed during this period, and these help us reconstruct his world.[3] By focusing on these buildings and the cities in which they are located, we can not only consider how the borders and spaces available to Sufis helped form their sense of themselves and their community, we may also learn something about how the borders and spaces available to us help form our sense of ourselves and our community.

MY WORK ON this book began in the summer of 1985, while traveling from Istanbul to Erzurum with a group of fellow students from the summer language program at Bosphorus University. As we traveled by bus from Amasya to Tokat and then to Sivas, I saw how medieval Islamic buildings worked in sequence within cities and from one city to another. Given the importance of this trip in the development of this book, it seems appropriate to begin by thanking my fellow travelers—David Hirsch, Mark Stein, Lorna Tate, and Alexander Whelan—for their insights, enthusiasm, and humor.

Writing a book about architecture and cities is as much about where people travel as where they rest. Since my first trip, I have been fortunate to find homes, both abroad and in the States, in a number of institutions and universities that provided me with financial support and intellectual stimulation. I would like to express my gratitude to the National Gallery of Art, the Society for the Humanities at Cornell University, and the Center for the Humanities at the University of New Hampshire. For supporting archival research in Istanbul and Ankara, I am indebted to Fulbright Hays, the American Association of University Women, and the vice president's office at the University of New Hampshire.

I am especially grateful to the many friends, colleagues, and students who have contributed to this book in ways too numerous to count. First and foremost, I wish to thank Leslie Peirce, whose encouragement and thoughtful criticisms have consistently been sources of aid and inspiration. Of special note are Lois Brown, Kelly Dennis, Salima Ikram, D. Fairchild Ruggles, Yvonne Seng, and Lucienne Thys-Şenocak. My special gratitude goes to the members of the Sufi in Society Project—Shahzad Bashir, Devin DeWeese, Jamal Elias, Farooq Ahmet, Ahmet Karamustafa, Omid Safi, and Kishwar Rizvi—and, especially, to Jamal Elias for helping me shape my thoughts on the historical development of Sufism. Much of what is good in this book came out of conversations with them and the inspiration I derived from their work. Early comments from Shahzad Bashir and Devin DeWeese were particularly helpful in shaping my thoughts about the role of hagiography in Sufi life. Finally, Kishwar Rizvi deserves special thanks for letting

me read sections of this work to her over the phone and for her general support and interest.

A number of friends and colleagues helped me shape this final project. Howard Crane, David Powers, Gülru Necipoğlu, Cemal Kafadar, Rudi Paul Lindner, Nasser Rabat, and Scott Redford have generously given their time in answering questions and discussing problems of architecture and religious studies with me. At the early stages of this project, I benefited from the counsel of Irene A. Bierman, Ira Lapidus, and Speros Vryonis Jr. I would also like to thank John Voll for his insightful comments on my manuscript, which helped me see more clearly what I was doing. I would like to thank an anonymous scholar who was kind enough to send me very helpful comments and suggestions. My colleagues at the University of New Hampshire deserve my special thanks for their support, especially Bill Harris. I would particularly like to thank those who read and heard some sections of this manuscript: David Frankfurter, Jennifer Beard, Greg McMahon, Nicky Gullace, Lucy Salyer, and Jeff Diefendorf. Likewise, Thomas Trout, Dean Hoskin, and Burt Feintuch were extremely generous in funding the illustrations for this book. Finally, Jeanne Mitchell worked her magic in smoothing out any difficulties.

I was the most fortunate of authors in finding such a supportive and professional press. I would particularly like to thank Gloria Kury for her wise insights, Jennifer Norton for her patience, and Lisa Tremaine and Tim Holsopple for their good cheer. I would also like to thank the Hemming family for their patience, love, and warmth. For assistance with maps and sketches, I would like to thank Karen Alexander, Chris Brest, and Photo Services at the University of New Hampshire.

There are a number of people for whom it is impossible for me adequately to express my gratitude. My parents, Alyce and Edward Wolper, have shaped and supported my intellectual endeavors since I was born. From my father I learned a love of travel and adventure, while my mother's thoughtful guidance taught me how to think about the world. Jake Viebrock was instrumental in every step of this project. He asked the right questions and encouraged me to think about nuances of the material only he could spot. It is for him that I wrote this book, and I hope it reflects my deep affection and admiration. To him and Natalie Viebrock, who continues to remind me of everything that is wonderful in the world, I dedicate this work.

akhī	(lit. "brother") member of a mystical-artisanal organization
amīr	military commander
Ayyūbids	Muslim dynasty that ruled in Egypt (1171–1250) and Syria (1174–1260)
Bābā	(lit. "father") honorific title, often used by Türkmen tribes to designate a religious leader
baraka	blessing
beylerbey	military governor
buqʿa	(lit. "place") lodge or convent
caravansaray	inn, large commercial building
Dānishmendids	Turkish dynasty that ruled central Anatolia from 1071 to 1177
dergāh	lodge or convent
dervish	"one who has renounced the world," an exponent of Sufism
dhikr	(lit. "repetition," "remembrance") commonest term for Sufi meditative exercises
Eretnids	Muslim dynasty that ruled central Anatolia from 1343 to 1380
Evliya Çelebi	famous Ottoman traveler of the seventeenth century who wrote the *Seyahatnāme*
faqīh	(pl. *fuqahāʾ*) anyone possessing knowledge (*fiqh*) of a thing; a technical term for a specialist in religious law
faqīr	(lit. "poor") in mystic terminology, a person who lives for God alone; in popular terminology, a beggar or poor man
ghāzī	"warrior of the faith," a person conquering non-Muslim territories
Ilkhānids	Mongol successor dynasty in Persia, 1256–1349
ʿimāra	(lit. "building") lodge, convent, or soup kitchen
iqtāʿ	land grant from a ruler for military or administrative services rendered by a client
īwān	recessed room usually enclosed on three sides, with the fourth opening onto a courtyard
khān	travel lodge, caravansaray
khānqāh	lodge or convent
madrasa	school for higher learning, especially for Islamic law
maidān	square, open place, field, or large hall where *dhikr* is performed
Mamlūks	Muslim dynasty that ruled over Egypt and Syria, 1250–1517
manāqib	legend, book of epic deeds
masjid	any Muslim place of worship where the prayer is performed in a group
Mawlawī	member of a Sufi order centered at Konya and organized by the followers of Jalāl al-Dīn Rūmī (d. 1273), often referred to as the "whirling dervishes"
miḥrāb	niche in the *qibla* wall of the mosque, indicating the direction of Mecca
mudarris	teacher, professor in a *madrasa*

Ottoman	Muslim dynasty based in Anatolia, 1281–1924
pervāne	(lit. "moth") title used to designate a high office in the Seljuk administration
qāḍī	Muslim judge
Qaramānids	Muslim Turkish dynasty that ruled over central Anatolia, 1256–1483
qibla	direction of prayer for a Muslim
ribāṭ	Sufi hospice, originally designated a military garrison
samāʿ	distinctive whirling dance performed by followers of Jalāl al-Dīn Rūmī as part of their *dhikr*
sayyid	(lit. "master," "lord") honorific title for Muhammad's descendants
Seljuks	Muslim dynasty, originally a family of the Oğuz Turks; a branch of the Seljuks, the Seljuks of Rūm, ruled Anatolia from 1037 to 1300
Sufi	exponent of Sufism, Islam's main mystical tradition
ṭarīqa	fully developed hierarchical orders
ʿulamāʾ	(lit. "learned men") those men versed in Islamic legal and religious texts
waqf	pious endowment for the upkeep of a mosque, hospital, or the like
waqfīya	deed setting out the conditions of the *waqf*
wazīr	officer (minister) to whom a ruler delegated the administration of his realm
zāwiya	lodge or convent

THIS BOOK QUOTES Arabic, Persian, and Ottoman Turkish source material. Because many words common to all three languages are pronounced differently, I have had in each instance to decide which pronunciation system to privilege over the others. Since the primary source material on Anatolian dervish lodges is in Arabic, I have chosen to follow the *International Journal of Middle Eastern Studies* guidelines for Arabic translit-eration, with the exception of the hamza, which is indicated by an apostrophe. Although the names of sultans and other figures are rendered according to Arabic usage, titles like *pervāne*, which are of Persian origin and Turkish use, are rendered according to a sim-plified system of transliteration. For the sake of simplicity and clarity, commonly used words such as "Seljuk," "Sufi," and "sultan" are rendered without diacritical marks. To further simplify matters, I have used modern Turkish to designate the cities and rivers of Anatolia. For similar reasons, plurals of foreign words are rendered according to the rules of English.

While the problems of transliteration and of geographical names make it impossible to please everyone, I hope that the approach outlined here will accurately reflect the way words are used in *waqf* documents and building inscriptions.

Introduction

The *Vilāyetnāme* (Book of sanctity) of Ḥājjī
Bektāsh recounts a meeting between a wandering dervish and a monk. In the story, the dervish
was sent to deliver wheat to the Christian monk.
Along the way, he sold the wheat to starving townspeople and replaced much of it with straw and
dust. When the dervish turned his load over to the
monk, he was impressed with the monk's hospitality and began to think that the monk would make a
good Muslim. The monk, having understood the
dervish's thoughts, informed him that "he was
already a Muslim, but he was afraid to be such a
Muslim as the dervish who had betrayed the trust
of his master by selling some of the grain." At that
moment, church services began, and Christians
entered the church. When the service was over and
the last Christian had left the church, the monk led
the dervish into the church and closed the door.
He then lifted a stone slab and opened a door hidden underneath. The door opened into a room
holding a tall dervish cap and a *miḥrāb* (prayer
niche). The monk donned the cap, prayed at the
miḥrāb, and "informed the astonished dervish that
he was himself a Bektāshī dervish." After his prayer,
the "monk" removed his dervish garb and put on
again his Christian garment.[1]

This anecdote underlines some of the contradictions between the nature of religious belief in
medieval Anatolia and the contemporary perception of that belief. The wise Christian monk, who

was also a Bektāshī dervish, understood that true
religious feeling and belief were different from the
appearance and trappings of faith; in this story,
even contemporary beholders were easily confused
by the tricky interplay of substance and shadow of
religious sentiment. Not surprisingly, modern
scholarship, in its efforts to understand the religious milieu of medieval Anatolia, sometimes forgets the complex historical, religious, and cultural
developments that shaped it. The following study
concentrates on a crucial element in these developments: the dervish lodges built in central Anatolia between the second half of the thirteenth
century and the second half of the fourteenth century, when Ḥājjī Bektāsh and other dervish leaders
began to have a significant following.[2] These
dervishes tried to impose their understanding of
the world onto a region undergoing rapid transformation by large numbers of immigrants and a
breakdown of central authority. With the help of
local *amīrs* (military and political leaders) and
other leaders who had prospered from newly
acquired landholdings, dervishes founded dervish
lodges as centers for communal worship and the
standardization of their practices. These dervish
lodges eventually became pilgrimage sites and
commercial centers where vigorous new communities came into being.

In the span of a hundred years, at least fifteen
dervish lodges were built in the important trading

FIGURE 1
Anatolia: major cities.

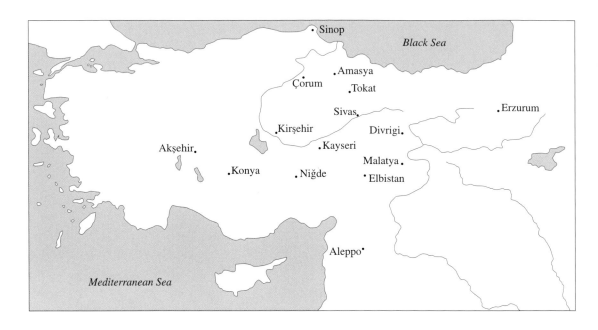

cities of Sivas, Tokat, and Amasya (fig. 1). In comparison to the few lodges built in these cities before the mid-thirteenth century, a visitor or resident would have noticed this large number of new dervish lodges because of both their number and their prominent location within these three cities.[3] For example, by the second half of the fourteenth century, dervish lodges occupied sites along major roads leading to three of the six gates of Sivas (see fig. 13), at the eastern and western entrances to Amasya (see fig. 19), and oriented toward the single entrance and exit of Tokat (see fig. 16). There were four dervish lodges near Tokat's primary markets, two near Amasya's market, and one at each of the three markets of Sivas. Generally, as in the example of Sivas, dervish lodges, markets, and city gateways were close to each other, so that both residents and visitors would have encountered them. Furthermore, the time between these encounters with the different lodges could have been short, because these cities were near each other along well-established trade routes running from the southeast to the northwest.[4]

Beginning in the thirteenth century, Sivas, Tokat, and Amasya became major immigration and trade sites for Muslims traveling from Iran and Central Asia.[5] At the same time, these cities were located in an area that was primarily Christian. The Muslim elite who ruled these cities were expected to support a number of distinct religious and educational services for Muslim devotional activity. Yet, because these cities had large non-Muslim populations, their rulers faced a variety of challenges. Between the mid-thirteenth and the mid-fourteenth centuries, more dervish lodges were endowed in Sivas, Tokat, and Amasya than any other pious institutions, suggesting that dervish lodges were seen as a response, if not a solution, to some of the new problems facing the rulers of these cities.[6] What this study attempts to demonstrate is how these local leaders used these buildings to support and foster local communities connected to dervishes. Not only did these dervish lodges provide each community with a geographical and spiritual center, they also became the physical structures around which new urban formations were organized.

AIMS AND APPROACHES

The main goal of this book is to examine the role of dervish lodges in religious and cultural transformation. To this end, the book combines three traditionally discrete fields: the history of Islamic architecture, the history of pre-Ottoman Anatolia, and the history of Sufism.[7] It draws upon these fields to construct a picture of dervish lodges as both buildings *and* institutions and asks two separate but interrelated questions about them. The first focuses on how the placement, orientation, and structure of these buildings changed the hierarchy of spaces in three Anatolian cities between the mid-thirteenth and mid-fourteenth centuries. The second question addresses how dervish lodges worked as places where different types of authority—religious, spiritual, and political— were mediated.[8]

As in any study of the role of architecture in social change, this book is based on a number of assumptions regarding how people interact with their environment. The most important assumption is that the organization of urban space has a major effect on one's perception and experience of the world.[9] Urban spaces are important because they form a spatial order that distinguishes a range of choices for the pedestrian by determining what buildings and sites he or she can or cannot see, and how easily. The resulting visual hierarchy helps to define the city's dominant features; in consequence, any significant change in the arrangement of urban spaces can redefine what those dominant features are.[10] Thus, major changes to urban space alter not only daily patterns of behavior but, to some extent, world outlooks.

At the same time, this study recognizes that no matter how much society employs architecture and urban space as a means to stabilize itself, architecture's inherent confrontation between space and its use dictates that space is constantly unstable and on the verge of change. In as simple an act as navigating city spaces, pedestrians always seek to alter the spatial order to suit their own needs. In such a way, changes in the spatial order reflect the dynamic between a preconceived hierarchy of spaces and the revision of that hierarchy by the visitors and residents navigating them.[11]

This study, then, asks what made people support, live in, and visit dervish lodges and not other buildings. Although this question may seem to be a simple one, answering it requires a knowledge of how medieval audiences understood their world. I argue that the location of dervish lodges within cities, their accessibility to the public, and the literature on them worked together in constructing new meanings, as well as creating and shaping new audiences, for them.

To address the dynamic interrelationship between audiences and buildings, the book is divided into three parts, each of which focuses on a different moment in a building's history: the initial funding and construction, the moment of completion, and the succeeding years of its history. Thus, each part examines a different set of relationships between buildings and their audiences. In the first, I focus on the mystically inclined religious elites who fled to the Seljuk court after the Mongol invasions of the early thirteenth century, and argue that competition among these figures created a situation where buildings, especially dervish lodges, took on an increased importance as visual markers of religious prestige, what I call visual authority. In addition, I point out that some of the social tensions caused by the intermixing of Christian residents and Türkmen immigrants were alleviated by dervish lodges: institutions that were relatively open and provided a wide range of social services. Finally, this part explains that rulers who supported dervish lodges were eligible for unique tax benefits because of the flexibility of these institutions.

In Part II, the focus turns to the actual buildings and examines how they were integrated into the visual and social environments of these three cities. Using the layout of dervish lodges in combination with information from endowment deeds, I discuss in this part how and why formal changes were made to the structure of dervish lodges and how these changes were tied to ritual practices. In Chapter 3, I document the major building activity for four twenty-five-year intervals in Sivas, Tokat, and Amasya. I also explore changes in the spatial order of these cities by examining how the construction of new buildings and the appropriation and adaptation of existing monuments altered the experience of city residents.

Part III looks at these buildings as repositories of history and as monuments to the foundation of the Sufi communities that began to form in the late fourteenth and early fifteenth centuries. I examine such questions as how buildings appeared in Sufi literature and how this literature looked at the role of Christians. Because a large number of dervish lodges mention women in their building inscriptions, I use this part to reevaluate the role of women in the Sufi communities of pre-Ottoman Anatolia. As guarantors of familial lines, women became important emblems of regional dynastic alliances. Finally, through an examination of the spatial and spiritual networks commanded by these lodges, I conclude this section with a focus on how communal identities were extended to other regions and time periods in Anatolia and the Middle East.

ANATOLIAN DERVISH LODGES AND OTTOMAN HISTORIOGRAPHY

"Dervish lodge" designates one of the most difficult categories of buildings in Islam. In this study, I use the term to refer to buildings that could be identified with a more technical vocabulary: *khānqāh* (Sufi hospice), *zāwiya* (Sufi hospice or

corner of a building), *dār al-siyyāda* (house of the *sayyids* [descendants of the Prophet]), *dār al-ṣulaḥā'* (house of the pious), *buqʿa* (Sufi hospice or tomb), and *ʿimāra* (building or hospice).[12] Although it could be argued that many of these terms have region-specific connotations,[13] the buildings indicated by them share important characteristics: each housed dervishes and provided a center for communal activities, including prayer, study, discussion, conversation with visitors, accommodation of travelers, feeding the poor, and sometimes the performance of *samāʿ* (audition) or *dhikr* (repetition of certain words in praise of God).[14] In general, these buildings included tombs and main halls to facilitate these activities. Although many activities were conducted around the tombs, other activities such as providing food, shelter, and entertainment for travelers usually took place in the main hall.

Aside from supporting prominent individuals, dervish lodges provided newly formed groups with a secure place for discussion, scholarship, and ritual activity. It was in these buildings that the details of ritual life and communal practice were worked out. By providing institutional support for the evolution of Sufi groups, these buildings became a crucial element in the development of Sufi practice, particularly the sanctification of Sufi saints.[15] Whether dead or alive, charismatic leaders rose to sainthood only through the efforts of individual followers and the micro societies that formed around them. Because of their proximity to God, these saints also became models of correct behavior. It was in dervish lodges where the very narratives that shaped the identities of those who later used these buildings began to be collected.[16]

Modern scholarship's understanding of the relationship between the Sufi mystical movement and the cultural transformation of Anatolia has created a number of problems for the study of dervish lodges, primarily because the study of

pre-Ottoman dervish lodges has often been subordinated to other inquiries: the rise of the Ottoman Empire, the Islamization and Turkification of Anatolia, and the development of Sufi orders. Beginning with the groundbreaking work of Fuad Köprülü (1890–1966), a Turkish scholar known as the father of Seljuk and Ottoman studies, dervish lodges came to be understood as crucial in the rise of the Ottoman Empire because of the role of dervishes in the Islamization and Turkification of Anatolia. Although no single figure has done more to enhance our understanding of the rise of the Ottomans, Köprülü, who wrote during the republican period in modern Turkey, followed a number of Turkish scholars from the 1920s by emphasizing the importance of the nomadic Turkish tribes that had come to Anatolia in the wake of the battle of Manzikert.[17] In his writing, Köprülü exalted the individuality of the Türkmen nomads, who had fought against oppressive foreign rulers, and stressed the role of Bābās ("fathers," an honorific title used to designate religious leaders) in carrying Central Asian traditions to Anatolia. In Köprülü's writing, Bābās converted the pagan Türkmens to a Turkish form of Islam that was heavily tinged with shamanism.[18]

In his focus on defining a Turkish Islam, Köprülü divided Anatolia's Muslim residents into two groups, with one a heterodox, rural, lower class and the other an orthodox, urban, educated group. He further divided them along linguistic lines between the Turkish and the Persian and Arab intellectual traditions. Thus, the heterodox group was traced back to Aḥmad Yasawī, a Central Asian Sufi who was described as representing the Turkish element, while the orthodox group was personified by such famous Sufis as Najm al-Dīn Rāzī and Bahāʾ al-Dīn Walad, representing the Persian tradition, and Ibn al-ʿArabī's stepson Ṣadr al-Dīn Qunawī, leading the Arab tradition.[19] Köprülü, who also wrote in reaction to European

scholars who stressed the Iranian and the Greek origin of the Ottoman state, focused on the spread of Islam to pagan Türkmen groups and diminished the role of the large number of Christian residents in Anatolia. In his focus on Central Asian Turkish traditions there was little room for any discussion of how Türkmens mixed with Christian residents and other immigrants.[20] Likewise, in his evaluation of Anatolian Sufism, in particular, his ideas about pagan survivals and Turkish Bābās marginalized the Sufism of any Turkish groups by placing them outside the mainstream Sufi tradition and at the same time diminished the role of Islam in this tradition.[21]

The implications of Köprülü's theory that the revolutionary and ethnically pure Türkmen Bābā–cum–shaman figure spread Islam in Anatolia through a Sufism that was close to pagan tribal traditions had a major impact on the study of dervish lodges as institutions *and buildings*.[22] In a 1942 article, Ömer Barkan used Köprülü's approach to argue that these Bābā shamanlike dervishes were "Kolonizer Dervishes" who used dervish lodges in the Islamization and Turkification of Anatolia. The Barkan thesis was given a formal basis of support twenty-one years later, in 1963, with Semavi Eyice's article entitled "İlk Osmanlı devrinin dinî-içtimaî bir müessesesi: Zâviyeler ve zâviyeli-camiler" (Zaviyes and zaviye camis: A social religious institution of the early Ottoman period).[23] In this article, Eyice set up a developmental scheme that began with a Central Asian house form that was brought to Anatolia by the Turks. In Anatolia, this form developed into what is called a T-style or Bursa mosque: a mosque that combined the functions of a dervish lodge and a mosque by incorporating side rooms into the mosque plan.[24] With Eyice's article and that of later Turkish art historians, Köprülü's work came full circle. Köprülü had used mystics to stress the Central Asian origin of the Ottomans, and later art historians buttressed that argument by

developing a formal schema whereby the Ottoman mosque complex was formed from the Central Asian house plan. In this schema, the dervish lodges built in thirteenth- and fourteenth-century Anatolia became the central element in this formation, acting as the conduit through which Central Asian traditions and building forms were brought to Anatolia.[25]

From the standpoint of the history of dervish lodges, the central problem with the Köprülü/Barkan/Eyice thesis is that it rests on a sharp distinction between popular or heterodox dervish groups and those upholding an orthodox Islam.[26] Many scholars, including those writing on the conversion of Christians in Asia Minor, used these divisions to suggest that lodges presented a more accessible form of Islam to a usually rural pagan and/or Christian population. Recent work by Ahmet Karamustafa, Reuven Amitai-Preiss, and Devin DeWeese has pointed out a number of problems with Köprülü's theory of shaman traditions and Islamization: it suggests the process of Islamization was superficial and divides Sufi piety into folk and elite traditions.[27] As pointed out by Karamustafa, this theory fits into the great-and-little-tradition paradigm and suggests that there was minimal interaction between a great orthodox tradition, expressed in Arabic and Persian, and a little heterodox tradition, expressed in Turkish.[28]

The most serious challenge to this division is the large number of dervishes designated as Qalandars. These wild antinomian figures, who rightly deserve to be considered heterodox, had no relationship with shamanism. Many of them were from prominent *ulamā* families and were well versed in Arabic and Persian sources. As pointed out by Karamustafa, the Qalandars cannot be considered part of a popular religious movement based on minimal Islamization; instead, they were part of a new mode in dervish religiosity. They had given up the comforts of settled urban life in

sophisticated Muslim centers and had set out in search of true religion. From their homes in Iran and Central Asia, they had watched different Sufi movements grow increasingly institutionalized and meaningless. Their response to the limitations of their theological and mystical training was literally to turn their backs on society and, like the early "friends of God" (*walī*/*awliyā'*), rely solely on God.[29]

In Asia Minor, a number of charismatic figures joined with Qalandar dervishes in what could best be called a "Qalandar" phase. The most prominent of these figures in the time period and area of this study was Fakhr al-Dīn ʿIrāqī (d. 688/1289). A study of his life indicates some of the problems in trying to fit many of the religious figures of Anatolia into elite/folk categories. Although ʿIrāqī was famous for his antinomian behavior, he came from a prominent family in Hamadan and eventually settled down for a brief period in Tokat. He was a favorite of the *amīr* Muʿīn al-Dīn Pervāne, Shams al-Dīn Juwaynī (the *ṣāḥib dīwān* [minister of state] of the Ilkhānids), and the Mamlūk sultan Qalawūn. According to a number of different historical sources, Muʿīn al-Dīn Pervāne and Shams al-Dīn Juwaynī built ʿIrāqī dervish lodges.[30] But even with the support of these elite politicians, ʿIrāqī continued his antinomian behavior. Typically, for example, he would allow the children of Tokat to lead him around on a leash.[31]

Many Anatolian dervish orders, like the followers of Jalāl al-Dīn Rūmī (the Mawlawīs) and the followers of Ḥājjī Bektāsh (the Bektāshīs), trace their beginning to the thirteenth century. Fully developed hierarchical orders (*ṭarīqas*), however, were rarely in existence before the fifteenth century.[32] Yet, modern scholars have discussed the thirteenth century as a time when there were standardized orders. In fact, what makes dervish movements in this period so confusing is that most of them have been understood

FIGURE 2
Anatolia, Dānishmendid
territory.

through the work of Aslıkpashazade, a fifteenth-century Ottoman Sufi who divided thirteenth-century Anatolian dervishes into the separate and distinct groups they became by the fifteenth century.[33] By assuming that there were standardized orders in thirteenth- and fourteenth-century Anatolia, scholars have made the orders more powerful and central than the local heterogeneous communities that surrounded important dervishes associated with particular buildings.[34]

DERVISH LODGES AND THE TRANSFORMATION OF ANATOLIAN CITIES

The way audiences reacted to dervish lodges was part of the larger story of how Anatolian cities changed between the middle of the thirteenth century and the middle of the fourteenth. As this study argues, the location and orientation of these dervish lodges was a crucial part of this change. Before the mid-thirteenth century only four lodges existed in the three cities—Sivas, Tokat, and Amasya—that form the subject of this book. But to understand why the large number built

between 1240 and 1350 created such a dramatic change in the organization of these cities requires a summary of the earlier events that molded their topography.

Sivas, Tokat, and Amasya are in a mountainous region of central Anatolia known as the Pontus. The region was named after the Pontus Euxinus (Black Sea), which lent its name to the original Pontic kingdom set up by Mithradates I in 302 B.C., with Amasya as the capital. Up until the mid-second century B.C. Amasya remained important as the burial site of the Pontic kings. Through late antiquity the name continued to define a separate administrative unit adjacent to Armenia Prima in the Roman Empire.[35] Under the Byzantines, the area came to be associated with some important Christian martyrs, the most famous which were the Forty Martyrs of Sebasteia, Roman soldiers who had perished for Christianity.[36]

With the Byzantine defeat by the Seljuk Turks at the Battle of Manzikert in 1071, the region came under the control of the Dānishmendids, a Turkish Muslim dynasty that ruled in northern

FIGURE 3
Anatolia in the time of ʿAlāʾ
al-Dīn Kay-Qubād.

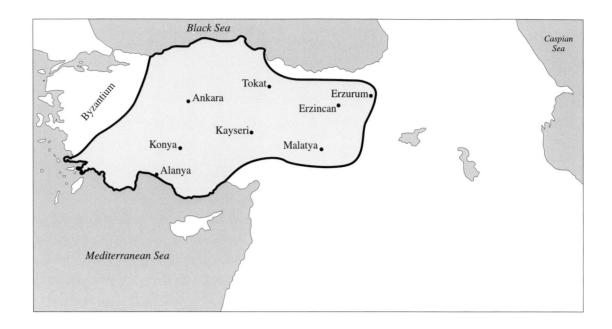

Cappadocia from the last quarter of the eleventh century until 1178. The century of Dānishmendid rule was marked by almost continual warfare. By the time of the first crusade, the eponymous leader of the Dānishmendids, Malik Dānishmend, had secured a territory including Sivas and Amasya. By 1142, Dānishmendid territory included two capitals: one in Sivas and one in Malatya (fig. 2). The Sivas branch ruled this region until they were conquered in 1178 by the other major Turkish Muslim force in the area, the Seljuks of Rūm.[37]

Although Dānishmendid rule lasted less than a century, the Dānishmendids had an enormous impact on the patterns of religious transformation for this region. Their pattern of conquest and adaptation followed an established tradition in the region: religious buildings that had first celebrated local cults, then Greek Orthodox and Armenian ones, were now adapted to the needs of the new rulers and so were converted into mosques.[38] As part of this pattern of adaptation, the Dānishmendids also adopted a bilingual coin that displayed a cruciform-nimbated bust of Christ and Greek inscriptions on one side.[39] Even in their epic work,

the *Dānishmendnāme*, there are frequent positive references to the Christian companions of Malik Dānishmend that reveal a conciliatory and inclusive attitude toward Christians.[40]

When the Seljuks of Rūm defeated the Dānishmendids, they brought about a new mix between the local Christian populations, Türkmen newcomers, and the representatives of the Seljuk state. Unlike the short-lived Dānishmendids, barely able to get beyond acquiring new territory, the Seljuks came to the region as an established empire following the bureaucratic traditions of the Great Seljuks of Iran, who had settled there around 1081. From Konya they had consolidated their rule over large portions of Anatolia. The Seljuks of Rūm reached the peak of their power in 1178 with the conquest of the Dānishmendids, a victory that gave them control of the overland trade route through Anatolia (fig. 3). During the reign of the Seljuk sultan ʿIzz al-Dīn Kay-Kāʾūs I (1210–19), the Seljuks gained power over two important ports, one on the Black Sea and one on the Mediterranean. With these conquests, the Seljuks controlled a north-south route that began

at the Black Sea ports of Sinop and Samsun and passed through Amasya, Tokat, and Sivas en route to Kayseri and Baghdad.[41]

Although both ruled as aliens over a population primarily made up of Greek and Armenian Christians and various Türkmen clans, the Seljuks differed from the Dānishmendids in patronizing urban institutions that emphasized the gulf between the ruling elite and the populace.[42] These institutions were the palace and the *madrasa*, a religious college for higher studies. Within each of these institutions, Arabic and Persian were the languages of instruction, worship, and discussion. In this way, the Seljuks excluded the local Greek and Armenian populations and Türkmen newcomers from these institutions. More directly, the Seljuks removed from circulation visual symbols familiar to the Christian population. When the Seljuks conquered Sivas, Tokat, and Amasya, for example, the bilingual Dānishmendid coin types seem to have been discontinued.[43]

The Seljuks' support of the *madrasa* reinforced the social distance between the local population, especially the Christian residents, and the governing elite.[44] In particular, it supported an emergent class of *'ulamā'* (scholars or learned men of Islam), which allied itself with the secular political elite. *Madrasa* education covered all aspects of religious, political, and civil life, including *'ibadāt* (laws regulating ritual and religious observances), family law, *fiqh* (Islamic jurisprudence), and laws of inheritance, property, and contract. *Fiqh* provided Muslims with a well-defined code of behavior that was sharply opposed to Christian religious and legal customs.[45] Thus the *madrasa* sponsored more than an elite cadre of scholars. It produced an elite group that followed a uniquely Muslim code regulating social life and administration. Finally, the *madrasa*, through its promotion of a relatively standardized code of ethical behavior, fostered a homogeneity of practice within the

Seljuk elite. With the promotion and imposition of this code, the Muslim minority was able to insert itself into and eventually dominate an urban administration previously controlled by Christians.

The Seljuk policy of taxing alien subjects while excluding them from participation in government was only viable with a divided subject population and adequate land resources. There were a number of separate Christian communities in Anatolia, including Greek Orthodox, Armenian, Nestorian, and Monophysite. Many of the Christians in this region had been transferred by the Byzantine Empire from southern Anatolia to central Anatolia in the latter part of the tenth and eleventh centuries.[46] For the most part, these groups were hostile to one another, the Greek Orthodox Church drawing particular animosity from the others. Thus, the local Christian populace did not possess a unifying institution that could provide a basis of support for communal resistance to the new Islamic order.

Paradoxically, the relationship between these Christians and recently arriving groups of Türkmen immigrants from Iran and Central Asia was often closer than that between the various Christian communities. In some cases, their religious practices grew to resemble each other. During the thirteenth century, when suitable land became scarce, a hostile relationship developed between the Seljuk state on one side and the indigenous Christians and Türkmens on the other side. When the Seljuk sultan Ghiyāth al-Dīn Kaykhusraw II (1237–45) tried to suppress the Türkmen elements within the empire, the situation in Anatolia became extremely volatile. The most dramatic consequence was the Bābā Rasūl, or Türkmen, revolt of 1240. Since Sivas, Tokat, and Amasya were together one of the main centers of this revolt, the story of the event and of the groups it brought together are crucial to the history of dervish lodges in these cities (fig. 4).

FIGURE 4
The Bābā Rasūl revolt.

According to the official Seljuk historian Ibn Bībī, the instigator was a Türkmen holy man from the Kefersud region in Syria who had lived in Seljuk territory, practicing magic and other related arts, under Sultan ʿAlāʾ al-Dīn Kay-Qubād (1219–37). With the accession of Kaykhusraw II, Bābā Rasūl fled to a dervish lodge in a village near Amasya. After gaining fame in that region, he traveled to southeast Anatolia and preached against the reigning Seljuk sultan Kaykhusraw. Kaykhusraw reacted by trying to have him killed. Not only did the sultan's envoy fail in his attempt, but Bābā Rasūl's followers grew so powerful that they were able to take over Tokat and Sivas. Even after Bābā Rasūl was captured and killed by the Seljuks, his following continued to grow. The movement was finally quashed by a special Seljuk force summoned from the East. According to Ibn Bībī, this force, which contained a number of Franks, massacred all of Bābā Rasūl's supporters, including women and children.[47]

Although there is a large corpus of material on the Bābā Rasūl revolt, most sources are in dis-agreement over such basic issues as the identity of its leader.[48] For example, a later account, written by Elwan Çelebi in 1358–59, states that the leader of the revolt was from Khurāsān. Other accounts of the revolt from the thirteenth and fourteenth centuries provide different details about the instigator, but all describe a religious figure who rose up against the Seljuk state and whose supporters were brutally put down by the forces of the Seljuks.[49] Some of these authors have pointed out Bābā Rasūl's close relationship with Christians. The Ottoman historian Hüseyin Hüsameddin, drawing largely upon unnamed earlier histories, claimed that the instigator was a Christian convert named Isaac sent to the region by the Comnene family to start a Greek empire in Amasya.[50] The inclusion of Christians, albeit in a different way, also appears in the account of Elwan Çelebi, where the instigator of the revolt was imprisoned in the fortress of Amasya with a Christian monk whom he converted to Islam. According to this account, both Bābā Ilyās and the Christian monk were united in their fear of

the Seljuks. But regardless of the identity of the instigator—a Khurāsānian, Türkmen, or Christian—we know that he was from one of the many groups that had grown in strength and power by the time of Kaykhusraw II. In this instance, their common claims against the Seljuk sultan exerted a force more powerful than the divisiveness of their individual identities, which helps to explain why there was enormous sympathy for the cause of Bābā Rasūl.[51]

In a number of accounts a dervish lodge in or near Amasya served as a meeting site for Bābā Rasūl and his followers.[52] As a result, whether these accounts reflected an actual fact or were apocryphal, dervish lodges were redefined as political places and came to be regarded by the Seljuks and later rulers as constituting a threat.

This was a major change from before the Bābā Rasūl revolt, when dervish lodges and dervish activity had been defined through experiences and traditions outside the local landscape. Many of the dervish leaders and building patrons of the thirteenth century came from Seljuk Iran, and in many ways the Anatolian dervish lodges built before 1240 were similar to the lodges of the Great Seljuks in Iran. Before 1240, dervish lodges functioned much like way stations, housing pilgrims and travelers, or, when set along border territories, were associated with various state-sponsored military operations. The Bābā Rasūl revolt, however, gave local meaning to these buildings; as such, they became places of political dissent and armed revolt. From here, it was not a big leap to transform them from sites of political unrest to centers crucial in building the local alliances that promote security.

The Bābā Rasūl revolt and infighting among Seljuk amīrs weakened the Seljuks of Rūm to the extent that they were unable to defend themselves against the Mongols. In 1243, the Seljuks of Rūm lost the Battle of Köse Dağ to the Mongols and became Mongol vassals. Although the Seljuks nominally still ruled the area until 1307, semi-independent local rulers, often former Seljuk amīrs or their descendants, increasingly impinged upon central Seljuk authority.[53] More than twenty independent principalities, or beyliks, came into existence after 1243, half of which were established before the beginning of the fourteenth century.

Two of these principalities, those of the Ṣāḥiboğulları and Pervāneoğulları, competed with the Mongols for hegemony over central Anatolia. The Ṣāḥiboğulları and Pervāneoğulları dynasties, like many others ruling Türkmen principalities, were begun by local military leaders connected to dervishes. Generally, a local amīr would acquire land and revenue by alienating them from the Seljuks, relying on a combination of external Mongol backing and internal local support that was mustered through affiliation with charismatic dervishes. Eventually, one of the more powerful of these principalities, that of the Eretnids, was able to drive the Mongols out of Anatolia. The Eretnids ruled over Sivas, Amasya, and Tokat from 1326 to 1360. In sum, the period from the second half of the thirteenth century to the second half of the fourteenth, commonly referred to as the pre-Ottoman period by modern scholars, witnessed the breakdown of centralized rule and the rise of a largely independent local landed aristocracy.[54]

These developments gave form to a new architectural order in central Anatolia. First, they created new types of building patrons. From 1240 to 1350 there were three groups of these patrons. The first group, directly involved in Seljuk administration, was composed of amīrs, wazīrs, and beylerbeys (high-ranking military commanders). They were the leading building patrons in this period, the Seljuk sultans having built their last royal building before 1250.[55] These patrons endowed buildings in Sivas, Tokat, and Amasya on behalf of the Seljuk sultans until the end of the

thirteenth century. The best-known of these patrons were Fakhr al-Dīn ʿAlī, the *ṣāḥib dīwān* of the Seljuk empire; ʿAbd al-Salām ibn Ṭurumṭay, the *beylerbey* of the Seljuk army; and *pervāne* Muʿīn al-Dīn, a high-ranking governor. Although they still supported *madrasas*, they also began to build dervish lodges, often building them close to their *madrasas*. The most prolific of these patrons were Fakhr al-Dīn ʿAlī and Muʿīn al-Dīn, two figures who tried to set up their own dynasties.

The second group of patrons, officials of the Ilkhānid dynasty, sponsored buildings in these three cities after the establishment of the Mongol protectorate. They also began to build dervish lodges as well as *madrasas*. For example, the *wazīr* Shams al-Dīn Juwaynī, the most prominent patron, built an elaborate *madrasa* in Sivas in 1271 and is also credited with building a dervish lodge for the prominent dervish Fakhr al-Dīn ʿIrāqī.[56] Juwaynī, like many other Mongol patrons who had prospered from trade in the Anatolian provinces, was encouraged to build pious structures in Anatolia.[57] Later Mongol patrons, like Nūr al-Dīn ibn Sentimūr, supported dervish lodges and tombs. The last Mongol building erected in these cities was completed in 1325.

Local aristocracy made up the third group, the most difficult group to classify. This group included local figures who, in many cases, were descendants, relations, or freed slaves of members of the house of Seljuk or were connected with the Mongols. As these individuals gained more power and wealth, they endowed more buildings. Their building activity spanned three decades from the end of the thirteenth century to approximately 1325. Although this group endowed a variety of buildings, they primarily funded dervish lodges.

During the twenty-five-year period between 1290 and 1315, when local leaders had assumed the responsibilities of rapidly weakening central rulers, all three of these groups supported building

activity. This is also the period during which sponsors endowed the greatest number of dervish lodges in Sivas, Tokat, and Amasya.

Location and patronage were not the only factors that separated the dervish lodges built after 1250 from more elite and selective institutions. The dervishes associated with these buildings embraced innovative practices and beliefs. Such tolerance of and even interest in heterogeneous practices and beliefs attracted a variety of adherents. Prominent dervishes attracted followers from different groups in society. For example, the *qāḍī* (judge) of Sivas, the Seljuk *wazīr* Fakhr al-Dīn ʿAlī, and common artisans were associated with Jalāl al-Dīn Rūmī.[58] In thirteenth- and fourteenth-century Anatolia, dervishes also had Christian adherents and sometimes incorporated Christian rituals into their devotional practices.[59] The symbiotic relationship among dervishes, non-Muslims, and Türkmen groups gave the dervish lodge prominence within the city. Dervishes followed alternative religious practices appealing to recent converts and even non-Muslims. The leaders of the new political structure, who supported dervish lodges over *madrasas*, in this way helped to displace the *madrasa*-trained bureaucratic and religious elite. As dervish lodges grew in popularity, dervishes and dervish practices regulated much communal activity in the religious, personal, and even social life of the urban residents.

In sum, this book examines the role of dervish lodges in the reformulation of religious communities in late Seljuk and early Beylik Anatolia and on that basis explains the massive transformations that took place in the pre-Ottoman period, when a breakdown of centralized rule and the rise of a largely independent local landed aristocracy translated into increasing power for local religious figures, who began to see themselves as spokesmen for the residents of Anatolia. Although their buildings are often understood as pious places of retreat

for the conversion of local Christians and pagan Türkmens, they first functioned as centers for the support, identification, and definition of religious communities formed around charismatic figures. In this way, dervish lodges served as central sites where the many relationships between the changing groups of Anatolia were mediated. Dervish lodges provided new bases of operations to recently uprooted religious leaders. They also provoked and gave shape to a series of compromises and cooperative agreements between their founders, benefactors, and users. By suggesting that it was individual lodges and not government patrons or Sufi orders (*ṭarīqa*) that provided the framework for new communal formations, I argue that buildings were central to identity formation. Placing dervish-lodge communities outside of a centralized government structure or *ṭarīqa* puts them in a local landscape. In the pre-Ottoman period that landscape had been most recently redefined by the Bābā Rasūl revolt and a number of other Türkmen uprisings and migrations.

درین وقت بهمراهی قلندران علیان پسیدهاند و صحبت حضرت شیخ بها الدین زکریا بشرف

کشیده اند چون تیکه که قلندران آنجا فرود آمده بودند قلندران را که نه دان که روان پسی باشد

که اگر یکبار دیگر من ملازمت شیخ بها الدین زکریا میر پسم دیگر باشما همراهی نمیتوانم کرد که مرا در

یک صحبت نزدیک بود که صید کند بنابران لطف همان که آخر روز بود و مسافر شدند چون روان شدند زهر

PART I

BUILDINGS AND RELIGIOUS AUTHORITY IN MEDIEVAL ANATOLIA

Visual Authority and Sufi Sanctification

NEGOTIATING ELITE SURVIVAL AFTER THE MONGOL CONQUEST

CHAPTER 1

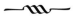

The leaders, dignitaries, and notables have thousands of houses, castles, and palaces; the houses of the merchants and ikdish¹ are loftier than the artisans', the amīrs' palaces are loftier than the merchants', and the sultans' palaces are even loftier than all the others.

—JALĀL AL-DĪN RŪMĪ²

COMING TO ANATOLIA

In the first decades of the thirteenth century, the sultan of the Seljuks of Rūm offered Bahā' al-Dīn Walad (d. 1230) and his son, Jalāl al-Dīn Rūmī (d. 1273), refuge at his court in Konya. Like many of the religious elites who came to Anatolia from Iran and Central Asia in the first quarter of the thirteenth century, Rūmī and his father settled in Seljuk Anatolia. Although it is difficult to imagine what Seljuk territory would have looked like to Rūmī and his father, we can assume that they would have noted some unique qualities of their new home. The first was its location. By the time Rūmī and his father arrived in Anatolia, the Seljuks of Rūm had gained control over a large centralized empire that extended to the Black Sea and Mediterranean coasts in the north and south and included Kars and Amida in the east. Because these new borders allowed easy passage from the southeast to the other cities of Seljuk Anatolia, Anatolian cities became a common stop for scholars traveling from Iran and Central Asia to Syria and beyond (fig. 5). Rūmī and his father, for example, followed a typical itinerary for religious scholars of this period; after leaving Balkh, in present-day Afghanistan, they stopped in Damascus and Mecca before arriving in Anatolia. Once in Anatolia, they stayed in Malatya for two years, Sivas for another two, Akşehir for three, and Laranda for seven (until 1228–29) before settling in Konya.³ Ibn al-ʿArabī traveled to similar destinations in separate trips from Damascus, arriving twice in Malatya (1205 and 1216–18) and once in Sivas and Konya (1215). In each of these cities, these religious elites met other scholars following similar itineraries. Not only did they help link the culture of separate Anatolian cities to each other, they also incorporated them into a larger international culture of scholars.⁴

The second quality that distinguished the cities of Anatolia from others that Rūmī and his father saw en route between Balkh and Konya was the constant building activity in the former. New mosques, palaces, city walls, and caravansarays were in an almost steady stream of construction between 1215 and 1238. By the time Rūmī and his father arrived at the Seljuk capital, new caravansarays marked the way from Konya along flourishing trade routes that headed by land to Constantinople, Aleppo, Mosul, and Tabriz, and to the Black Sea port of Sinop and the Mediterranean port of Antalya. As an example of the amazing pace of building activity under the Seljuks of Rūm, at least twenty-four caravansarays were established on

the road between Sivas and Kayseri during the first half of the thirteenth century.⁵ Aside from these magnificent buildings, it is likely that Rūmī and his father would have noted the wealth of cultivated land, gardens, and orchards.⁶

At the head of this bounty was the Seljuk sultan ʿAlāʾ al-Dīn Kay-Qubād. His reign (1219–37) marked the peak of Seljuk power in Anatolia. He came to power after some key military conquests and was able to build on this success by continuing to increase and consolidate Seljuk territory. Most important, Kay-Qubād's power over local leaders and Seljuk statesmen was strong enough to overcome internal rebellions, which had threatened the reigns of other sultans.⁷ To improve the safety of the empire, Kay-Qubād had his *amīrs* build city walls, fortifications, and caravansarays.

Through the display of some key features, these military constructions worked in tandem with newly built and reconstructed mosques in Alanya, Niğde, Konya, and Ankara to spread a unified Seljuk style throughout Kay-Qubād's territory.⁸ Kay-Qubād also built a number of palaces, where he entertained royalty and prominent religious scholars.

Kay-Qubād saw his court as part of an international *sunnī* culture. He followed in the footsteps of his predecessor, Kay-Kāʾūs (1210–19), by inviting religious scholars to his court.⁹ Yet Kay-Qubād, unlike his predecessor, had to face the first major Mongol incursions into Iran. The immediate effect of the Mongol attacks on the cities of northeastern Iran was that large numbers of religious scholars fled to Anatolia, where they settled in

FIGURE 5
Anatolia and its neighbors.

such cities as Konya, Kayseri, Sivas, and Tokat. To have such prominent scholars in an area that had only recently come under Muslim control represented a dramatic change in the cultural life of these cities. From the standpoint of a Seljuk sultan wanting the prestige and blessing that such scholars brought to his court, the arrival of such noted figures as Najm al-Dīn Rāzī (d. 1256–57) and Bahā' al-Dīn Walad must have seemed an auspicious event.[10] Yet, from the viewpoint of these scholars, many of whom had come to Anatolia after being displaced more than once, life in Anatolia could not have been easy. Many had been forced to flee under the most frightening circumstances, leaving family and property behind. The Mongol invasions had robbed them of homelands where they had established ways of life that were not and could not simply be transferred to Anatolia, especially since many of them came from cities that had been thriving centers of Muslim life for two or three centuries. The contrast with their former homes in Iran and Central Asia, which had large numbers of *madrasas* and dervish lodges, must have been great and made Anatolian cities seem like frontier outposts.

Najm al-Dīn Rāzī's story highlights some of the traumas associated with the migration to Anatolia. He began his migration in the 1220s, after a period during which, in Najm al-Dīn's own words, "each new day some new disaster would emerge and bring distraction to my heart and confusion to my mind." When "an army of Tartar infidels [Mongols] conquered Khurāsān," he abandoned his family and wandered in search of a suitable home until he was told about Anatolia, where the ruler was a "God-fearing, religious, nurturing" king. He traveled to Anatolia and there met another famous Sufi leader, ʿUmar Suhrawardī (d. 632/1234), who was seeking audience with the Seljuk sultan. Najm al-Dīn described this meeting as one in which ʿUmar Suhrawardī persuaded him

to stay in Anatolia and accept the patronage of the sultan, even though, in his words, it was "the custom of the Sufis to avoid the company of kings and sultans."[11] Aside from giving us a sense of how many notable religious figures traveled through Anatolia at this time, the description of the meeting between these two figures underlines how difficult it was for a Sufi scholar to change patrons. Both Najm al-Dīn and the Seljuk sultan needed the blessing of Suhrawardī to cement their new alignment. At the same time, the description of Najm al-Dīn's travails illustrates his need to negotiate his survival in Anatolia by accepting support from the sultan.

Even with the patronage of princes, however, life in Anatolia remained insecure. For although the Seljuk sultan welcomed these religious dignitaries, their position was mediated through local religious figures and could be altered at any moment by continuing immigration of outside dignitaries or a change in political rule. No individual, no matter how luminous, was protected from this competitive situation. Although Rūmī is credited with making Konya one of the spiritual centers of the world, he faced constant challenges from other religious elites in Anatolia. For example, he was not named Shaikh al-Islām of the Seljuks; that honor went to Ṣadr al-Dīn Qunawī, another eminent religious scholar in Konya.[12]

Not only did Rūmī and other notables have to contend with local elites and the many religious dignitaries that either stayed in Konya during their travels or immigrated there, they also faced competition from the many Türkmen groups that had begun to immigrate into Anatolia after the Byzantine defeat in 1071.[13] These Türkmen groups continued to immigrate to Anatolia for the next few centuries. Some of them came because of the Seljuk policy of allocating a district as *iqtāʿ* (temporary land grant) to a chieftain who would immigrate to the area with his clan. Generally, the

chieftain's position would be inherited by his descendants. These Türkmen clans settled in border areas and were sometimes called on to perform military services for the Seljuks. The Türkmens, many of whom had been living in Iran and other parts of the Islamic world before their immigration, were often accompanied by religious figures called Bābās. Although these groups tended to move with their tribes through regions outside major cities, the religious figures from this Türkmen milieu spent long periods of time in Anatolian cities and even reached positions of great prominence. Some of these figures attracted large followings and the patronage of princes.[14] By the time Rūmī reached late middle age, Bābās and other immigrant Sufis had become extremely popular. In many cases, Rūmī responded to their popularity with jealousy and anger. For example, after the Seljuk sultan Rukn al-Dīn Qilij Arslān (1248–64) had transferred his allegiance from Rūmī to Shaikh Bābā Marandī, the recently spurned Rūmī stated that the actions of this sultan were responsible for the decline of the house of Seljuk.[15]

CONSTRUCTING VISUAL AUTHORITY

Each of these religious elites, worried about his place in this new land, was understandably concerned with status and security. With hierarchies and questions of religious authority on their minds, Anatolia's new religious elites must have searched for ways to concretize and stabilize their positions. In the Islamic world, where one of the ways that princes honored religious scholars was through the patronage of pious institutions, buildings served as permanent testaments to what were often temporary alliances. It would not be surprising to discover that Anatolia's religious elites began to see buildings as visible signs of one's place in this new society.[16] Certainly, in the century and a half following Rūmī's arrival in Konya, Sufi authors increasingly wrote about buildings.

The large number of these references as well as the way that they are handled suggests the central role that buildings had in promoting new elites.

Before we can understand the use of buildings in Sufi texts, it is necessary to gain some general understanding of how these texts functioned in thirteenth- and fourteenth-century Anatolia. During the thirteenth century, religious elites and Türkmen Bābās had fled to Anatolia, where they began to form followings among the residents and newly settled immigrants. It was, however, not until the fourteenth century that the histories of these individuals were put down in writing. These histories often took the form of manāqibs, or books of legends written about particular saints.[17] Among their many functions, these texts helped organize a community of followers around a charismatic leader and a set of practices. In the fourteenth century, manāqibs were written about such noteworthy thirteenth-century figures as Jalāl al-Dīn Rūmī and Bābā Ilyās Khurāsānī.[18]

Because many of the Anatolian manāqibs were written close to a century after the deaths of their subjects, and because of their apologist nature, the information in them is often apocryphal and allegorical. For this reason, they are generally not used to research the building activity associated with Sufi orders in Seljuk and Beylik Anatolia. By ignoring these texts, however, we miss out on the crucial perspective that some of them provide on how one of the largest and most influential audiences understood the function and meaning of these buildings. They also give us an insight into how architecture, in general, functioned in the formation and identification of competing textual communities that used the same landscape to negotiate their place and identity within the world.

The passage at the beginning of this chapter is just one example of the many references to buildings in the Manāqib al-ʿārifīn (718/1318–19 – 754/1353–54). The text includes detailed

information about buildings, building directors, and travels between buildings. One reason the author of this text may have found it necessary to point out in whose building a certain discussion took place and even in what caravansaray someone stayed en route to a city was that the text was written during a period of competition among the Sufi communities of Anatolia. Contemporary religious elites, both Sufis and *ʿulamāʾ*, rivaled one another in producing texts that associated Anatolia's buildings with the rise of charismatic figures. Through this process, buildings were given increased importance as markers of status, or what I call visual authority.

One example of the relationship between visual authority and buildings in the *Manāqib al-ʿārifīn* is a description of a meeting between Rūmī's father and the Seljuk sultan of Anatolia. In the anecdote, Sultan Kay-Qubād invites Rūmī and his father to stay with him in his palace. Rūmī's father refuses the offer and chooses instead to find lodging in a *madrasa* because *"shaikhs* reside in *khānqāhs*, *imāms* (prayer leaders) in *madrasas*, *dervishes* in *zāwiyas*, *amīrs* in *sarays* (palaces), merchants in *khāns*, the *runud* (street gangs) on house corners, and strangers on the *mistāba* (bench)."[19] Through this anecdote, Rūmī's biographer described a perfectly ordered world in which a simple one-to-one relationship pertained between buildings and audiences. This anecdote, however, implies a more orderly world than was likely in late medieval Konya. Rūmī's biographer no doubt felt the need to describe this one-to-one connection between segments of the population and their respective habitats in order to bolster a "masterplan" of who belonged where in a world in which competing Sufi groups were trying to control the definition and function of Islamic institutions. After this introduction to the Seljuk capital, it should come as no surprise that Rūmī himself was reported to have described Konya in the similarly

hierarchical and stratified terms represented in the passage at the beginning of this chapter.

In reality, there could have been no simple one-to-one relationship between buildings and their audiences. Aside from the fact that the definition of these buildings changed during the time between the mid-thirteenth and mid-fourteenth centuries, buildings at any given time meant different things to different groups, especially in Anatolia. We can understand the relationship between some of these groups and buildings through the framework of interpretive communities. I use the term "interpretive community" to indicate groups with a common vision about the world around them.[20] Some of these communities, like the *ʿulamāʾ*, functioned within a framework of legal or institutional textuality, while others coalesced around Sufi literature or other kinds of texts. Each of these communities provided its individual members with visions of human relations and the world around them.

Understanding audiences as interpretive communities requires a somewhat different approach to the normal range of source material used to study dervish lodges in pre-Ottoman Anatolia. Instead of assuming that the sum of information from all these sources can give us a better picture of Anatolia in this period, I argue instead that each source presents one of many competing views. Aside from the buildings and cities themselves, two sources, *waqf* documents and Sufi hagiographies, play an important role in this study because of their relationship to some of the interpretive communities that would have used dervish lodges.

DERVISH LODGES AND INTERPRETIVE COMMUNITIES: NEW WAYS TO USE OLD SOURCES

Two biographical works on Rūmī and his followers survive from this period: Sipahsālār's *manāqib* (book of legends) and Aflākī's later but more

detailed *Manāqib al-ʿārifīn*. Because of Huart's French translation of the *Manāqib al-ʿārifīn* and his later article on the historical value of the work, Aflākī's *Manāqib* has been the basis for most scholarship on mystic life in Seljuk Anatolia.[21] Because many of Aflākī's accounts are corroborated in other sources, scholars tend to categorize this text as historically accurate on the urban and religious life of Anatolia. Before assuming, however, that the details of this text were simply intended to provide background material on the life of Rūmī and his followers, we need to examine some of the conditions of its creation. Rūmī's grandson, the man for whom the text was commissioned, was responsible for the construction of more dervish lodges in and outside of Anatolia than almost any other figure associated with Rūmī.[22] Through the joint work of shrine building and the commissioning of this hagiography, this grandson helped enlarge the community that had formed around his grandfather. The text, therefore, even though it contains many descriptions of buildings, building directors, and travels between buildings, is a problematic source for architectural history. Because Aflākī wished to augment the greatness of Jalāl al-Dīn Rūmī, he may have described buildings and the *shaikhs* who resided in them as more closely connected to Jalāl al-Dīn Rūmī than they really were. For example, a number of the buildings Aflākī associates with Jalāl al-Dīn Rūmī are linked to different Sufis in other sources.

The *Manāqib al-qudsiyye* of Elwan Çelebi is another Anatolian text in which buildings play a significant role. It tells the story of Bābā Ilyās Khurāsānī and the Bābā Rasūl revolt. This Turkish text was written by the great grandson of Bābā Ilyās in 760/1358–59. It provides a crucial insight into how the followers of Bābā Ilyās understood the role of their landscape in creating a sacred history for their founding figure and his disciples. The text delineates a genealogy of descendants and line of disciples from Bābā Ilyās through to Elwan Çelebi and links each with a different site in Anatolia. Many of these sites, connected through this genealogy, became points along new pilgrimage routes.

The *Merṣād al-ʿibād* of Najm al-Dīn Rāzī also includes many sections that define Sufi buildings. A version of the text was completed in Sivas in 620/1223–24 and dedicated to the Seljuk sultan ʿAlāʾ al-Dīn Kay-Qubād. It was in great demand during the thirteenth and fourteenth centuries; a summary of it was translated into Turkish in 741/1340 under the name *Qanz al-qubarāʾ* by Shaykhoğlu Mustafa.[23]

The accounts of the *futūwwa* (*futūwwa-nāme*) are included in this category of Sufi texts because they incorporated a Sufi framework and were written by and about Sufi adherents.[24] The *futūwwa*, a men's organization devoted to chivalrous ideas,[25] was introduced into Anatolia by ʿUmar Suhrawardī, the chief advisor of the ʿAbbasid caliph Naṣīr.[26] In Anatolia, these ideals were adhered to by groups under *akhī* leadership. These groups of young men were usually craftsmen organized into guilds. They followed a strict initiation ritual and adhered to a distinct mode of behavior. By the fourteenth century, they formed a major presence in many Anatolian cities and towns. At times, they even served as a semiofficial police force. A *futūwwa-nāme* was written by al-Naṣīrī in Tokat in the very first part of the fourteenth century. This text, like other *futūwwa-nāme*, even includes a description of what should occur in *akhī* buildings.[27]

Sufi communities were not the only groups that wrote about dervish lodges. In Anatolia, as in other parts of the Islamic world, one of the central institutions, controlled by the *ʿulamāʾ*, was the *waqf*, a pious endowment maintained in perpetuity. In the time of this study, a *waqfīya*, the deed for such a specially designated endowment, was drawn up when a pious institution was endowed or

when new income was provided for an endowed position or other additions to the institution. Rules governing the administration and inheritance of these endowments as well as the types of property that could be accepted as *waqf* varied according to the school of law (*madhab*). Under the Malikī school, for example, restrictions on who could be a benefactor made it difficult to create family-run endowments. As a result, many Sufi institutions that followed the Malikī school in the other parts of the world were privately run.[28] In Anatolia, where the primary legal school of interpretation was the Hanafi, it was easy to set up family-run endowments as *waqf*.

Through the institution of *waqf*, the *'ulamā'* controlled the writing, witnessing, and storing of documents on a large portion of property. The *waqf* document, or *waqfīya*, was drawn up for a patron whose piety and mental state were verified by the document. The body of the text was divided between information on the location of the endowed building and a list and description of the properties that were designated as *waqf*. Often, the last part of the document contained stipulations on how the patron's monies should be distributed among the building, its residents, and its administrators. Activities stipulated to be held in the building (e.g., public readings of the Qur'ān and food distribution for the poor) were mentioned as well.[29]

In order to use these documents to understand something about the communities that formed around dervish lodges we must negotiate two problems inherent to them.[30] First, while *waqfīyas* are rich source documents, the information in them is only prescriptive. Each document reflects what the founder's wishes were when the deed was drawn up. The founder's stipulations carried no guarantee that they would be scrupulously respected after the foundation was established. Second, understanding the difference between what is formulaic

in these documents and what may be specific historical information is often difficult. For example, *waqfīyas* of dervish lodges use a variety of terms for the beneficiaries of an endowment. Yet, by understanding the information in *waqfīyas* in the context of other sources and as drawn up at one of the many moments in a building's history, these problems can be avoided. Moreover, *waqf* documents remain the best source of information on how patrons worked with the legal establishment to define these buildings.

CONCLUSION

I have argued that competition between the mystically inclined religious elites who fled to the Seljuk court after the Mongol invasions created a situation where buildings took on increased importance as visual markers of religious prestige. In the next century, as the Sufi communities that coalesced around these elites began to write the histories of their founders, buildings were incorporated into hagiographies, where they were given two important functions. One, individual buildings came to be associated with the prestige and pious achievement of various saints, an association that gained importance during a period of competition among the Sufi communities of Anatolia. As visual conveyers of authority, these structures were dependent on audiences trained to read them. By including building details in the story of a saint's life, for example, the author of a Sufi text could ensure that his readers would associate specific buildings with specific figures and actions. In this way, buildings were defined by groups familiar with certain texts.

Two, because there was no simple one-to-one relationship between buildings and their audiences, Sufi writing regulated the meanings and practices associated with dervish lodges and other buildings. For pious institutions, like the scholars

who inhabited them, were subject to influences from the large number of immigrants that came to this region. As these immigrants began to form communities around saints, they used their writings to define these buildings. Although many of these groups formed around Sufi leaders, they also gathered around shared legal, political, and literary circles. Texts were the foundation for these "interpretive communities," but membership was not limited to the literate. All that was required was that one member could read or had memorized a body of information.[31] The followers of Rūmī, for example, could be considered an interpretive community. Even if they could not read, they would have known how buildings functioned from the various works written about Rūmī, his father, and his influential followers. They were one of the many Sufi groups that wrote these texts to inscribe the local landscape into their own worldview. At the same time, Sufi communities competed with each other to inscribe themselves into all levels of society as a way to ensure their power and reproduction. And one way the local communities integrated themselves into the landscape was by associating buildings with their important saints. This process of naming, claiming, and defining the landscape went on in a competitive fashion throughout the fourteenth and fifteenth centuries. For many Sufis their first encounter with some of these buildings would have come through texts. In this way, the development of hagiographies affected and controlled architectural programs and made these buildings major sites of identity formation.

The Patron and the Sufi

MEDIATING RELIGIOUS AUTHORITY THROUGH DERVISH LODGES

CHAPTER 2

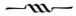

In approaching God, the highest, and asking for his affection, the weak slave ʿAbd Allāh ibn al-Muḥyī erects this building, the house of those who are thankful and the shelter of those who remember [dār al-shākirīn wa ma'wa al-dhākirīn], in the reign of the august sultan Abū Saʿīd ibn Uljaitū, may God preserve his reign, in the month of rabīʿ *in the year 717.*

— BUILDING INSCRIPTION OF THE ʿABD AL-MUṬṬALIB LODGE, TOKAT

In many ways, residents in dervish lodges had the best of both worlds. They could be critical of some *madrasa* scholars for their expensive habits and separation from the true will of God, while their support was guaranteed through buildings whose very endowment was set up under the auspices of legal formations controlled by the *madrasa*-trained *ʿulamāʾ*. Sufi authors frequently criticized the judges (*qāḍīs*) whose signatures appeared at the bottom of the documents that protected *waqf* revenue. Elwan Çelebi, the biographer of Bābā Ilyās, blamed the *qāḍī* of Amasya for the persecutions that led to the Bābā Rasūl revolt. This antagonism toward *qāḍīs* and other figures associated with the *madrasa* was not limited to the followers of Bābā Ilyās. Rūmī's main biography includes a telling anecdote about a poor dervish who peers in the window of a *madrasa* and, after seeing the elaborate dress and expensive eating habits of the *madrasa*'s inhabitants, wishes to become one of them.[1] What makes the criticisms against *ʿulamāʾ* somewhat problematic, however, is that only in rare cases did Sufis truly reject *ʿulamāʾ* protection, for dervish lodges, as buildings supported by *waqf*, were protected by the very group that many dervish-lodge residents often criticized.[2]

Not surprisingly, the *ʿulamāʾ* frequently attacked the residents of dervish lodges.[3] Ironically, they were joined in their criticism by some very prominent Sufis.[4] The fundamental issues in many of these attacks were money and religious authority. In areas outside of Anatolia, such as Ayyūbid Syria, Sufis benefited from the patronage of princes. In the last quarter of the twelfth century, the Ayyūbid sultan Nūr al-Dīn, who used the epithet "al-Zāhid" (the ascetic), built three dervish lodges in Aleppo. The grandeur of Aleppo's Sufi buildings caused Ibn Jubayr to write that "these Sufis are the Kings of the land, for God has spared them the trouble of getting provisions and cleared their minds for His worship." Although allowing Sufis to focus on more important matters could be cited as one of the reasons why dervish lodges were built, some may have questioned why these buildings needed to be "palaces that remind them of the palaces of Paradise."[5] In Baghdad, the Hanbalī scholar Ibn al-Jawzī (d. 597/1200) was much more severe in his criticism of dervish lodges (*khānqāhs*), noting that they were "decorated palaces," and incorporated this observation into his criticisms of what he saw as dangerous trends in Sufi activity. In Mamlūk Cairo, another Hanbalī scholar, Ibn Taymīya

(661–728/1262–1328), followed Ibn al-Jawzī in his condemnation of many contemporary Sufi practices. He questioned the power and piety of those who claimed mystic status and ended up in palatial dervish lodges.[6] Other religious scholars and even Mamlūk chroniclers criticized the residents of dervish lodges for being lazy opportunists with little real devotion to the Sufi path. Tāqī al-Dīn Abī al-ʿAbbās Aḥmad ibn ʿAlī al-Maqrīzī, a Mamlūk chronicler, barely contained his hostility toward the Sufi groups residing in Cairo. His enmity seemed especially vehement toward the foreign Sufis who had benefited from free residence in the palatial structures built by sultans and *amīrs.*[7]

The cities of Aleppo and Baghdad in the twelfth century were similar to Cairo in the fourteenth century in witnessing the growing popularity of Sufis. Criticisms against Sufi practice were directly contemporary with a sudden increase in the support of Sufi institutions. In Mamlūk Cairo, the *ʿulamāʾ* who questioned the sanctity of the Sufis and the large expenditures that went to these institutions were often trying to adjust to the decreasing financial support given to *madrasas* and other pious institutions by the ruling elite. As the standard of living for residents in dervish lodges grew higher, prominent *ʿulamāʾ* even tried to establish residence in dervish lodges instead of *madrasas.*[8]

Although we do not have the same wealth of sources on the Seljuks of Rūm as on the Ayyūbids or Mamlūks during Seljuk and Beylik times, the cities of Sivas, Tokat, and Amasya were like Mamlūk Cairo and Ayyūbid Aleppo in that under these political regimes the endowments for dervish lodges grew in size and number while those for *madrasas* decreased. Although it is usually assumed that patrons built more dervish lodges because of the special functions associated with them, a change in political structure created new economic and social motivations for those patrons who took over building activity after the last royal

Seljuk foundation was built in 1243. These political changes made dervish lodges a choice object of patronage.[9]

WAQF AND MULK AFTER KÖSE DAĞ

From the second half of the thirteenth century to the second half of the fourteenth, centralized rule broke down in Anatolia, to be replaced by a largely independent local landed aristocracy. In this sociopolitical environment, the endowment of dervish lodges became the easiest means for these local rulers to extend their control over newly acquired lands.[10] Because the initial investment required for dervish lodges could be less than for other pious buildings, they were also one of the cheapest beneficiaries for protected endowments. Supporting a dervish lodge allowed rulers to tie up revenues from these lands as *waqf,* which served two purposes. It supported new institutions and permanently dedicated land revenues toward that end, allowing *amīrs* to protect and invest the land they had acquired from the bankrupt Seljuk state.[11] When property values increased, these investments could grow, and although the *amīr* could not sell *waqf* property, he could ensure that he and his descendants controlled the use of that revenue and, by naming him or his descendants as holders of an endowed position, assure a steady income from the foundation. In other words, *amīrs* could use a *waqf* foundation supporting a dervish lodge to set up a lucrative source of income for themselves that remained outside of state control.

The Battle of Köse Dağ in 1243 marked a major change in land allocation in which power and land shifted from the centralized Seljuk sultanate to the local *amīrs.* Before this battle, it had been difficult for *amīrs* to acquire their own land. In general, they had been supported by the land grants known as *iqṭāʿ,* which were held only temporarily in return for military or administrative service.[12] After the Mongol victory, the Mongols

began to tax the Seljuks and their subjects, further decreasing the revenues of the Seljuk state, already depleted by corrupt policies and internal rebellions. Seljuk rule continued to cast a faint shadow until 1307, but real authority siphoned off into local hands. Seljuk sultans who needed money were forced to sell or give land to *amīrs* in the form of *mulk*, which gave full and permanent ownership, not just temporary rights, to the land and its revenues. The local *amīrs*, for their part, ironically themselves often former Seljuk rulers or their descendants, used both Mongol and communal backing to achieve their ends. The new distribution of land as *mulk* was so widespread that, by the beginning of the fourteenth century, most of the land that had belonged to the Rūm Seljuks had become private property.[13]

Mulk could be transformed into *waqf*, and by doing so the patron laid permanent claim to the property, rendering it inalienable.[14] This was especially important after 1277, when the Mongols sought to recover Seljuk *iqṭāʿs* that had been made into *mulk*.[15] *Amīrs* reacted to this attempt by building new dervish lodges; the greatest number of dervish lodges were built in Anatolia between 1277 and 1300, a period that coincided with the most direct Mongol involvement in Anatolia. In Tokat, for example, three lodges—the Shams al-Dīn ibn Ḥusayn (1288), Khalif Ghāzī (1299), and Sunbul Bābā (1298–99)—were built within an eleven-year period. The *waqf* also ensured that the foundation would provide an income for officials within the institution. By appointing themselves or their family members to these offices, *wāqifs* (donors of *waqfs*) ensured that either they or family members would receive that permanent income. In some cases, where officials' salaries were based on a percentage of income, the salaries could increase as the value of the foundation rose.

The official who controlled the collection and distribution of *waqf* revenues was an important figure. Known as the *nāẓir*, he had final discretion over the disposal of funds.[16] The position of *nāẓir* was usually passed on in a family from generation to generation to ensure that control of *waqf* revenues would remain in that family. Because activities connected to the dervish lodge, unlike those connected to other "pious" institutions such as *madrasas* and mosques, did not involve *ʿulamā*', the *nāẓir* may have exercised more independence in choosing how to divide funds, invest revenues, and levy rents.[17] Furthermore, the patron of a dervish lodge was able to appoint the *nāẓir* and specify how his position would be passed on. For many of the same reasons, by the fourteenth century the *wāqif* began to name the *shaikh* and even stipulate that this position, like that of the *wāqif* or *nāẓir*, be passed on to his descendants.[18] In this way, the patron could control the allegiances of the key figures in the foundation and further benefit from its revenues. During periods of extreme political insecurity, in particular, endowing a dervish lodge was a way of ensuring that the control of assets would remain within one family. By turning former state land into *waqf* and thus controlling the future of their estates, patrons left their descendants powerful and land-rich, and these families in turn continued to shelter their assets by endowing other pious institutions controlled by the administrators of their choice.

Another important financial incentive for choosing dervish lodges to patronize was that they were cheaper than other buildings. Local *amīrs* did not have the resources of sultans and could never have afforded to invest their property as *waqf* for mosques or *madrasas*.[19] Although dervish lodges could be lavish, they were not required to have special rooms for prayer, lodging, food preparation, or teaching, and their *waqfīyas*, unlike those of *madrasas*, did not have to provide the large stipends allotted to the *imām*, *mudarris*, or students. The salary of a *mudarris*, in particular,

was often at least twice as high as that of other officials.[20] The salary for a *shaikh*, however, was significantly lower. A 1272 *waqfīya* from Kirşehir, for example, allotted 1,200 *dirhāms* per year to a *mudarris*, a figure more than double that for the *shaikh*, which ranged from 420 to 600 *dirhāms* a year.[21]

In thirteenth- and fourteenth-century Anatolia, where control over newly available land was directly related to acquisition of political power, the patronage of architecture was one means by which *amīrs* were able to hold on to property. The three most prolific building patrons from this period—the *pervāne* Muʿīn al-Dīn, the *wazīr* Fakhr al-Dīn ʿAlī, and the *atabeg* Jalāl al-Dīn Qarāṭay—and their descendants were highly successful in quickly converting private property into protected *waqf*. Through this method, they were able to establish semi-independent rule over entire regions.[22]

To these patrons, dervish lodges were much more than simple tax shelters. As previously pointed out, local leaders chose to build dervish lodges, as opposed to mosques and *madrasas*, because dervishes had an enormous influence over the local population and the Türkmen groups. This second reason was important because, by the second half of the thirteenth century, *amīrs* could no longer rely upon Seljuk forces to protect their cities from external threats or to quell rebellions. Thus, they wanted to form alliances with leaders of resident groups to provide local military support and to help ensure their popularity.

By building dervish lodges in accessible and popular locations, *amīrs* fostered alliances between themselves and this new power base made up of resident groups. Furthermore, in the same *waqfīyas* used to set up these buildings, patrons supplied dervish lodges with salaried positions and provisions. These positions and provisions ensured

that the lodges would have a visible and audible role in the life of their cities. For patrons were as concerned with the future and fame of their buildings and institutions as with control of land assets.

SALARIED POSITIONS

The *waqfīyas* for dervish lodges of thirteenth- and fourteenth-century Anatolia stipulated a wide range of salaried positions. Although the inclusion of any of these positions was not a requirement for the dervish lodges, the number of officials so specified was in some cases equal to the number found in *waqfīyas* from much larger *madrasas*. For example, the *waqfīya* from the Shams al-Dīn ibn Ḥusayn lodge in Tokat mentions a *mutawallī*, *shaikh*, *muʾadhdhin*, *bawwāb*, *mushrif*, *khādim*, and two *hāfizes* in addition to a cook and a cleaner. Each of these positions was supported by a yearly or monthly salary that was either a fixed amount or, as was more likely, a portion of the proceeds of the *waqf* revenues. The positions varied according to salary level and inheritability.

The Shaikh *and the* Mutawallī

One of the least tangible but most significant functions of the dervish lodge was as a spiritual and educational center. An individual connected to a lodge as a *shaikh* served as intermediary between the holy figure enshrined in the tomb and the pilgrims who came to worship. *Shaikhs* became the receptacles in which the words and deeds of the holy figures connected to these sites were stored. In Anatolia, where dervish lodges attracted groups with varied religious backgrounds and limited knowledge of Arabic or Persian, the *shaikhs* literally served as interpreters for the heterogeneous groups that came to the lodges. Furthermore, these *shaikhs* linked holy figures to Christians and Türkmen groups through legends and parables. At the same time, a dervish lodge provided a forum for theological discussions between *shaikh*,

dervishes, and learned men.[23] An increase of visitors and pilgrims augmented the fame of a *shaikh* and the importance of his or her dervish lodge.

During the thirteenth and fourteenth centuries, *shaikhs* gained a large degree of independence, as evidenced by the development of their role vis-à-vis the building endowment from 1240 to 1350. While *waqfīyas* for the dervish lodges built before 1289, such as the Gök Madrasa lodges of Sivas and Amasya, did not include the names of specific *shaikhs*, those from the end of the fourteenth century not only listed specific *shaikhs* but specified a line of descent.[24] The *waqfīya* of the Ya'qūb Pasha lodge in Amasya is typical of the *waqfīyas* from after 1300 in containing a stipulation about how the position of *shaikh* would be passed on; it stipulates that the *shaikh* be a descendant of 'Alī ibn Siyawūsh.[25] Before this period, when neither the *shaikh* nor his heir was stipulated by the *wāqif*, it was the responsibility of the *mutawallī* (administrator) or *nāẓir* (administrator) to appoint a *shaikh*. This prerogative to choose the spiritual head of life within the lodge lent the *nāẓir* or *mutawallī* great power.[26]

Issues related to community formation help explain why the *waqfīyas* from the fourteenth century emphasize the role of the *shaikh* and his or her descendants. The stipulations about a *shaikh* and his or her line of descent ensured a continuity in the communities formed around these dervish lodges. The lodges themselves, as buildings, reified the alliances between patrons and *shaikhs*. Once a community had formed around a lodge, it was important to its continuation to carry this alliance into the future and assure that the patron's descendants and the *shaikh*'s descendants had a permanent place marking their relationship.

Although the *shaikh* was considered the spiritual master of the dervish lodge, his stipend was regulated by the *mutawallī* or *nāẓir*. The *mutawallī* also decided how to invest *waqf* revenues and to distribute any profits generated by the foundation. The *mutawallī* represented the interests of the *wāqif* insofar as he enforced compliance with the stipulations in the *waqfīya*. His salary was usually significantly higher than that of the other appointments in the dervish lodge.[27] In some *waqfīyas* the *mutawallī* is even named as the heir to the *waqf* if the *wāqif* dies.

The Hāfflfiz *and* Mu'adhdhin

The *ḥāfiẓ* (one who has memorized the Qur'ān) assured that attention would be drawn to the building and its tomb. Almost all the dervish lodges built in Sivas, Tokat, and Amasya between the second half of the thirteenth century and the second half of the fourteenth century had tombs. One of the main purposes of the endowments of many Anatolian dervish lodges was to preserve these tombs as objects of veneration for lodge residents, local residents, and pilgrims. Each *waqfīya* included funds for the upkeep of a tomb, usually a square domed room with at least one cenotaph. These cenotaphs were the object of special veneration through daily Qur'ān readings, which were generally listed as a stipulation (*shart*) of the endowment. Most *waqfīyas* for dervish lodges include a formula stating where, when, and by whom the Qur'ān should be read. For example, the deed of the Shams al-Dīn ibn Ḥusayn lodge stipulates that "each day two people among the *huffaz* read a part of the Qur'ān in the above-mentioned tomb."[28] The salary of the *ḥāfiẓ* also was usually listed as a *shart* of the foundation.[29]

Unlike Qur'ānic recitations, which could theoretically be heard and observed via a large street-level window by all ethnic and religious groups, the performance of prayer inside the lodge was restricted to a select group of dervishes, a number usually determined by the *wāqif*.[30] Furthermore, the physical layout of the lodge served to isolate and limit the prayer area. The prayer hall, or

maidān, generally located in the back of the lodge, with little or no public access, was not visible from the street. What windows it had were usually very small, and their sills were placed far above six feet. In this way, the prayer hall, like the individual cells for mystics, was a private space separated from the outside world both by the lodge's thick rear walls and by the rooms facing the street.

Although a limited group was allowed to enter the dervish lodge for prayer, the call to prayer must have been important. Most of the extant *waqfīyas* from this region provide a salary for a *mu'adhdhin*, who was expected to perform the five calls to prayer.[31] As a result of this stipulation, the call to Muslim prayer would have emanated from these dervish lodges, thus helping to associate them with Muslim religious practice. The call signaled and emphasized the adherence of dervishes to the most visible and central part of Islamic belief and at the same time distinguished the lodges from soup houses and other shelters. Because only a select group of people were able to enter the prayer hall during prayer time, the call to prayer also drew attention to the privilege this group of dervishes enjoyed. The importance of the *mu'adhdhins* was underlined by their high salaries.[32]

The Bawwāb *and Resident Dervishes*

Waqfīyas for dervish lodges in Sivas, Tokat, and Amasya include stipulations for a *bawwāb*, who was usually guaranteed as generous a salary as the *imām* or *ḥāfiẓ*. He decided who was allowed inside and may have had final judgment on how people were recognized and admitted. It can be assumed that, in addition to the resident dervishes, others must have come to the lodge for discussions and meals. The *bawwāb* was responsible for determining which of these outsiders was to be allowed in. He also kept extra dervishes out of the lodge during prayer time and in the evening. Since *waqfīyas* only included the most general guidelines about

who should and could use a building,[33] it would appear that it was up to the *bawwāb* to determine who could enter. This position gave him a significant role in the function of each lodge. On a symbolic level, the *bawwāb*, within the urban environment, marked the threshold between nonrestricted and restricted space as well as between holy or blessed space and secular space. On a more mundane level, the *bawwāb*'s required presence meant that someone would be directing various audiences to specific buildings and parts of buildings.

The number of resident dervishes, however, was not left up to the discretion of the *bawwāb*. That number was usually specified in the *waqfīya*. For most of the dervish lodges in this study, this number was below ten. Each dervish was given a fairly generous stipend; the amount was less than that of the *shaikh* and *mutawallī* but equal to the *mu'adhdhin*, *ḥāfiẓ*, and *bawwāb*. In addition, dervishes were often given such supplies as soap and wax and required to be fed meat. Given the amounts of these stipends, it may have been difficult for lodges to support more than ten dervishes. For these residents, life inside the lodge must have been a welcome relief from the outside world, especially after the third quarter of the thirteenth century, when there were a number of famines and an increase in Türkmen raids.[34]

Although very little information survives concerning the dervishes who lived in dervish lodges, *waqfīyas* stipulated that they perform Friday prayer and provided for celebrations during the major Muslim holidays.[35] The *wāqif*'s motive in ensuring that Sufi residents observed these central Islamic practices is not easy to ascertain. Given the many stipulations about the pious nature of the residents, the stipulation concerning observances seems odd. On the other hand, many of the residents were involved with secular activities that brought them out to the fields and markets. It is

possible that such stipulations staved off questions about the piety of the residents and hence about the institution. At the same time, because some of the more antinomian Sufis may have spurned many of these visible and audible practices, the stipulations ensured that a certain type of Sufi would be representing the institution.

STIPULATED ACTIVITIES

Building patrons who endowed dervish lodges also stipulated that the residents perform duties such as welcoming visitors, praying, reciting the Qur'ān, and distributing food. In general, the performance of these rituals reinforced the solidarity of the dervishes connected to specific buildings and also encouraged interactions between the dervishes and an outside community of followers. Some of the more public activities were intended to emphasize the piety and mystical power of the lodge's dervishes. Finally, the staging of other activities, like prayer and discussion, displayed the connection between political leaders and dervish leaders to a large urban audience.

Distributing food to the poor was a *shart* of some of the endowment deeds for the dervish lodges from Sivas, Tokat, and Amasya. According to the building endowment for the Sunbul Bābā lodge in Tokat, food was to be dispersed to the poor (*faqīr*) on Wednesdays.[36] In the deeds of other lodges, the day for food distribution was not specified.[37] Food distribution drew masses of people to the dervish lodge and signaled its popularity to a broader urban audience.

Such distribution, of course, was only one reason for preparing food in the lodge, for meals also had to be prepared for dervishes and their guests. Food preparation and the meals themselves were important adjuncts of entertainment, initiation, and ritual celebrations. According to later sources, meals in dervish lodges usually were eaten by dervishes and notable guests, such as Muʿīn al-Dīn

Pervāne. Meals were taken in a large oblong hall, the *maidān*, the same hall used for prayer.[38] Through communal meals, dervishes and guests came together on a frequent basis, including those occasions on which the dervish lodge served as a hostel for travelers. Guests who were invited to these meals spread stories about the lodge's dervishes and benefactor to lodges in other cities, in essence publicizing the lodge abroad.

Similarly, sheltering travelers and pilgrims, another of the lodge's primary functions, extended the fame of the lodge as both a hostel and a pilgrimage site.[39] During a visit to Sivas, the fourteenth-century traveler Ibn Baṭṭūṭa was invited to stay at two different dervish lodges. When he and his group arrived at the gates of the city, they were met by "a large company, some riding and some on foot," of followers of Akhī Biçakçı. Directly after, they were met by associates of Akhī Çelebi, who invited Ibn Baṭṭūṭa to lodge with them. As Ibn Baṭṭūṭa points out, he "could not accept the invitation, owing to the priority of the former." As a sort of compromise, he and his company "entered the city in the company of both parties, who were boasting against one another, and those who had met us first showed the liveliest joy at our lodging with them."[40]

Guests who traveled along trade and pilgrimage routes reinforced the connection between dervish lodges and other holy sites along these routes. During the thirteenth and fourteenth centuries a close relationship developed between dervishes and the revival of ancient religious sites.[41] A number of thirteenth- and fourteenth-century buildings along the Sinop-Antalya and Tabriz-Constantinople trade and pilgrimage routes were linked to holy figures embraced by Sufi communities after the rediscovery of their tombs. A number of these sites evolved into dervish lodges by housing or at least feeding dervishes. Their tombs, as pilgrimage sites, attracted both dervishes and

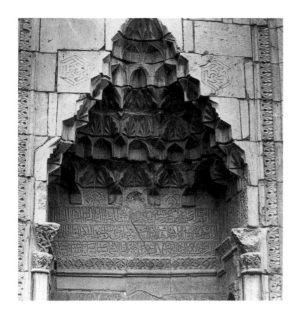

merchants. They also offered entertainment and discussion to a variety of audiences, both residents and visitors.

No other activity more clearly illustrates the outward orientation of dervish lodges than the performance of the *dhikr* and *samāʿ*.[42] In the milieu of the late thirteenth century, some dervish lodges sought followers through music and dance. The *dhikr*, a spiritual exercise meant to welcome God's presence throughout one's being, could be performed in a variety of manners. Generally, *dhikrs* were group meetings in which those present sought to become one with God through rhythmic and repetitive invocations of God's names.[43] Some dervishes were known for practicing flamboyant *dhikrs* and *samāʿs* in which they whipped themselves or made animal noises. This behavior was the object of strong disapproval by Sufis like Jalāl al-Dīn Rūmī and Najm al-Dīn Rāzī. Najm al-Dīn Rāzī felt that the rituals of flamboyant wandering dervishes had no connection to Islamic practices. He made pleas for the performance of silent *dhikrs* that took place in private or through the guidance of a knowledgeable master.[44] Some of the disapproval, however, was based on

jealousy, because these flamboyant dervishes developed a popular following. When Rūmī's second wife left the house without her husband's permission in order to watch a group of Rifāʿī dervishes performing in a *madrasa* in Konya, Rūmī reacted to her absence with great anger, an anger caused in part by jealousy.[45] No less than these dervishes, he

FIGURE 6
Tokat, Sunbul Bābā lodge: portal (left).

FIGURE 7
Tokat, Sunbul Bābā lodge: façade (right).

FIGURE 8
Tokat, Sunbul Bābā lodge:
reconstructed façade.

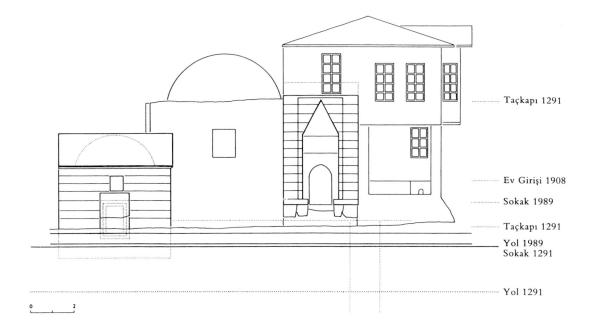

Taçkapı 1291

Ev Girişi 1908

Sokak 1989

Taçkapı 1291

Yol 1989
Sokak 1291

Yol 1291

0 2

and his followers tried to attract and accommodate the needs of audiences who were not ascetics, performing the *samāʿ* after every Friday prayer.[46] Rūmī was even quoted as saying that he had to use music and dance to appeal to the Anatolians.[47]

The *dhikr* and *samāʿ* were often performed by dervishes in *madrasas* and palaces, though these were clearly different from those performed in the dervish lodges. Nevertheless, dervish-lodge patrons who had palaces of their own would still attend the *dhikr* or *samāʿ* in dervish lodges, advertising their association with dervishes to a wider audience.

THE DISTRIBUTION OF FUNDS

In addition to salaries, *waqf* endowments provided steady funds for the upkeep of the lodge and its adjoining tomb. The largest proportion of *waqf* funds went to the upkeep of the dervish-lodge building. In the case of an endowment for the Sunbul Bābā lodge in Tokat, half of the endowment's income was earmarked for the building.[48] Since the building had been built at least fifteen years before an endowment was drawn up, one

wonders if such a division of monies was meant to ensure the building against seizure by the building officials. Upkeep expenses could have included everything from building repairs to furnishings and other accoutrements. Given the still impressive detail found on the Sunbul Bābā lodge (fig. 6), it is quite possible that the building's furnishings and its library were equally lavish. At the same time, devoting such a large proportion of the endowment's money to the upkeep of the building also ensured the soundness of the endowment, for any money not spent on the building went back into the endowment, and with such a high rate of allotment for the building, some money surely went unspent in some years.

In most cases, the tomb was the most important part of a dervish lodge. By this tangible connection to a holy figure, the lodge attracted visits from wandering dervishes, merchants, and pilgrims. They traveled to the building in order to derive *baraka* (blessing, holiness) from the tomb. What is not clear is the relationship between these holy figures and the building endowment, that is,

FIGURE 9
Tokat, Khalif Ghāzī lodge: tomb
windows.

which came first. Although *shaikhs* were often
buried in the tombs of their dervish lodges, a num-
ber of lodges were built around earlier tombs. That
many of the *waqfīyas* for lodges are filled with spe-
cial stipulations about these tombs only suggests
that they were meant to be the centerpieces of
their lodges. Yet, even though an entombed holy
figure was the distinguishing mark of a dervish
lodge, contemporary sources rarely mention who
was buried in the tomb. This stands in strong con-
trast to the many separate tombs within the city
and to the tombs incorporated into *madrasas*. Iron-
ically, it is possible that many of the entombed fig-
ures gained prominence through the dervish lodge
in which they were buried. Anatolian audiences
knew these buildings were built on sacred sites,
and may just have assumed that the entombed

figures themselves were holy. When individual
dervish lodges were taken over by established
orders, the new hierarchy simply incorporated the
holy figures buried in the tombs into their own
orders.[49]

From the location and orientation of the tombs
in most of the dervish lodges in Sivas, Amasya, and
Tokat, one can assume that tombs were intended
to be the most accessible part of the lodges. With
few exceptions, the façades of the buildings
included windows into the tomb rooms (see figs.
27, 28, and 30). Although most dervish lodges
had two domed chambers—a tomb room and an
often larger room for ritual gatherings and meals—
tomb rooms were distinguished from these other
domed chambers by visual cues. A prominent fea-
ture of all the tombs from the extant dervish lodges

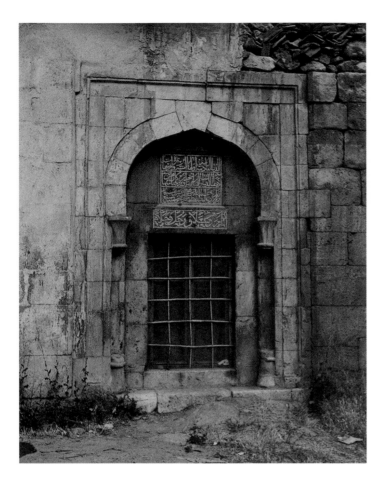
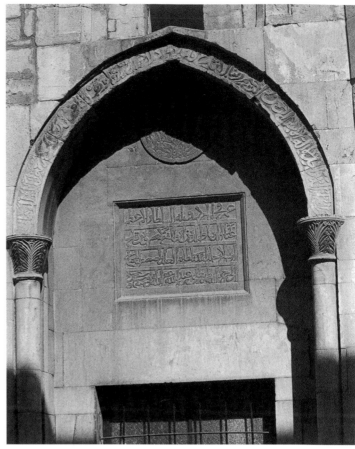

FIGURE 10
Tokat, ʿAbd al-Muṭṭalib lodge:
tomb window (left).

FIGURE 11
Amasya, Gök Madrasa lodge:
tomb window with inscription
(right).

in Sivas, Tokat, and Amasya are large windows that allow visual access to the tomb (figs. 7–11). These tomb windows usually faced a main thoroughfare (see figs. 27, 29, 30, and 31) and had marble revetments with inscriptions and ornamentation that drew further attention to the window (figs. 7, 9, 10, and 11). Thus, the Qur'ān readings that took place in tomb rooms near open windows would have been audible on the street, allowing and even compelling the passerby to listen.

Although Qur'ānic recitations were held at almost all tombs, individual tombs and *madrasa* tombs were not accessible to as large an audience as dervish-lodge tombs. Single-tomb structures were often located in remote areas, far away from urban centers. The ʿAbd al-Wahhāb tomb, for

example, was located outside the city walls, on a hill two kilometers east of Sivas.[50] Tomb rooms inside *madrasas*, *masjids*, and hospitals, on the other hand, though located in urban centers, were closed off behind the walls of courtyards and accessible only from inside the buildings. The grand domes of these tombs may have been visible from a distance, as were the elite who were allowed access to them, but the tombs themselves were, for all intents and purposes, though right in the urban midst, remote from the average resident and traveler (fig. 12).

Because the dervish lodges were relatively open and were located in market areas, merchants and traders came into contact with dervishes and, whether passively or actively, witnessed their

activities.[51] The significance of this contact between the veneration of holy men and mercantile activities was far-reaching. By sponsoring dervish activity within busy urban settings, patrons encouraged close connections between dervishes and other urban groups, such as craftsmen and non-Muslims. Many of these patrons were *amīrs* who, in the aftermath of the Seljuk defeat by the Mongols, relied on local military and financial support. To secure that support, they needed to attract to their cities both merchants and pilgrims, which they accomplished through, among other means, their own support of dervish lodges with the tombs of popular holy men. Traveling merchants spread the fame of these holy men to other merchants and pilgrims they met during their travels. Through these merchants, dervish lodges, including those of Sivas, Tokat, and Amasya, were connected to other pilgrimage sites along the trade routes.

WAQF ENDOWMENTS, SUFI HAGIOGRAPHIES, AND LOCAL SUPPORT

Although the lodges were one of the easiest ways to protect property available to the patrons of the thirteenth and fourteenth centuries, financial concerns were not the only reason why so many dervish lodges were endowed in this period. In the aftermath of the Seljuk loss to the Mongols in 1243, local leaders, who could no longer depend on the Seljuk state for military and financial support, needed to promote peace and stability in their provinces. These patrons wanted the physical and spiritual protection that they thought inhered in these local pious institutions.[52] Since part of the exchange between these patrons and the communities in their provinces depended on the patrons' providing and being recognized for services to their people, patrons believed, in the case of dervish lodges, that they could gain local support

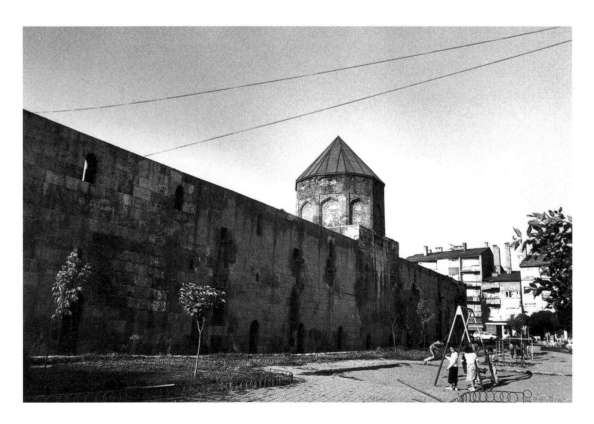

FIGURE 12
Sivas, Seljuk hospital: view from the west.

by associating themselves with and investing in the prestige and piety of some of the more popular charismatic figures.

Although the building of dervish lodges created permanent monuments to a patron's ties with Sufi *shaikhs*, this support did not guarantee an audience for these lodges. Even if there was an audience, there were no assurances that visitors to the lodges would associate them with their patrons. Although local elites could use *waqf* endowments to ensure that dervish lodges performed rites over tombs and distributed food to the poor, it was up to Sufi scholars to spread information about the patron.

Although there were obvious spiritual benefits to patrons from being mentioned in hagiographies, the way descriptions of this interaction are handled in these sources suggests that the relationship between a patron and a Sufi saint was far from a simple one. In many of these accounts, the Sufi saints are portrayed as unwilling recipients of patrons' largess. Ironically, these same saints often dedicated their texts to their patrons.

The relationship between Muʿīn al-Dīn Pervāne, who ruled over most of the former Dānishmendid region between 1262 and 1277, and Fakhr al-Dīn ʿIrāqī (d. 1288) was typically multidimensional. But since the events of these years are directly tied to Muʿīn al-Dīn's ambitions in Anatolia, it may be helpful to present a brief summary of his rise to power. Although he is first mentioned as the commander of Tokat, through his association with Mongol generals he was also assigned various other positions and awarded territories in Sinop and Tokat. One of these positions was as *wazīr* to the Seljuk sultan Qilij Arslān, who controlled the eastern half of the Seljuk empire. However, in 1256, when Muʿīn al-Dīn arranged to have the sultan murdered and installed the sultan's infant son, Kaykhusraw III, Muʿīn al-Dīn became the de facto ruler of the Seljuk state. His meteoric

rise to power came to an end in 1277, however, when he was put to death by the Mongols, who suspected him of conspiring against them.[53]

Fakhr al-Dīn ʿIrāqī dedicated his *Lamaʿat* to Muʿīn al-Dīn.[54] We know from Aflākī's *Manāqib al-ʿārifīn* that Muʿīn al-Dīn often attended the *samāʿ* of ʿIrāqī in a dervish lodge that he built for ʿIrāqī in Tokat.[55] Yet, in ʿIrāqī's hagiography a number of accounts stress ʿIrāqī's dismissal of Muʿīn al-Dīn's affection. In one account, Muʿīn al-Dīn was passing by a polo field, where he saw ʿIrāqī playing polo with some youths. Muʿīn al-Dīn offered to join the game and asked ʿIrāqī what position he should take. In response, ʿIrāqī pointed to the road and said, "That position." According to this account, Muʿīn al-Dīn walked away in silence.[56] Although this account seems to suggest that ʿIrāqī was immune to Muʿīn al-Dīn's affection and power, we should not forget that ʿIrāqī dedicated a manuscript to him. By itself, the dedication suggests a mutually dependent relationship between the two figures. But the mutuality of the relationship did not entail equal footing for each party thereto or consistent expression thereof. For ʿIrāqī dramatically rebuffed Muʿīn al-Dīn in public and only expressed his deference or gratitude in private, on a dedication page.

The relationship between ʿIrāqī and Muʿīn al-Dīn became increasingly close during the final years of Muʿīn al-Dīn's life. Muʿīn al-Dīn's affection for ʿIrāqī was well known. According to many accounts, when Muʿīn al-Dīn was put to death, he left all of his wealth (if not the entire wealth of the Rūm treasury) with ʿIrāqī.[57] ʿIrāqī then took Muʿīn al-Dīn's money to Egypt to win the freedom of Muʿīn al-Dīn's son, who had been jailed by the Mamlūks. In some accounts, ʿIrāqī is even linked with Muʿīn al-Dīn's daughter. However this may actually have been, the accounts indicate a bond between a political patron and a holy figure that continued after the death of the former.

Accounts of meetings between Jalāl al-Dīn Rūmī and Muʿīn al-Dīn are similarly equivocal. Rūmī's main biography includes nearly one hundred references to Muʿīn al-Dīn, and conversations between the two figures are also recorded in the *Fīhi mā fīhi* and the *Mathnawī*. In his relations with Rūmī, much as in his relations with ʿIrāqī, Muʿīn al-Dīn took on the roles of disciple and patron. According to Rūmī's biographer, Muʿīn al-Dīn often sought Rūmī's counsel. And like ʿIrāqī, according to the accounts, Rūmī refused to treat Muʿīn al-Dīn with any great deference and was often quite dismissive of him. It is also made clear that Rūmī advised Muʿīn al-Dīn not to double-cross the Mongols. But given Muʿīn al-Dīn's grisly death, Rūmī's biographer, in his portrayal of the poet's relationship with Muʿīn al-Dīn, would not have wanted to implicate Rūmī or his disciples in an act of intrigue against the Mongols.

Descriptions of Muʿīn al-Dīn's support for Rūmī's tomb and dervish lodge in Konya depict Rūmī, again like ʿIrāqī, as an unwilling and noncommitted recipient of the prince's generosity. This relationship falls into the familiar pattern of the world-rejecting saint and the worldly patron. Biographers argue that Rūmī did not wish to have his grave marked. This repudiation of the memorial tradition was common to Sufi saints of the period. For example, according to Rūmī's main biographer, Aflākī, the architect Ṣāḥib al-Iṣfahānī twice raised a memorial arch or dome above the grave of Burhān al-Din Muḥaqqiq, but both collapsed within a few days of construction. Burhān then appeared to Ṣāḥib al-Iṣfahānī in a dream, asking that no structure be erected over his grave.[58] In Rūmī's case, however, his disciples' desire to mark his grave prevailed over these sentiments. For a short time after his death, in 672/1273, his followers built a mausoleum over his grave, in Konya. This was no ordinary mausoleum and no ordinary building project. In the year following Rūmī's death an architect was commissioned to build the tomb. Approximately eighty years later, in 1353, when a disciple of Rūmī's grandson wrote the main biographical work on Rūmī and his followers, both the tomb's architect and patron were given a prominent place in the text.[59]

The tomb tower, which is now enclosed in a large and sprawling complex, has a fluted drum supporting a conical roof. A band of Qurʾānic citations runs around the rim of the roof. In subsequent centuries, first under Qaramānid and then under Ottoman patronage, Rūmī's tomb became the center of a large multiunit complex. Whoever inherited the position of administrator of this building also became the leader of Rūmī's followers, a manner of succession that further demonstrates the significance of these buildings in the process of sanctification and the development of Sufi orders.

CONCLUSION

The authors of fourteenth-century *manāqibs* used descriptions of dervish buildings to exalt relationships between the Sufis and patrons of the thirteenth century. The Muʿīn al-Dīn Pervāne dervish lodge in Tokat, built for the Qalandar dervish Fakhr al-Dīn ʿIrāqī by Muʿīn al-Dīn, is described as a place where the praises of Rūmī were preached.[60] Likewise, the ʿAbd al-Muṭṭalib lodge of Tokat is mentioned as a lodge for Rūmī's followers. Through these written accounts, hagiographers infused new meaning into the built environment. At the same time, the association of these buildings with particular saints continually attracted new disciples by alerting followers to their existence. Thus, the joint venture of shrine and lodge building in market areas in Sivas, Tokat, and Amasya provided one venue for the formation of new group identities that were also being encouraged in Sufi biographies.

The buildings that patrons built for Sufi leaders worked within two spaces—the literal space of

the cityscape and the literary space of the hagiography—as evidence of the patrons' support. Hagiographies formalized the relations between Sufi saints and the representatives of the Seljuk dynasty, going so far as to include the names of patrons, something that no doubt provided further incentive for future acts of largess. The Sufi leaders, for their part, profited from the added prestige of having prominent politicians as disciples, as long as these disciples knew their place.

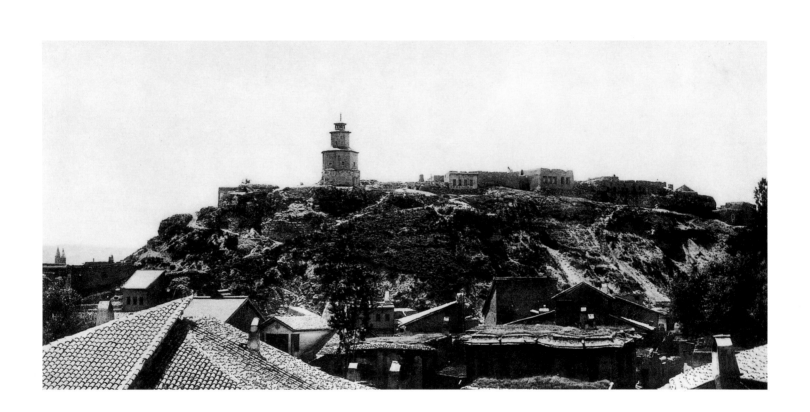

PART II

DERVISH LODGES AND URBAN SPACES: SIVAS, TOKAT, AND AMASYA

Dervish Lodges and the Transformation of City Spaces

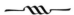

My Lord has created a city
In between two worlds.
One sees the beloved if one looks
At the edge of that city.

I came upon that city
And saw it being built.
I too was built with it
Amidst stone and earth

— Ḥājjī Bayrām Walī (d. 1429–30)[1]

Between the time when Jalāl al-Dīn Rūmī first came to Anatolia and the year 1360 a new world was created in Sivas, Tokat, and Amasya. Those who saw and watched these cities grow were, as described in Ḥājjī Bayrām Walī's words, built with them. Yet, at the same time, they were as instrumental in the city's change as those who lifted the stones and the earth and paid for supplies. For while new buildings may alter a previous spatial order by privileging some sites and obscuring others, pedestrians always seek to alter this order to their own needs.

By 1350, the experience of Anatolian cities had been dramatically altered through the placement and orientation of a series of newly built dervish lodges. In no place was this more evident than in the cities of Sivas, Tokat, and Amasya. Here, after the eclipse of the Seljuks, dervish lodges were made to encourage the growth of specific kinds of mixed communities. Built near city entrances and exits, along main thoroughfares, and in key locations in market areas, dervish lodges of this period broke former alliances and hierarchies by drawing attention away from the former Seljuk urban center and to the surrounding city; this brought dervishes into contact with merchants. By their location, orientation, and function, these lodges helped foster a new alliance between dervish groups, merchants, and local rulers.

To study the changes in the spatial order of Sivas, Tokat, and Amasya, I have broken down the interval between 1240 and 1350 into an initial thirty-five year period and three subsequent twenty-five year periods. For each interval I chart the location of all the major building activity for that period.

Before 1240, each successive political order in these three cities grafted its own organization of public and private spaces onto that of the Byzantines. The first transformation by Islamic rulers was that of the Dānishmendids, who appropriated and converted Byzantine imperial spaces to suit their own needs.[2] They occupied the citadels and converted major churches into mosques or

madrasas. After the Seljuk sultans captured these cities from the Dānishmendids, they in turn occupied the citadels, built or fortified some city walls, and transformed Dānishmendid buildings into Seljuk structures by adding minarets.

With the addition of Seljuk-style minarets onto Dānishmendid buildings, Sivas, Tokat, and Amasya each became the image of a standard Seljuk city and thus were linked to other Seljuk territories. The Christian and Türkmen populations lived outside the city walls, usually near the city gates.[3] Many of them lived on *waqf* property where they had to pay rent, which supported the upkeep and construction of new Seljuk centers. They also contributed a significant portion of the craftsmen who came to these cities to practice their trades.[4] Cities provided few services to those outside the gates; use of the educational and charitable institutions within the city—*madrasas,* mosques, hospitals, and tombs—was restricted to the members of the new urban bureaucratic elite and visiting dignitaries.[5]

SIVAS

Sivas is in central Anatolia in the flatter part of the classical Pontus, near the Kızıl Irmak.[6] Three bridges over the river linked Sivas to major trade routes. One bridge led to the Kayseri road, another to the road south to Malatya and eventually Mesopotamia, and the third to the road to Erzincan and Erzurum.[7]

Originally known as Sebasteia, Sivas was conquered by the Dānishmendids in 1071. It was taken over by the Seljuks in 1171 and was ruled solely by them until 1243, when the Seljuks were defeated by the Mongols. Although Seljuk representatives remained in the city, they were eventually joined by Ilkhānid officials. From 1325 to 1352, long after the demise of the Seljuks and the withdrawal of the Mongols, Sivas belonged to the Eretnids, a Türkmen principality, or *beylik,*

1 Citadel
2 Gök Madrasa
3 Main Mosque (Ulu Cami)
4 Seljuk Hospital-Madrasa
5 Çifte Minare Madrasa
6 Gök Madrasa Lodge
7 Yaghi Basan Lodge
8 Burujiyye Madrasa
9 Aḥmad ibn Rāḥa Tomb
10 Dār al-Rāḥa Lodge
11 Güdük Minare Tomb
12 Dervish Lodge

0 400 m

founded by Qāḍī Aḥmad Burhān al-Dīn. Sivas served as the seat of the Eretnid principality.[8]

Because of its location, Sivas flourished as a center of trade. Its important commercial status partially explains why it was the capital of two dynasties: the Dānishmendids and the Eretnids. Even the Seljuks, whose capital was in Konya, briefly made Sivas their capital when the Qaramānids took over Konya. After the Seljuks gained control of ports in the Black Sea and the Mediterranean, Sivas became a center for foreign

FIGURE 13
Sivas, Turkey: reconstructed plan.

traders, especially Venetians and Genoese.[9] It was also the site of the central market for the trade in *mamlūks*. By 1260, a number of caravansarays safeguarded the route from Sivas through Tokat to the Black Sea.[10]

Sivas Before 1240

Before 1240, Sivas was surrounded by a wall with six gates (fig. 13). At its center stood a large hypostyle mosque, and nearby the Yāghī Basān dervish lodge.[11] The mosque still exists (no. 3). The Yāghī Basān lodge (no. 7) is the only lost Dānish-mendid building for which there is existing documentation.[12] According to historical accounts, the city walls, erected after the Seljuk conquest in 1171 by the Seljuk sultan ʿAlā' al-Dīn Kay-Qubād, were circular.[13] Next to the Yāghī Basān lodge, built by the sultan, was a large hospital and medical school (no. 4).[14] The sultan's decagonal tomb was at the southern end of the hospital, with a pointed roof that rose above the walls of the hospital to signal its presence (see fig. 12).[15] The large Seljuk minaret on the main mosque near the hospital rose above the other structures in Sivas to form a recognizable Seljuk center. The only other high point in the city was a walled area known as Toprak Teppe, or the higher citadel (no. 1), in the southeastern part of the city, toward the Kayseri Gate. The citadel hill was forty meters high, a hundred meters wide, and possibly walled.[16] No pre-Ottoman structures remain on this hill, but it is likely that those built there were military structures.

From a surviving copy of a Seljuk *waqfīya*, we can identify some of the structures in the city center. In addition to the hypostyle mosque with the Seljuk minaret and the Seljuk hospital, a *madrasa*, a palace, and a dervish lodge were mentioned in various *waqfīyas*, but none remains. According to the hospital's *waqfīya*, it was built to one side of the Seljuk *madrasa*, probably the northern side, since the hospital still has a door there.[17] The same

waqfīya also mentions that the royal garden and Yāghī Basān lodge bordered the hospital on the other two sides.[18]

Before 1240, someone approaching Sivas would have seen a walled city with a central core defined by civil, religious, and commercial structures, primarily under the control of the Seljuk sultans. The walls, minaret, and tomb, the first architectural features visible to visitors, proclaimed the city as Seljuk, linking it with other Seljuk cities that travelers had seen en route and would see again when they continued on their journey. Thus, in approaching this city, a visitor expected to find protected places to trade wares as well as places to perform religious duties.

Sivas's caravansarays, tombs, and *khāns* were generally built outside the walled city, near the city gates. Because of this location and their lack of minarets and high tomb windows, they were not visible from afar. One caravansaray occupied a site in the southern part of the city, near the citadel hill and oriented toward the road to Kayseri. A second stood near the Tokmak and Palash gates, in the eastern part.[19] These buildings and other small structures scattered around the city did not duplicate the services of the urban core but reinforced them.

Sivas After 1240

Building activity between 1240 and 1350 changed the organization of space in Sivas. We can get some idea of the extent of this change by comparing information in the *waqfīya* of the Seljuk hospital, dated 617/1220, with that of the Gök Madrasa, dated 678/1278. Between these two dates a thriving marketplace had developed. This is not surprising given Sivas's commercial status. According to Mustafa Cezar, who links the location of Sivas's medieval market to the sites of its Ottoman ones, the city's market area began south of the main mosque (no. 3) and spread to the Gök

Madrasa (no. 2).[20] Ottoman sources list another market, called the Baghdad Bazaar, in the northeast of the city, near the Jan Jun Gate.[21] It is likely that the twenty *khāns* listed in the *waqfīya* of Fakhr al-Dīn ʿAlī were in the market area.[22] Dervish lodges were placed in strategic locations between these markets and the city gates.

The organization of space in Sivas was significantly changed in 1271, when three new *madrasas* were built. Two of them were the first Ilkhānid-sponsored buildings in the city. Their location in the urban core previously dominated by the Seljuk *madrasa*, hospital, and palace proclaimed the Ilkhānid sultanate's control of Sivas. One of these two Ilkhānid *madrasas* was the Çifte Minare Madrasa built by the Ilkhānid *wazīr* Shams al-Dīn Juwaynī (no. 5).[23] It was directly opposite the Seljuk hospital (fig. 14). In this location, Juwaynī's statement of Ilkhānid sovereignty was unmistakable.[24] Hamd Barūjirdī, an otherwise unknown individual representing the Ilkhānids, built the other Ilkhānid *madrasa* of 1271 in the same central urban region (no. 8). By contrast to Juwaynī and Burujiyye, the two Ilkhānid patrons, Fakhr al-Dīn ʿAlī, the *amīr-dād* of the Seljuk sultan, sited his *madrasa* in a new area of the city. Fakhr al-Dīn's *madrasa*, known today as the Gök Madrasa, was built in the southern region of the city along the road to Kayseri (fig. 15). This building is oriented toward one of the two gates of the citadel and the market. The portal of the Gök Madrasa, like the portal of the Çifte Minare Madrasa, is surmounted by double minarets that are visible outside of the city. The location of Fakhr al-Dīn's Gök Madrasa, strategically between the city walls and a market area, set the Gök Madrasa apart from the other two 1271 *madrasas*, while its double minarets competed with them.

The visitor of 1271 saw a dramatically different city as a result of these three new *madrasas*. The skyline was no longer dominated by the single minaret of the main mosque. The two new sets of double minarets, on the Çifte Minare Madrasa and the Gök Madrasa, marked two competing centers, the central area and the region near the upper citadel, closer to the Kayseri Gate.[25] If the visitor entered Sivas through the Kayseri Gate, the minarets of the Gök Madrasa dominated the

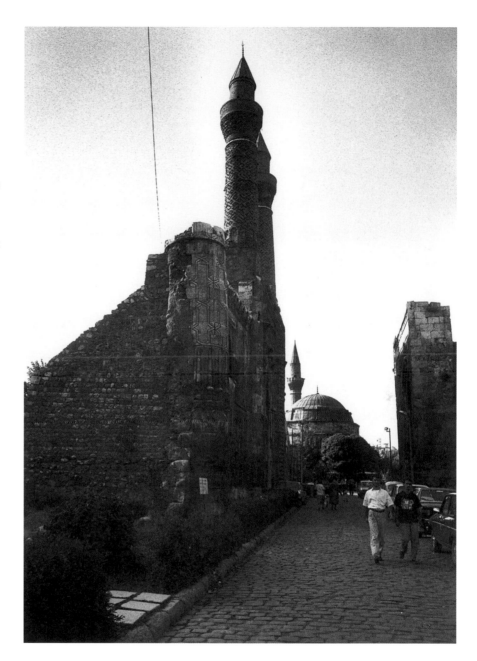

FIGURE 14
Sivas, Çifte Minare Madrasa
(on the left) and Seljuk hospital
(on the right).

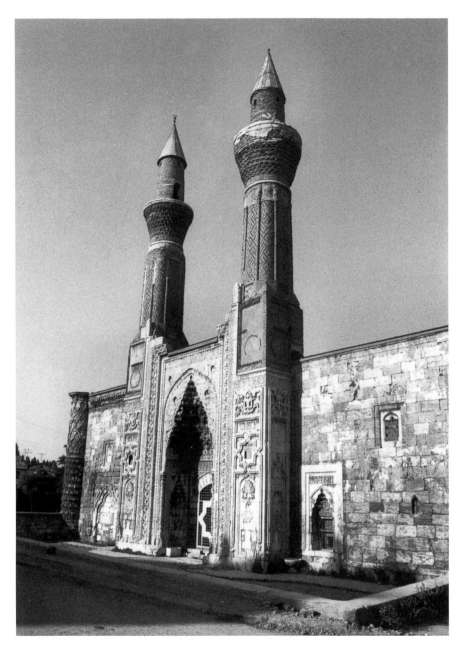

FIGURE 15
Sivas, Gök Madrasa.

that the Çifte Minare Madrasa dominated the visitor's view of the city.

The Gök Madrasa differed from the two other 1271 *madrasas* most conspicuously in having a neighboring dervish lodge (no. 6). The dervish lodge was built by Fakhr al-Dīn ʿAlī in 1275, four years after his Gök Madrasa and as part of the same foundation. The *waqfīya*, from 1278, includes a statement that the *dār al-ḍiyāfa* (guest house) outside of the *madrasa* was endowed for the *faqīr*, while the Gök Madrasa would house the *fuqahā'* (scholars of Islamic law). According to the *waqfīya*, the *dār al-ḍiyāfa* provided food for three groups, the *faqīr*, the forty *fuqahā'* within the *madrasa*, and thirty of those "coming and going" among the *sayyids* and *ʿalawīs*.[26] Importantly, this dervish lodge gave the Gök Madrasa a broader audience than the other *madrasas*.

After 1271 Sivas had an urban core that represented the ruling elite and reflected the change from Seljuk to Ilkhānid hegemony.[27] Fakhr al-Dīn ʿAlī's Gök Madrasa, however, became an alternative locus of power, providing residents and visitors with many of the same services as were dispensed at the city's center. It trained a group of *ʿulamā'* loyal to the Seljuk *amīr-dād*, Fakhr al-Dīn ʿAlī. This patron acquired great power and influence with the breakdown of Seljuk rule, when he was able to alienate large amounts of former Seljuk land. Thus, he represented the new group of patrons who arose after the Battle of Köse Dağ. He protected his newly acquired land through a number of *waqf* endowments that supported buildings in Seljuk trading centers, such as Konya, Sivas, and Kayseri. At the time he built the Gök Madrasa, he was *amīr* of the military zone along the eastern march. Like his other foundations, his Gök Madrasa trained a group of Muslim bureaucrats. What is not clear, however, is whether these bureaucrats were loyal to what was left of the

minarets of the Çifte Minare Madrasa by their size and proximity. From the vantage point of the Tokmak or Palash Gate also, the Gök Madrasa minarets were closer than the Çifte Minare Madrasa minarets. It was only from the three other gates, Salpur, Jan Jun, and a now nameless gate,

Seljuk state or served Fakhr al-Dīn ʿAlī's growing dynastic ambitions.

In the next period of building activity, between 1275 and 1300, a second dervish lodge was built in Sivas, which is today known as the Shams al-Dīn Sivasī lodge. Located in the northeast of the city, near the Jan Jun Gate, this dervish lodge was the second built along a major road leading to the city walls (no. 12).[28] The Shams al-Dīn Sivasī lodge, like the Gök Madrasa lodge, was near an important market, the Baghdad Bazaar. These two new dervish lodges housed, fed, entertained, and offered spiritual guidance to travelers, dervishes, and residents, and the nearby markets offered opportunities for trade. With the establishment of the lodges near the Kayseri and Jan Jun Gates, visitors from Niksar and the Black Sea could enter Sivas from the north and continue on their way to Erzurum, Baghdad, or Kayseri without needing to pass through the urban core.

By the end of the third period, a large multi-building dervish-lodge complex, the Dār al-Rāha (no. 10), had been built in the vicinity of the Tokmak and Palash Gates, near the eastern cemetery. The building was named Dār al-Rāha after the original founder of the building, Kamāl al-Dīn Ahmad ibn Rāha. According to the *waqfīya*, he endowed it for the *ahl al-dīn* (people of religion), the *fuqarāʾ* (wandering mystics), and the *masākīn* (various dervishes and ascetics). According to Ibn Bībī, the original founder was linked to a caravansaray of the year 629/1229 known as the *ribāṭ* of Kamāl al-Dīn Ahmad ibn Rāha or the caravansaray of Isfahānī.[29] A *waqfīya* from the year 720/1320 that refers to the caravansary mentions a *zāwiya* and *masjid*, known as Dār al-Rāha, and provides salaries for a specific *shaikh*, a servant, a "reader from the *hāfiz* of the two mosques," a baker, and a cook. According to a text that documents the restoration of the Dār al-Rāha in 779 A.H.:

In need of the mercy of God, the highest, the brothers al-Khaṭṭāb and al-Husayn, the sons of the deceased Kamāl al-Dīn Ahmad ibn Rāha, may God have pity upon them and mercy to them both, have made *waqf* of this *buqʿa* for the *sulahāʾi* among the people of religion and the *fuqarāʾ* and the *masākin*, and it is known as Dār al-Rāha, and they made it in the year 720. Then, in the year 779, in need of God's mercy, the weak slave Shaikh Hasan, son of the deceased ʿAbd al-Wahhāb ibn al-Husayn ibn Ahmad ibn Rahat, may God have mercy upon him, renewed it.[30]

Based on the evidence of this inscription and the 720/1320 *waqfīya*, one may postulate that the caravansaray either was not extant or had been transformed into the building complex known as the Dār al-Rāha by 720/1320.[31] Although Albert Gabriel, as well as Ridwan Nafiz and İsmail Hakkı Uzunçarşılı, dated the original building to the last part of thirteenth century, all these authors argued that the earlier building was a caravansaray.[32]

With the construction of the Dār al-Rāha, dervish lodges now were located along major roads leading to four of Sivas's gates. More important, a path probably connected the Gök Madrasa dervish lodge to the Dār al-Rāha as well as, further along, the Shams al-Dīn Sivasī lodge, allowing one to pass from one gate and one market to another without crossing the Ilkhānid-controlled city center.

In the next period, between 1325 and 1350, two large tombs were built in Sivas. Importantly, these tombs were located near dervish lodges: the Güdük Minare tomb (no. 11), near the Shams al-Dīn Sivasī dervish lodge (no. 12), and the tomb of Ahmad ibn Rāha (no. 9), near the Dār al-Rāha (no. 10). The Güdük Minare tomb, mounted on a hill and covered with a pointed dome, was visible from most locations within the city. From

outside the city, it was visible to visitors approaching from the north, signaling the location of the nearby Shams al-Dīn Sivasī dervish lodge.[33] The tomb of Aḥmad ibn Rāḥa, with its pointed dome, was visible to visitors from the east.[34] These domed tombs, rising above earlier structures in the city, directed attention to dervish lodges, adding to their popularity and importance as pilgrimage sites. By the mid-fourteenth century, a traveler to Sivas encountered four separate urban centers, whose distinctive high pointed domes and/or minarets were visible from both inside and outside the city.[35]

Some of the buildings in these centers were linked to other buildings outside of Sivas by the design of their façades. For example, the Gök Madrasa lodge in Sivas, along the road to the Kayseri Gate, and the Ṣaḥibiyye Madrasa in Kayseri, both built by Fakhr al-Dīn ʿAlī, have in common an oversized Seljuk portal and double minarets, and share similar large molded panels of foot-long hexagonal designs cut in high relief. Visitors from Kayseri would have seen the Gök Madrasa lodge before any other building in Sivas and would likely have recognized the similarity in design between it and their own Ṣaḥibiyye Madrasa. The Ṣaḥibiyye and Gök Madrasas would in turn have evoked other Fakhr al-Dīn ʿAlī *madrasas*, all of which used the distinctive Seljuk-style portals and double minarets. These other buildings were strung out along the north-south caravan route in cities such as Konya and Akşehir. Thus, the use of this façade style on the Fakhr al-Dīn ʿAlī *madrasa* facing the Kayseri Gate rendered it familiar to visitors from Kayseri, Akşehir, and Konya, who may have linked it with Fakhr al-Dīn ʿAlī's patronage and were drawn to the building.[36]

In the mid-fourteenth century, the area of the city known as the lower citadel remained a prominent site. The Ilkhānids, Seljuks, Dānishmendids, and Byzantines had concentrated their building

activity in this area. Possibly surrounded by a set of walls, it was the most restricted area in the city and reflected a need to provide protection for a small bureaucratic and military elite. Physically and socially, the two *madrasas* built within the walled section of the city in 1271 represented a small closed-off elite. Yet, by 1350 Sivas had been transformed from a city with a single urban core into a city with a number of smaller competing centers. New patrons with their own political aspirations provided these centers with political, economic, and religious support.

Residents or travelers in the mid-fourteenth century still saw a fortified city with a traditional center, yet when they entered the city, they may never have needed to travel to the city center to conduct their business. Visitors had only to travel to the nearest dervish lodge to conduct business and fulfill other needs of daily life. As these dervish lodges attracted more and more street traffic, they began to create and control their own market regions, leaving the market near the main mosque and the lower citadel simply as the shadow of a centralized Seljuk city that no longer existed.

TOKAT

Tokat, like Sivas, is located in the flatter part of the Pontus. Tokat grew and coexisted with, then succeeded, the classical temple city of Comana Pontica.[37] It was an important Dānishmendid city, built up by the Dānishmendid ruler Yāghī Basān. It was controlled by the Seljuks from the twelfth century, when Tokat was given to Rukn al-Dīn in an 1192 partition of the Seljuk territory between the sons of Qilij Arslān. For a brief period between 1250 and 1257 the Türkmens of Kastamonu held Tokat. The city was freed from the Kastamonu by Muʿīn al-Dīn Pervāne in alliance with the Mongols and the Seljuk sultan Rukn al-Dīn. With their backing Muʿīn al-Dīn became the actual ruler of Tokat

between 1262 and 1273. After Muʿīn al-Dīn's death, the city, although under Mongol domination, was really controlled by independent and semi-independent *amīrs*, some loyal to Muʿīn al-Dīn, others to the Seljuk sultan, while others appeared to trace their lineage to both. These *amīrs* controlled Tokat until it became an Eretnid territory in the first quarter of the fourteenth century.

Tokat Before 1240

The city of Tokat was almost equidistant between Sivas and Amasya.[38] Its two main roads resembled intersecting rectangular axes, with a river running closely parallel to the north-south road. In the period of the Mongol protectorate, Tokat flourished as a trading city and pilgrimage center. The first Muslim rulers in Tokat, the Dānishmendids, took over the existing citadel and built a few key structures, among them the large Garipler Mosque (fig. 16, no. 3), built in 1074 directly south of the citadel (no. 1). One of the city's market areas followed the citadel's southern perimeter.[39] The remainder of the city, including residences, the main market, and churches, was massed below and to the east of the citadel, along the north-south road.

The Seljuks primarily modified Dānishmendid structures and constructed smaller tombs and *masjids*. Most of the their building activity occurred on the high hill of the citadel, in the northwest quadrant of the city. For example, in 1233/34, the Seljuks built the domed tomb of ʿAlī Ṭūsī (no. 4), named after Abū al-Qāsim ibn ʿAlī al-Ṭūsī. This tomb is directly north of the Çukur Madrasa (no. 5),[40] a large domed building originally constructed in 1151/52 on the southern slope of the citadel hill. In 1247, the Seljuk sultan ʿIzz al-Dīn Kay-Kāʾūs rebuilt this *madrasa*, transforming it into a Seljuk building.

Given the steep mountain on the western side of Tokat, it was likely that one would enter the city

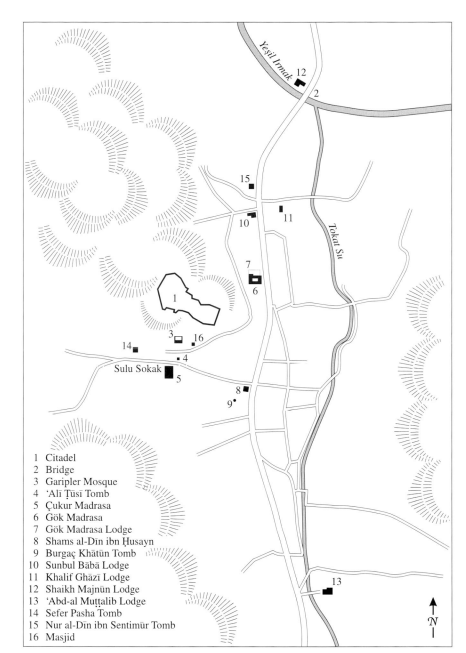

1 Citadel
2 Bridge
3 Garipler Mosque
4 ʿAlī Ṭūsī Tomb
5 Çukur Madrasa
6 Gök Madrasa
7 Gök Madrasa Lodge
8 Shams al-Dīn ibn Ḥusayn
9 Burgaç Khātūn Tomb
10 Sunbul Bābā Lodge
11 Khalif Ghāzī Lodge
12 Shaikh Majnūn Lodge
13 ʿAbd-al Muṭṭalib Lodge
14 Sefer Pasha Tomb
15 Nur al-Dīn ibn Sentimūr Tomb
16 Masjid

from the east, across the Yeşil Irmak (Green River). In the Seljuk period, traffic was directed to the city from an elaborate bridge northeast of the city (no. 2).[41] After crossing the bridge, one continued south along the north-south road. To travel west from Tokat, to Amasya or Çorum, one would ordinarily use this same northern bridge before turning west,

FIGURE 16
Tokat, Turkey: reconstructed plan.

rather than negotiate the steep western slope of the east-west road south of the citadel.[42] Thus, the bridge was the main point of connection for roads coming from Amasya and Turhal in the west and from the Black Sea in the north.[43]

Before 1240, Tokat, like other Seljuk cities, was dominated by a large citadel on a hill and had an urban core controlled by a ruling Seljuk Muslim elite. In this way, the orientation of space within Tokat resembled that of other Seljuk cities housing a Muslim elite. The Christian population, confined to neighborhoods north and south of the intersection between Tokat's two main thoroughfares, was segregated from the Muslim population and excluded from the services provided by buildings in the citadel area. These Christian residents, while traveling to markets below the citadel, saw the Seljuk urban core rising above these markets.

Tokat After 1240

In Tokat the rise in power of local elites correlated closely with the endowment of dervish lodges. Local elites built these lodges to create urban centers separate and independent from the citadel area. In doing so, they dramatically altered the orientation of space inside Tokat. Seen from outside the city, however, Tokat seemed still to be dominated by a single center. But over the course of the century under discussion, Tokat, like Sivas, was transformed from a city organized around a single high center to one organized around separate accessible centers. The location and orientation of new dervish lodges reflected this transformation.

In the first indication of reorganization, Mu'in al-Din Pervāne, who ruled the city from 1262 to 1273, built a dervish lodge, *madrasa*, and bath complex on the north-south road (nos. 6 and 7). Like that of Fakhr al-Din 'Alī, Mu'in al-Din's *madrasa*, known as the Gök Madrasa, and his dervish lodge were built on the site of an earlier building, possibly a Dānishmendid dervish lodge.[44]

His dervish lodge was attached to the northern side of the Gök Madrasa and, like the *madrasa*, faced east toward the city square. Although the endowment deed no longer survives, separate rooms and a large hall with a barrel vault still exist.

With the addition of the Gök Madrasa, dervish lodge, and bath complex, the visitor of 1275 encountered a dramatically different city. From outside, the city appeared essentially as it had in 1240, for the citadel still dominated the view. Yet, once he entered the city, the traveler confronted the large building complex containing a dervish lodge. Located on the main square, the complex duplicated many of the services found in the *madrasas*, tombs, and markets of the citadel area.

The patron of the dervish lodge, Mu'in al-Din, like Sivas's Fakhr al-Din 'Alī, chose to transform what was primarily a commercial section of the city into a self-sufficient urban center competitive with the citadel. He built the three buildings of his complex so that they served as an obstacle between the main square and the citadel. In this location, they literally prevented anyone from entering the citadel from its eastern side. Furthermore, their orientation—the dervish lodge and *madrasa* facing the main square, the bath stretching to the west, toward the region of the main mosque—meant that these buildings discouraged one from continuing south to the intersection of the citadel road without stopping in front of them.

The citadel continued to train and house a select government bureaucracy representing the Seljuks. By 1271, it contained a combination of new and older constructions that included a palace, a mosque, a *masjid*, and two tombs. One of the post-1240 constructions was the Sefer Pasha tomb, built in 1251. Located near the citadel hill, directly to the southwest, it was endowed by Ibn Lokman, an *amīr* of the Seljuk sultan Kaykhusraw. Both of the tombs near the citadel, the Sefer Pasha and 'Alī al-Ṭūsī tombs (nos. 14 and 4), were built

within a span of seventeen years by *amīrs* acting on behalf of the Seljuk sultan. ʿAlī al-Ṭūsī had been a Seljuk *wazīr*. Thus, both structures helped to concentrate attention on the centralized urban area under Seljuk rule.

Although from a vantage point outside the city Tokat remained unchanged from 1275 to 1300, the four dervish lodges built in this period by competing *amīrs*—buildings that were strategically located in areas near the main markets, the Christian neighborhoods to the north of the city, and the citadel—overshadowed the urban core (fig. 16) and dominated the city's building activity, which otherwise included only a *masjid* with a minaret and fountain (no. 16), built near the citadel in 1300 by an unknown patron.[45] The minaret, however, unlike the dervish lodges, was visible from outside the city and reinforced the remnants of a Seljuk presence.

According to epigraphic evidence, the first lodge constructed between 1275 and 1300 was the Shams al-Dīn ibn Ḥusayn lodge, built in 1289. The building inscription states that the dervish lodge (*khānqāh*) was built in the days of Sultan Kay-Kāʾūs and Princess Ṣafwat al-Dunyā wa al-Dīn by Abū al-Ḥusayn ibn Shams.[46] The *waqfīya*, drawn up in the year 1300, lists Shams al-Dīn ibn Ḥusayn as the *wāqif*. An Amīr Ḥusayn is mentioned in connection with Tokat, and there is some possibility that this was the same Ḥusayn who endowed the dervish lodge.[47] Located in the Yash Maidān,[48] this dervish lodge occupied a rectangular site on the southwest corner of the intersection between the north-south caravan road and the east-west road (no. 8). The western portion of the east-west road ran along the southern edge of the citadel and had a variety of markets. The dervish lodge faces north so that the entrance portal looks out toward the *maidān*. There is also a small free-standing mausoleum to the west of the dervish lodge (no. 9). The mausoleum bears no

inscription, although it is known under the name Burgaç Khātūn. The brickwork and general style point toward a thirteenth-century date.[49] With this location and orientation, the dervish lodge of Shams al-Dīn ibn Ḥusayn and the neighboring tomb were highly visible to anyone who traveled up the east-west citadel road and only slightly less so to anyone traveling on the north-south road.

The inscriptions on two other dervish lodges in Tokat have the date 1299. These are the Sunbul Bābā lodge, sponsored by the freed slave of the daughter of Muʿīn al-Dīn, and the Khalif Ghāzī lodge. According to its inscriptions, the Sunbul Bābā lodge was built in the time of Sultan Kay-Kāʾūs and Ṣafwat al-Dunyā wa al-Dīn, the daughter of Muʿīn al-Dīn, by ʿAbd Allāh ibn Ḥājjī Sunbul, the princess's former slave.[50] Ḥājjī Sunbul was a student of Ḥājjī Bayrām, the founder of the Bayrāmī dervishes from Ankara.[51]

The Sunbul Bābā lodge (no. 10) is directly north of the Muʿīn al-Dīn dervish lodge (no. 7). Similar to the Muʿīn al-Dīn lodge, its main portal faces the city square, as does a large window on the tomb associated with it. The Khalif Ghāzī lodge (no. 11) faces the city square from the other side of the street, across from the Sunbul Bābā lodge. According to the building inscription, the dervish lodge was built in the days of the sultan Kay-Kāʾūs and Seljukī Khwand, the daughter of Qilij Arslān, by Khalif ibn Sulaymān.[52] The woman listed on the inscription, the Princess Seljukī Khwand, unlike Ṣafwat al-Dunyā wa al-Dīn, was connected to the Ilkhānids, suggesting that these buildings were built in competition with each other. Like the Sunbul Bābā dervish lodge, the Khalif Ghāzī lodge is oriented toward the *maidān*. It is a rectangular building with two attached domed chambers that most likely served as tombs. The chambers had large windows facing the main square, oriented in the same direction as the main portal.

FIGURE 17
Tokat, ʿAbd al-Muṭṭalib lodge:
view toward tomb window.

The fourth lodge built in this period was the Shaikh Majnūn lodge (no. 12). It has been dated to the end of the thirteenth century on stylistic grounds.[53] Located directly across from the Seljuk bridge at the northern threshold to the city, it was the first building a visitor came across on entering the city and the last building passed on leaving. The building still contains an inscription that mentions Masʿūd ibn Kay-Kāʾūs.[54]

The location of these four dervish lodges dramatically altered the configuration of space within the city. They affected how various groups navigated to the city center. The Shaikh Majnūn lodge was the first building that greeted a visitor to the city; the second and third buildings seen by such a visitor, the Sunbul Bābā and the Khalif Ghāzī lodges, represented a northern extension of the maidān along the main caravan road that ran through Tokat; and on the way to the east-west citadel road the visitor confronted the Shams al-Dīn ibn Ḥusayn lodge. Anyone entering or exiting the city saw dervish lodges in strategic locations at the main entrance to the city, near the main market, and at the main intersection.

The patrons of these lodges endowed them in order to attract visitors and residents and, most important, to deter these groups from patronizing buildings and markets in the citadel region. These patrons competed with each other for audiences and visitors and thus had their buildings face the maidān and fitted their attached tombs with large embellished windows. By endowing lodges across from each other, however, they greatly expanded the maidān area below the citadel. Unlike Muʿīn al-Dīn, Fakhr al-Dīn ʿAlī, and ʿAbd al-Salām ibn Ṭurumṭay, these patrons were not well-known statesmen but amīrs and freed slaves who were loosely aligned with Muʿīn al-Dīn, Mongol leaders, Seljuk sultans, or a combination thereof.[55]

Between 1300 and 1325, a new group of patrons endowed buildings in the northern and southern

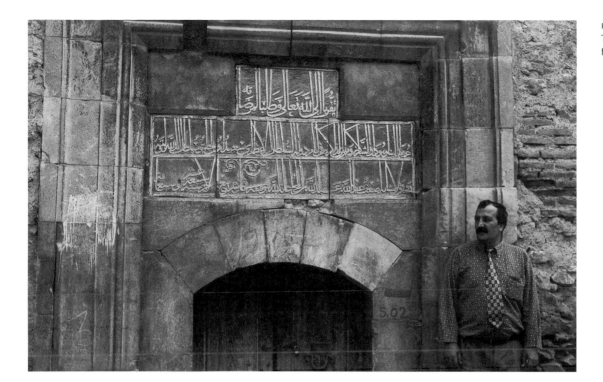

FIGURE 18
Tokat, ʿAbd al-Muṭṭalib lodge:
façade.

areas of Tokat (fig. 16). Two of these patrons were *akhīs* building in the name of the Ilkhānid sultan, while a third patron, who added an endowment to the Sunbul Bābā lodge, was an *amīr* connected to a prominent family in the region.

In 717/1318, a period when Tokat was under Ilkhānid rule, the large multiunit complex known as the ʿAbd al-Muṭṭalib lodge was built along the southern end of the north-south road through the city (no. 13). According to the building inscription, the lodge was built in the days of the Ilkhānid sultan Abū Saʿīd Uljaitū (1316–35) by ʿAbd Allāh ibn al-Muḥyī. The building is also associated with ʿAbd al-Muṭṭalib, whose name appears in an inscription on the lodge's tomb window. A *waqf* document lists ʿAbd al-Muṭṭalib as the *wāqif*. The building's tomb window faces east, toward a main thoroughfare, in a direction different from that of the main portal (fig. 31). Given the resemblance between this portal (fig. 18) and those found on Armenian architecture from Ana-

tolia, it is quite possible that this building was originally an Armenian church, especially because there were Christian neighborhoods in this part of the city.

Constructions in the northern part of the city included the tomb of Nūr al-Dīn ibn Sentimūr (no. 15). This square structure with an octagonal-star-shaped spire was built in 713/1313 in the name of the Ilkhānid sultan. Nūr al-Dīn ibn Sentimūr was most likely the same figure as Akhī Nūr al-Dīn, who had fought so hard in the defense of Tokat.[56] The tomb was built to the north of the Sunbul Bābā dervish lodge in 1325, signaling further expansion into the northern region.

Also in 1325, Beyler Çelebi added to the Sunbul Bābā dervish lodge a generous endowment to support a number of officials, such as a *mutawallī*, a *shaikh*, and a *bawwāb*, and to feed the poor each Wednesday.[57] No further secure record, written or archaeological, survives for any other large building-related activity between 1325 and 1350.

FIGURE 19
Amasya, Turkey: reconstructed
plan.

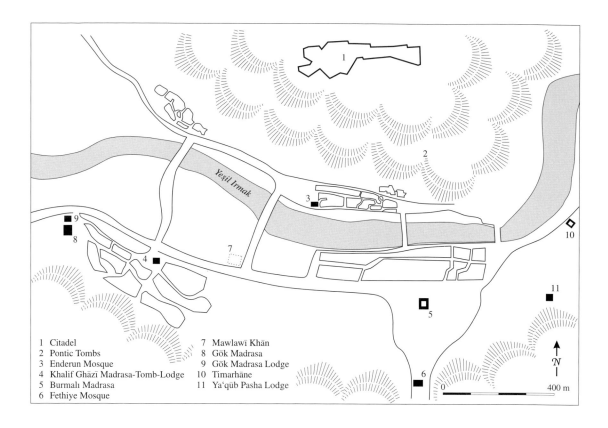

1 Citadel
2 Pontic Tombs
3 Enderun Mosque
4 Khalif Ghāzī Madrasa-Tomb-Lodge
5 Burmalı Madrasa
6 Fethiye Mosque
7 Mawlawī Khān
8 Gök Madrasa
9 Gök Madrasa Lodge
10 Timarhāne
11 Ya'qūb Pasha Lodge

Tokat Transformed

The dervish lodges built in Tokat between 1240 and 1350, similar to those in Sivas, follow a pattern that illustrates the close relationship between the rise of the power of local elites and the endowment of the lodges. By building dervish lodges outside of the former Seljuk center and endowing them with a variety of services, these elites forged a new alignment between themselves, on the one hand, and dervish leaders and their followers, on the other. They also supported an alignment between trade and spiritual activity that undermined the power of more restrictive institutions, like mosques and *madrasas*, that were controlled by the *'ulamā'*. Furthermore, these lodges made a tangible connection between elites and other dervish lodges in cities along trade routes, extending their influence over those regions and their ability to benefit from trading. For almost all of

Tokat's dervish lodges, like those in Sivas, were built near or next to market areas and were oriented toward foreign visitors. One of Tokat's market areas stretched to the south of the citadel, while the main market area was in the main square of the city, to the east of the citadel. By the second half of the fourteenth century, there were three dervish lodges strategically located next to the main market, whereas, before Mu'īn al-Dīn's takeover of Tokat, there had been only one dervish lodge in the area, between the market and the citadel. These newly endowed dervish lodges, placed in succession between the bridge and the citadel, drew visitors' attention away from the Seljuk center. Located along a path traveled by every caravan that entered the city, these lodges, with their oversized portals, altered the way a visitor navigated his way through the city. Three of the dervish lodges framed a new urban space, the

maidān, actually creating visual barriers between the *maidān* and the citadel.

AMASYA

Amasya, formerly Amaseia, lies on both sides of the Yeşil Irmak (Green River) at a point where the river cuts a narrow gorge through the mountains. In the Middle Ages the two sides of the city were connected by five bridges. The Christian population was spread out on its eastern and western borders; a large church occupied a site in the east, to the west of the Khalif Ghāzī Madrasa. "Arab," "Kurdish," and Armenian communities were located to the northeast, southeast, and southwest, outside the city walls. One of the markets of the city was near a gate to the lower citadel, on the northern bank in the western part of the city. Amasya lay on the same north-south trade route as Tokat and Sivas, that which connected these three cities to the Black Sea port of Sinop. The trip between Tokat and Amasya took three days by caravan.

The city was home to the Hellenic kings of the Pontus but was conquered by the Dānishmendid sultan Malik Ghāzī in 1083.[58] The Dānishmendids, the first Islamic rulers of the city, transformed it and put their stamp on it with a number of key constructions. They took over the citadel and in 1116 converted the Byzantine church on the highest point in the city into a mosque, the Fethiye Mosque (no. 6). They built another mosque, the Endurun Cami, outside the inner walls of the city on the northern side of the river (no. 3).[59]

The Seljuk sultan Masʿūd I annexed Amasya in 1116. When the Seljuk realm was divided among Qilij Arslān II's sons in 1156, Amasya was given to Nizām al-Dīn Arghun Shāh as an *iqtāʿ*. He ruled Amasya until it was seized by the Seljuk sultan Rukn al-Dīn Sulaymān in 1196. During their rule, the Seljuks built a mosque, a *madrasa*, a bath house, a dervish lodge, and a palace within the city.[60] The Seljuk sultan Kay-Qubād I restored the fortress, reinforcing it with a set of walls, and in 1229 gave Amasya as an *iqtāʿ* to the Khwarzm-Shāh Turks, who had once controlled the most powerful empire in Central Asia.

During the medieval period Amasya was the site of a number of revolts, the most famous among them the Bābā Rasūl revolt of 1240. Both the revolt and its aftermath were significant for construction in the city.

In some interpretations, the Bābā Rasūl revolt united the Christians and Türkmens who lived along the eastern and western borders of Amasya into a dervish-led alliance against the corrupt and abusive Seljuk sultan Ghiyāth al-Dīn Kaykhusraw II. As previously mentioned, the leader of the revolt, Bābā Ilyās, and his followers successfully held the city for two years.[61] Accounts of the revolt that stress the close relationship between its instigator and local Christians suggest that the ties between Christians and dervishes were one of the revolt's most notable features. Another feature stressed in many accounts of the revolt was the enormous and widespread sympathy for the cause of Bābā Rasūl and his powerful following of Türkmens, Christians, and dervishes.[62]

These events and, just as important, the perception of these events by local *amīrs* and the Seljuk sultans provoked changes in Amasya that differentiated its layout from that of Sivas and Tokat, though its natural topography already rendered it particularly suited to separate urban centers. Since the days of Justinian, building activity had been dispersed along both sides of the gorge on which the city had been founded, with the northern side the site of the citadel (no. 1) and the tombs of the Pontic kings (no. 2 and fig. 20), the southern side the site of a large church on a prominent peak and smaller churches descending toward the banks of the river.[63]

Shortly after the Bābā Rasūl revolt, Seljuk military commanders converted two churches on the

FIGURE 20
Amasya, view to the north.

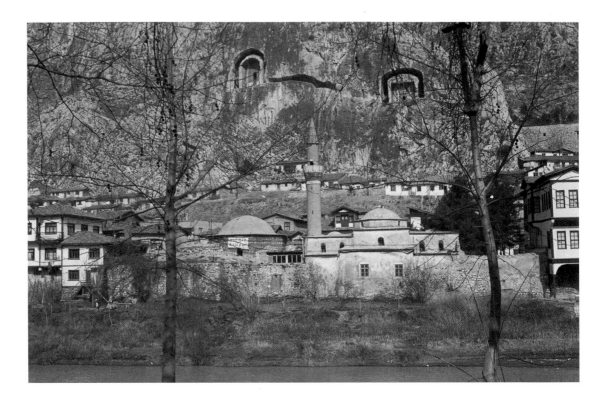

southwestern border of the city into *madrasas*. These churches were in Christian neighborhoods near the reputed site of the Bābā Rasūl lodge. The Seljuks also endowed two *madrasas* near the bank of the river in the central part of the city (nos. 4 and 5). Each of these *madrasas* was attached to a domed tomb.

Throughout the second part of the thirteenth century, there was still a strong Seljuk presence in the city, embodied by such important Seljuk military leaders as Khalif Alp and ʿAbd al-Salām ibn Ṭurumṭay. But at the end of the thirteenth century, the Mongols began to rule more directly and to dominate building activity in the city. By the second half of the fourteenth century, however, Amasya, like Sivas and Tokat, had fallen under Eretnid rule.

Amasya Before 1240

Immediately before 1240, a visitor to Amasya confronted a walled city containing separate urban centers defined by civil, religious, and commercial structures primarily under the direct control of the Seljuks. The citadel and the walls, the first structures visible to a visitor, proclaimed the city as Seljuk property, linking it with the other Seljuk cities that the visitor would already have seen en route and those he would see later. Both mosques, one inside the citadel and one on the opposite mountain, dominated the skyline, proclaiming that Amasya was under Muslim rule.

Inside Amasya, many temporal layers of building activity were evident. The main mosque, or Fethiye Cami, had originally been a seventh-century Byzantine church (no. 6) but had been converted into a mosque by the Dānishmendids in 1116, and by 1240 it also boasted a single minaret. Except for the minaret, the exterior of the building closely followed the plan of the original Byzantine church. This building was located on a high slope on the southern bank of the river. Another church,

also built by a Byzantine emperor, was converted into a Muslim building by the Dānishmendids and is today known as the Khalif Ghāzī Madrasa (no. 4). By 1250, the *madrasa* had an attached tomb with a pointed octagonal dome, and an Arabic inscription linked it to the Seljuk military leader Khalif Alp.[64] The *madrasa* was endowed in the first quarter of the thirteenth century. Today, only the tomb survives.

The only pre-1240 dervish lodge in Amasya for which there is any information is the lodge connected to the Bābā Rasūl revolt. Known as the "Hanakah-i Mesūdī" or Shaikh Kırık Tekke, it was located in the Kupceğiz neighborhood close to the Gök Madrasa in the historical district of Simre on the southern bank of the river.[65] Originally built in the year 1150 by the Seljuk sultan Mas'ūd, the lodge continued to attract attention from revered *shaikhs* and political figures throughout the next two centuries. The lodge was closed after Seljuk forces regained Amasya, but was reopened in 1248 by Shams al-Dīn Maḥmūd and Fakhr al-Dīn 'Alī, with Suj al-Dīn Ilyās (Bābā Ilyās) reinstated as the *shaikh*. This cycle of opening and closing continued for the next century, during which the lodge attracted such other prominent *shaikhs* as Muḥlis Pasha, Baraq Bābā from Tokat, and Amīr Coban from Sivas.[66] The significance of the site must have been great. After the revolt was quelled, the next two major acts of construction in Amasya, the Khalif Ghāzī Madrasa and the Burmalı Madrasa (nos. 4 and 5), were undertaken near the dervish lodge. These two ventures were supported by Seljuk military *amīrs*.[67]

Amasya After 1240

Building activity between the second half of the thirteenth century and the second half of the fourteenth century dramatically transformed the eastern and western borders of Amasya. Three dervish lodges built in this period helped transform outlying Christian suburbs, beyond the city walls, into thriving market areas and religious centers. As in Sivas and Tokat, dervish lodges presented new popular sites that drew attention away from the Seljuk centers. By doing this, they altered the way a visitor experienced the city, and even controlled what he or she saw.

From 1240 to 1275, one dervish lodge was endowed in Amasya. It was located in a western suburb on the southern bank of the river. The dervish lodge (no. 9) was directly across from the Gök Madrasa (no. 8) and part of the same endowment. The *waqfīya*, drawn up in 1266, lists 'Abd al-Salām ibn Ṭurumṭay as the patron of the buildings. Ṭurumṭay, along with Mu'īn al-Dīn Pervāne and Fakhr al-Dīn 'Alı, was one of the earliest patrons to build a dervish lodge, and like them he included this lodge in his endowment for a *madrasa*. Furthermore, the buildings built by these three patrons all shared a number of important qualities. From the archaeological evidence it appears that all three *madrasas* were larger than the nearby dervish lodges. As was noted in Chapter 2, it is quite probable that all three were built on preexisting structures. Most important, all of these early *madrasas*/dervish lodges were built near city borders.

Ṭurumṭay's *madrasa* stood beside the road to Tokat, across from one of the gates to the outer citadel, in a formerly Christian neighborhood. Archaeological evidence suggests that his *madrasa* was adapted from a three-aisle church and his dervish lodge from a small chapel.[68] Ṭurumṭay's Gök Madrasa was the second church converted into a *madrasa* on the western border of the southern bank of the river. Built directly west of the Khalif Ghāzī Madrasa, also the site of a former Byzantine church, the Ṭurumṭay's Gök Madrasa and dervish lodge extended the western border of the city. As Muslim institutions, they introduced a focus for Muslim communities. Ṭurumṭay, a convert to Islam from Christianity, was a *beylerbey* in

charge of Seljuk forces. His dervish lodge was the first to house travelers and pilgrims coming from Tokat and could have reduced the number of dervishes and dervish followers visiting the more volatile dervish leaders at the Bābā Rasūl lodge.

Archival evidence suggests that one dervish lodge was built during the twenty-five-year period from 1275 to 1300. This dervish lodge was described in a 1314 waqfīya as the Mawlawī-khān of ʿAlāʾ al-Dīn.[69] Hüseyin Hüsameddin believes that ʿAlāʾ al-Dīn refers to ʿAlāʾ al-Dīn ʿAlī Pervāne Bey, especially because a 1661 sijill (Ottoman register) refers to a "Mevlevihāne-ī merhūm ʿAlāʾ al-Dīn Pervāne."[70] If Hüseyin Hüsameddin is correct, the dervish lodge was built by the same patron who built a masjid in Amasya in 692/1293. Because of this connection and repeated references to a lodge in Amasya where early disciples of Jalāl al-Dīn Rūmī, such as Aḥmad Dede and Meḥmed Dede, preached, Hüsameddin dates this building to before 1300 (no. 7). According to the 1314 waqfīya, the lodge, near the Hukumet Bridge, was in a Christian Armenian neighborhood directly across from a part of the city, on the northern bank, that had belonged to a Greek businessman.

ʿAlāʾ al-Dīn Pervāne, like his famous father Muʿīn al-Dīn Pervāne, supported dervish leaders.[71] Yet, unlike his father and other contemporary patrons, ʿAlāʾ al-Dīn endowed a building that was quickly appropriated by the followers of Rūmī. For by 1319 his lodge was referred to as a Mawlawī dervish lodge.[72] This nomenclature may reflect the increased standardization of dervish lodges. More likely, however, ʿAlāʾ al-Dīn sought to attract dervishes and dervish leaders from outside the region and, more important, outside the influence of Bābā Rasūl and his followers.[73]

From 1300 to 1325, Ilkhānid patrons endowed buildings on the eastern side of Amasya, on the southern bank of the river. A large timarhāne, or mental hospital, was built here in 1308 (no. 10). Two years later the Yaʿqūb Pasha dervish lodge was endowed (no. 11). According to its waqfīya the lodge was on the slope of the Farhad mountain in the Timarhāne district. It was endowed by a Mongol amīr. The foundation supported a large staff, including two Qurʾān readers instructed to read every day,[74] a mutawallī, a shaikh, an imām, a cook, a muʾadhdhin, and a doorman. According to the waqfīya, Siyawūsh ibn Pir Ilyās was to be the shaikh, and his position was to be passed on to his descendants.[75] Today, the original Yaʿqūb Pasha dervish lodge is no longer extant. Its site, however, is occupied by a fifteenth-century tomb dedicated to Pir Ilyās, the founder of the Khalwatī order. Pir Ilyās was a descendent of the instigator of the Bābā Rasūl revolt, and it is possible that the Mongol amīr chose to support Pir Ilyās through this dervish lodge as a way to compete with other lodges in the area, especially the nearby lodge adopted by the followers of Rūmī.

According to the 1331 traveler Ibn Baṭṭūṭa, a lodge connected to the Akhī brotherhood stood outside the city. Since we know that when Ibn Baṭṭūṭa visited Amasya, he stayed in the lodge of Aḥmad Kujek ibn Taj al-Dīn, the father of Aḥmad Kujek was most likely the same Taj al-Dīn who endowed the Sunbul Bābā lodge in Tokat and buildings in other neighboring regions, such as Osmancık.[76] Similar to former amīrs, Taj al-Dīn used his property to support buildings that provided him with a secure place to participate in the increasingly intertwined activities of trade and dervish ritual. He endowed a large mosque in the central part of the southern bank in 1325. This mosque, known as the Gümüshlü mosque, was on a small hill and overlooked activities on the eastern and western borders.[77]

Amasya Transformed

By 1350, Amasya was transformed from a city that

followed the pattern of the classical city, with a citadel and market area, to an urban area composed of separate centers. As new local elites rose to power, new centers were developed in an attempt to limit the influence of older centers. Dervish lodges were endowed along the city edges, in Christian neighborhoods, and near older dervish lodges, in a movement of continuing decentralization.

CONCLUSION

In the complex social situation existing in Tokat, Amasya, and Sivas from the second half of the thirteenth century to the second half of the fourteenth century, newly wealthy building patrons used the funding and siting of dervish lodges to incorporate and appropriate the activities and revenues of an unstable indigenous population. Before this period, Christians and their lands had been taxed to support the state. Through the institution of *waqf*, such taxes were now channeled instead to pious endowments. Dervish lodges varied enough in the activities they included and the audiences they attracted to redraw categories of identity for city residents. For example, dervish lodges blurred the division between private religious space, intended for a specific religious and ethnic group, and the public market. In this setting, the dervish lodges from the thirteenth and fourteenth centuries, adjacent to markets and joining secular and religious space, created new borders for activity within the city.

From 1240 to 1275, in each of the three cities, Sivas, Tokat, and Amasya, one building patron who had risen through the ranks of the Seljuk state and had his own dynastic aspirations endowed a dervish lodge next to or across from a *madrasa*. From 1275 to 1300 separate dervish lodges were built by competing *amīrs* and *akhī* leaders. These lodges were strategically situated; a dervish lodge would often be the first building a visitor encountered as he entered a city or the only building near a market

area. Dervish lodges, unlike caravansarays, were dedicated to the spiritual and physical nourishment of their guests. And also unlike caravansarays, which were usually located outside cities, dervish lodges were usually placed in a city's border areas, extending the city radius, altering the city's pattern of space.

The daily activity involving markets and dervish lodges altered how residents and visitors navigated their way through the city. These residents and visitors were able to find a number of services outside the citadel, in new public zones that made the citadel peripheral. As residents and visitors changed their routes and destinations in these cities, bypassing the citadel in favor of dervish lodges and the markets around the *maidān*, the former hierarchy of space was undercut. It was replaced with a different hierarchy defined by many smaller centers controlled by a new alignment of *amīrs* and dervish leaders.

Dervish lodges, with their highly visible portals and important locations, proclaimed a new range of activities supported by a new group of elites. These portals denoted the institution of the dervish lodge, which, in itself, connoted religious and economic activities supportive of indigenous Christians and various groups of immigrants. According to endowment deeds, chronicles, and dervish biographies, dervish lodges provided lodging and entertainment for residents and travelers. Recitals of the Qur'ān took place in front of elaborate windows in those with attached tombs. Some dervish lodges gave out free food to the poor and had elaborate dances and spectacles for the curious and devout. Also, dervish lodges were important places for scholarly discussions of theological and philosophical matters, discussions that drew scholars from all religions. With these provisions, lodges appealed to audiences that had previously been omitted from all but the most mercantile aspects of urban life.

City Streets and Dervish Lodges

CONSTRUCTING SPIRITUAL AUTHORITY IN SIVAS, TOKAT, AND AMASYA

CHAPTER 4

Very little of the scholarship on medieval Islamic architecture has yet dealt with the architecture of dervish lodges.[1] With few exceptions, such basic questions as how dervish lodges were recognized or what their basic structure was have been left unanswered.[2] In part, these omissions are the result of the limited evidence for pre-Ottoman dervish lodges. The biggest problem, however, is that dervish lodges are primarily understood as institutions and not as buildings. By ignoring the dervish lodges as buildings, however, we lose an insight into an important component of their institutional role: their accessibility to medieval audiences. Views of the activities associated with these buildings and, where relevant, of the actions within the buildings were mediated through their architecture. As the form of the lodges changed, so did the performance, impact, and accessibility of these activities.

Between 1240 and 1350 the dervish lodges of Sivas, Tokat, and Amasya grew in number and size. Archaeological and archival evidence suggests that three types of dervish lodges were built in these cities during this period. These three types can be grouped chronologically. The first, or earliest, type was built between 1240 and 1275 and is distinguished from the other two types by its proximity to larger structures. The second type, which was primarily built between 1288 and 1302, was an independent building with one or two tomb chambers. The third type, the multiunit complex, made its first appearance in the fourteenth century.

EARLY DERVISH LODGES

Dervish lodges built between 1240 and 1275, such as those adjoining the Gök Madrasas in Sivas, Tokat, and Amasya, were small appendages to *madrasas*. Either directly connected to *madrasas* or in their immediate vicinity, these dervish lodges were secondary structures dependent on *madrasas* in terms of both their endowment and visual program. In some cases, as with the dervish lodge outside the Gök Madrasa in Sivas, the lodge was added to the *madrasa* along with other dependent buildings, such as bathhouses and fountains.[3] Only two of the three known dervish lodges of this type are extant, and both are small buildings. One of these dervish lodges is situated in front of the Gök Madrasa in Amasya (fig. 21). The second is a small, partially extant building attached to the northern side of the Gök Madrasa in Tokat (fig. 22).[4]

Although each of these lodges is distinctly smaller than its neighboring or adjoining *madrasa*, it is placed so that most visitors would need to pass by the lodge before entering the *madrasa*. For example, the lodge of the Gök Madrasa in Amasya is directly in front of the *madrasa*'s main entrance portal (fig. 19, no. 9). It is also the first building one sees as one exits the *madrasa*. Likewise, the lodge of the Gök Madrasa in Tokat is attached to the northern end of the *madrasa*, facing the entrance to the city (fig. 16, no. 7).[5] Although Işık Aksulu and Ibrahim Numan use the examples of other Seljuk buildings to argue that the lodge of

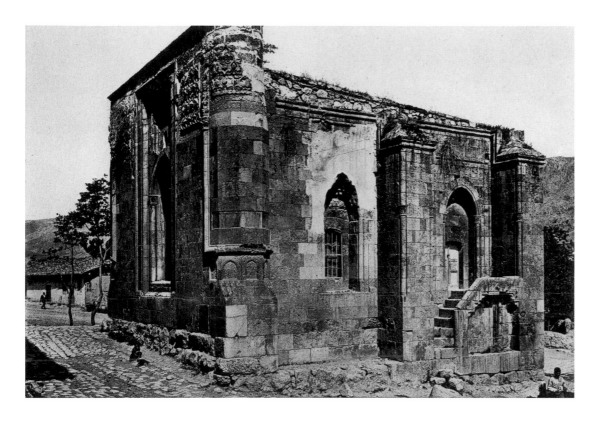

FIGURE 21
Amasya, Gök Madrasa lodge.

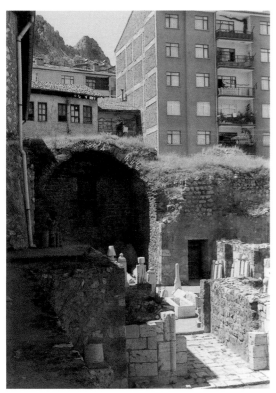

Tokat's Gök Madrasa was most likely a hospital, the portal arrangement of a *madrasa* and adjoining lodge was common to the time and to this type of amirial patronage.[6] An extant example of this arrangement is found in the Fakhr al-Dīn *madrasa* and lodge in Akşehir, where the lodge entrance is an extension of the *madrasa* façade. Although nothing remains of the lodge of the Gök Madrasa in Sivas, the building's *waqfīya* and Ibn Baṭṭūṭa describe a lodgelike structure near the entrance to the *madrasa*. If we can assume that these sources are accurate—and there is no compelling reason to assume otherwise—it would have been impossible to enter the Sivas Gök Madrasa, like the Tokat and Amasya Gök Madrasas, without encountering a dervish lodge.

Evidence from the plan of the only fully extant *madrasa*-lodge combination, the Gök Madrasa–lodge in Amasya, suggests a plausible origin for the layout of the *madrasa*-lodge (fig. 23 and fig. 19,

FIGURE 22
Tokat, interior of Gök Madrasa lodge.

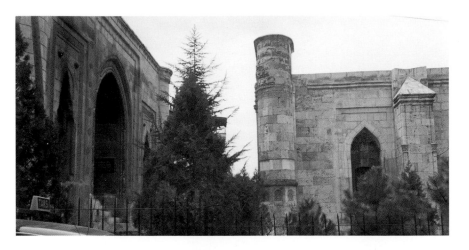

Amasya, known today as the Ṭurumṭay Tomb, is a two-story building built around a rectangular shell, with a taller southern end and an eastern entrance that projects slightly from the wall (figs. 21 and 23).[8] The second floor is accessed via a set of steps arranged in an inverted V leading to the eastern portal. The eastern and western corners of the southern side are extended by engaged columns with applied stucco decoration ranging from floral motifs to calligraphy and echoing that of the Gök Madrasa (fig. 24). The building has five windows similar in size and shape to the eastern, or main, portal. The southern end, that facing the entrance to the Gök Madrasa, has a modified *pishtaq* (high and formal gateway constituting the façade of a building) and a large ornate central window with a dedication inscription and Qur'ānic passages (see fig. 11). This window allows one to view and hear activities within the building from the outside *īwān* of the *madrasa* portal. Since this *īwān* portal was a common place for a variety of formal and informal meetings, many would have visual and aural access to the smaller building. The tomb room inside the Gök Madrasa, by contrast, was visible from a distance, through its roof, but otherwise invisible and impenetrable unless one was inside the building.

Like the Gök Madrasa–lodge in Amasya, the Gök Madrasa–lodges in Sivas and Tokat may also have been connected to preexisting structures. Both Aptullah Kuran and Barbara Brend have suggested that Sivas's Gök Madrasa was originally a caravansaray.[9] Süheyl Ünver has found evidence of an earlier building in the foundation of the Gök Madrasa in Tokat.[10] It is possible that the basis for *madrasas* with linked dervish lodges may be traced to the conversion of churches into caravansarays after the Seljuk conquest. Ibn al-ʿArabī had advised the Seljuk sultan Kay-Kāʾūs (1210–19) to make churches offer every Muslim three nights lodging and nourishment.[11] In this way, churches

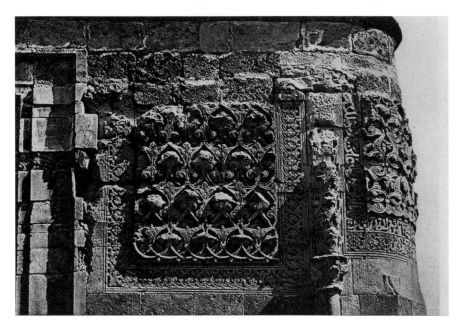

FIGURE 23
Amasya, Gök Madrasa lodge.

FIGURE 24
Amasya, Gök Madrasa lodge: detail.

no. 9). The arrangement of a small building in front of a much larger one appears often in the Christian architecture of Anatolia. According to Hüseyin Hüsameddin, the Amasya Gök Madrasa–lodge stood on the site of a church and patriarchate. The church and patriarchate were damaged by the Muslim conquest and rebuilt using the same foundation and stones.[7]

The form and layout of the Amasya lodge indicate why this preexisting structure was well suited to the dervish lodge–*madrasa*. The lodge in

went through an incremental process of transformation from churches, the remnants of which we can still see in the Gök Madrasa–lodge in Amasya, to caravansarays, which we can see in the plans of the Gök Madrasas in Tokat and Sivas. Devoting a small enclosed space in front of a *madrasa* to mystic adherents and the poor made such a *madrasa* very different from the other *madrasas* endowed in these cities at the same time. Thus, the addition of a dervish lodge distinguished one type of *madrasa* from another and signaled that a broader range of people and activities would be associated with that which was linked with a lodge.

DERVISH LODGES AFTER 1288

Between 1288 and 1315 dervish lodges and *madrasas* were no longer endowed together in the same *waqfīya*. From 1288 until 1315 at least five dervish lodges were endowed as separate structures in Sivas and Tokat alone: the Shams al-Dīn Sivasī lodge in Sivas, and the Sunbul Bābā (1291–92), Khalif Ghāzī (1291–92), Shams al-Dīn ibn Ḥusayn (1288), and Shaikh Majnūn (c. 1300) dervish lodges in Tokat (figs. 27–30). In Tokat, where most of these were endowed, the appearance of separate dervish lodges coincided with the disappearance of *madrasas*. It would appear that with the establishment of the dervish lodge as a separate building, the need for *madrasas* decreased. In all three cities, only one *madrasa* was built between 1288 and 1315.

All of the four lodges built in Tokat between 1288 and 1315 were independent structures. Although the lodges that were built in Amasya and Sivas between 1288 and 1315 are no longer extant, all of the Tokat lodges from this period still exist. A brief overview of the extant buildings suggests that, like the early lodges, many of them cannibalized earlier structures. Given the rapid rate at which these were built, such an assumption seems quite logical. The Sunbul Bābā lodge, for example, was

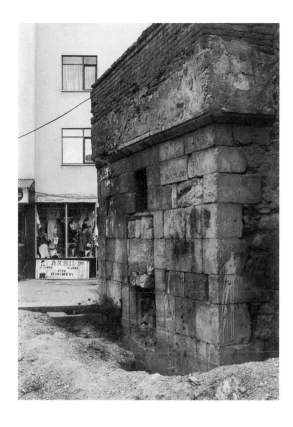

FIGURE 25
Tokat, Sunbul Bābā lodge:
tomb room with cornice.

built in two, possibly three, stages. According to the seventeenth-century Turkish traveler Evliya Çelebi, the Sunbul Bābā lodge was built on top of a preexisting shrine that catered to "nonbelievers."[12] Remnants of a cornice can be seen along the eastern face of the tomb room (fig. 25). These various layers of building activity help explain the rather unusual building inscription. The inscription states: this *maqām* (blessed place) is called *dār al-ṣulaḥā'*. Given Evliya Çelebi's observations, the remnants from a pre-Islamic and even pre-Christian structure, and the term *maqām*, it is quite plausible that this building was built on a site with important local religious significance predating the Muslim and even Christian conquest. That different material was used for the tomb (cut stone) and the rest of the building (rubble) strongly supports this hypothesis (fig. 26).[13]

These four Tokat lodges share a similar plan. Each was a single-story structure with a number of

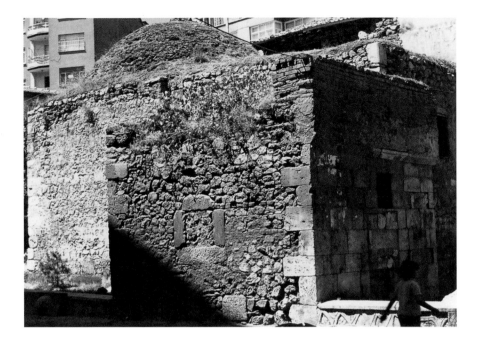

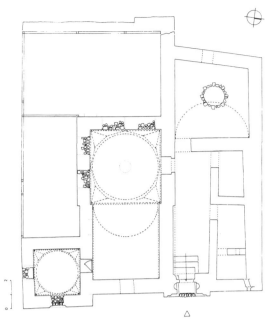

FIGURE 26
Tokat, Sunbul Bābā lodge:
detail (left).

FIGURE 27
Tokat, Sunbul Bābā lodge:
reconstructed plan (right).

different rooms (see fig. 27).[14] These lodges also
contained a square domed room (*sofa*) leading
into with a barrel-vaulted hall with an entrance
into a second, smaller square domed tomb room.
They varied in their alignment of the domed
tomb chambers with other rooms, choice of build-
ing material, and the embellishment of the
façade. Usually, the *sofa* was in the most secluded
part of the lodge, while the domed tomb room
was near the most visible parts of the building.[15]

In terms of structural alignment, the four
Tokat lodges can be divided into two groups.
Each lodge of the first group—the Shams al-Dīn
ibn Ḥusayn and Shaikh Majnūn lodges—has no
separate entranceway; one steps immediately into
a square domed chamber with an adjoining bar-
rel-vaulted hall. Likewise, entrance to the tomb is
possible only through the barrel-vaulted hall, or
īwān. Each lodge also contains a second barrel-
vaulted hall (and, in the Shams al-Dīn ibn
Ḥusayn lodge, possibly a third), which is reached
through a corridor (or corridors) off the square
domed room. As the central element in these

buildings, the square domed room allowed for a
range of activities, including ritual performances.
We can assume that audiences for these perform-
ances would have been relegated to the *īwān*
chamber, where they would not only have faced
the activities of the dervishes but would have
encountered the holy site of the tomb directly to
one side. Visitors who were not privileged to enter
the lodge were still able to pray at the tomb
through large waist-level windows.[16] By contrast,
windows in the other parts of the lodge were very
high, making them inaccessible.

The alignment of rooms in the Sunbul Bābā
and Khalif Ghāzī lodges (fig. 30) differed from
that of the previous two by the introduction of
entrance hallways. With these halls one could
enter the large domed room only by passing at
least one entrance to another room. As a result of
this new arrangement, the domed tomb room
could be placed behind the façade and still be in
its important location next to the barrel-vaulted
hall that opened into the *sofa*. Why smaller rooms
were introduced into the structure is unclear.

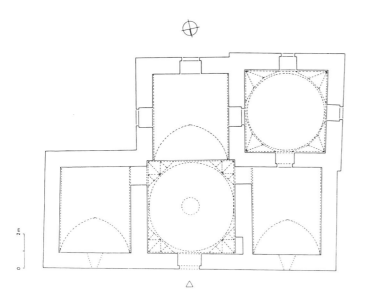

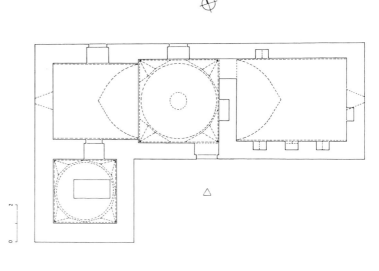

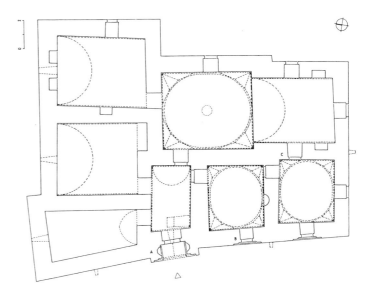

These rooms were accessible through the hallway and could be used without one's having to pass through the larger areas of the dervish lodge. Perhaps the designers had responded to some special need to cordon off smaller, more private areas that could serve as visiting rooms for people who did not belong in the lodge. On the other hand, perhaps these smaller sections were created to separate men from women.[17] It seems plausible that the growing division of spaces within the lodge represented an increasing desire to create some kind of hierarchy among the various members of the community who formed around these lodges. Such an interpretation is supported by the increasing power of *shaikhs*, who understood that their greatest power lay in acquiring communal leaders as disciples. Although both communal leaders and *shaikhs* wished for larger followings, they needed to make sure that their role as leaders would always be recognized. Certainly, the room arrangement in the Sunbul Bābā and Khalif Ghāzī lodges made for easy separation of dervish followers.

FIGURE 28
Tokat, Shams al-Dīn ibn Ḥusayn lodge: reconstruced plan (top left).

FIGURE 29
Tokat, Shaikh Majnūn lodge: reconstructed plan (top right).

FIGURE 30
Tokat, Khalif Ghāzī lodge: reconstructed plan (bottom right).

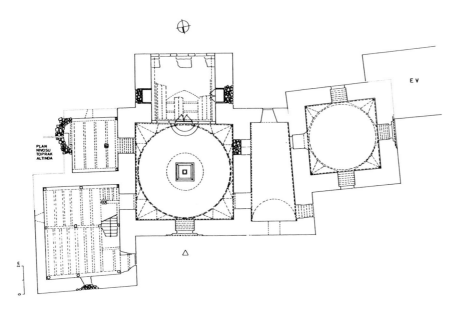

FIGURE 31
Tokat, ʿAbd al-Muṭṭalib lodge:
reconstructed plan.

DERVISH LODGES AND BUILDING COMPLEXES

Although there is only one extant lodge built between 1315 and 1325, textual sources indicate that dervish lodges changed in two important ways after 1315. By the early part of the fourteenth century, local patrons had made dervish lodges, not *madrasas*, the center of large and growing building complexes. One example of this type of building activity is the Dār al-Rāḥa, where a dervish lodge was later embellished by the addition of a tomb. It would appear that the same pattern was followed with the Shams al-Dīn Sivasī lodge, where, after the dervish lodge was endowed, a tomb or second dervish lodge was added near the original lodge. In this way, the single dervish lodge replaced the *madrasa* as the center of building complexes. As this happened, the building structure began to incorporate sharper divisions between public and private space.

Although only one post-1315 dervish lodge survives today, the building is well preserved (figs. 18 and 31). The most notable feature of the ʿAbd al-Muṭṭalib lodge is that the building is arranged around a central domed room. As Sedat Emir points out, the existence of a central domed room with smaller side rooms represented a dramatic change from the previous dervish lodges built in Tokat.[18] The reason for the different layout of space in the ʿAbd al-Muṭṭalib lodge may have been a greater desire for privacy coupled with a need for a larger meeting room. The building is larger than the earlier lodges and could easily have housed a number of residents and visitors, who otherwise would have been housed in neighboring apartments (*buyūt*).[19] The most accessible part of the lodge is the tomb, which is oriented toward a different street from that before the entrance façade. In fact, the entrance façade is almost hidden from the street view (see fig. 17). Such a change in layout may have been caused by a variety of factors. There has been some conjecture, for example, that this building was originally an Armenian church. Although the plan is not that typical for a church, it is possible that tombs and other dependencies were later added onto a large central domed room. It would seem reasonable also to suggest that there was a need to separate visitors to the tomb from those who lived and were allowed within the dervish lodge proper.

How all of these types of lodges were recognized by the changing audiences of Anatolia requires a discussion of the difference in spatial strategies between dervish lodges and other contemporary buildings. One of the most difficult questions to ask about dervish lodges is how they were recognized. Although the question may seem simple, we must remember that many of the people who were meant to patronize these buildings were visitors from other cities and regions. At the same time, they possessed different levels of literacy, which not only affected their ability to read an inscription but, more important, gave them different ways of recognizing a building. One way to understand how medieval audiences recognized dervish lodges is to ask how these

buildings compared to others. As will be shown, two basic spatial strategies distinguished these types from other buildings: first, the relation between interior and exterior space; second, the orientation of the domed tomb chamber.

Dervish Lodges and Madrasas

Two buildings that shared many of the same functions as dervish lodges were *madrasas* and tombs. Aside from teaching functions, *madrasas* provided housing, including spaces for visitors and semipermanent residents. In Anatolia, *madrasas* were large and well endowed. But they reached their peak of production before 1277, after which their number began to taper off. Even though a number of important *madrasas* were built in Anatolia after that year, more resources were devoted to other types of buildings, such as lodges and tombs. Few *madrasas* were built in Sivas, Tokat, and Amasya for at least a hundred years after 1277. The reason people stopped building *madrasas* at this point illustrates some of the differences between the *madrasa* and Sufi lodge as buildings.

The spatial orientation of Anatolian *madrasas* is distinctive. With few exceptions, each building was arranged around a central courtyard, which was covered or uncovered, depending on the size and number of stories of the building (fig. 32). *Madrasa* façades provided few clues about what went on within the walls of the institution. They were usually larger than dervish-lodge façades but had smaller and fewer windows (figs. 15, 23, 33–36). Often, the surface of the façade was elaborately detailed with pseudowindows or blind niches, creating a sharp sense of outside and inside as it prevented outsiders from passively absorbing or engaging with the activities of the *madrasa*. The few windows on *madrasa* façades, unlike those on dervish-lodge façades, were often far above eye level, occupying only a small part of the façades and providing little access to the inte-

rior, as were those of the Burmalı Minare and Gök Madrasas in Amasya (figs. 35 and 36). Although domes made *madrasa* tomb chambers visible from a distance, these tombs could not be seen from street level. The only visual and aural access to the activity inside *madrasas* was provided

FIGURE 32
Tokat, Gök Madrasa, interior courtyard.

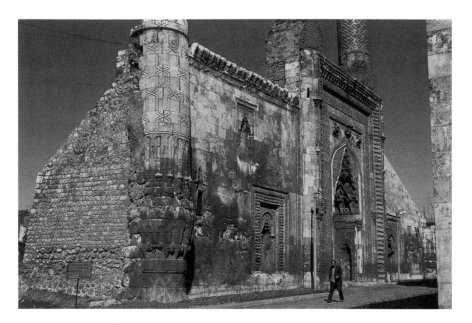

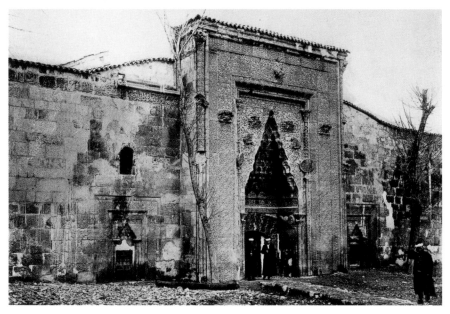

Sunbul Bābā, Khalif Ghāzī, and Shams al-Dīn ibn Ḥusayn lodges in Tokat was almost one-to-one. The main reason for this was the large area of the dervish-lodge tomb-chamber windows. In fact, the windows on these dervish-lodge tomb chambers were similar in size to those on individual tomb chambers.

As pointed out in Chapter 2, tomb chambers were the most conspicuous features of these dervish lodges. Their large windows were oriented for the most exposure, allowing pedestrians to see into the chambers.[22] The ʿAbd al-Muṭṭalib dervish lodge in Tokat provides an example of this orientation of a tomb window for maximum exposure. Its tomb window is on a side of the building facing a main street of Tokat (see fig. 16, no. 13). Likewise, the tomb windows of the Shams al-Dīn ibn Ḥusayn, Sunbul Bābā, and Khalif Ghāzī lodges were originally oriented toward the main road running through Tokat (fig. 37, nos. 8, 10, and 11), for even though the reconstruction of the Shams al-Dīn ibn Ḥusayn plan shows the tomb in the building's southwest corner, Aksulu has shown that the tomb was originally on the southeast side, which would have been facing the main thoroughfare.[23]

Not only physical evidence suggests that the motives determining the relationship between interior and exterior space in *madrasas* were different from those pertaining to dervish lodges. From their *waqfīyas*, it is clear that *madrasas* and dervish lodges supported and encouraged different groups. As institutions, *madrasas* were developed to reinforce the social distance between the local population, especially the Christian residents, and the governing elite. In Anatolia, *madrasas* supported an emergent stratum of ʿulamāʾ that allied itself with the political elite.[24] This elite group professed a uniquely Muslim code that regulated social life and administration.[25] Thus, the *madrasa*, through its promotion

by oversized portals with carved wooden doors. These doors, however, were usually closed.[20]

The relationship between exterior and interior space in the dervish lodge differed dramatically from that in the *madrasa*. On façades, the ratio of openings, such as windows and portals, to solid surface was much greater.[21] The ratio between fenestration and solid surface on the façades of the

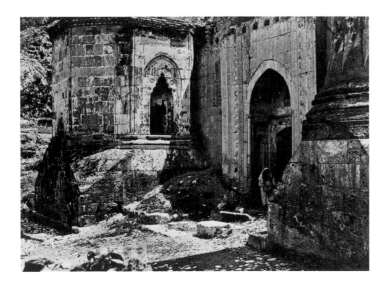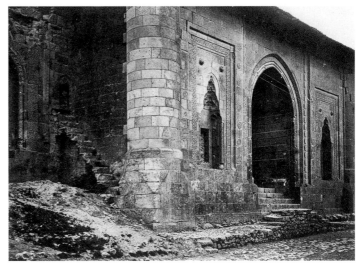

of a relatively standardized code of ethical behavior, fostered a homogeneity of practice within the Seljuk elite.

By contrast, dervish lodges were built and endowed to provide an alternative space for many of the same services as provided by the *madrasas*. Dervish lodges provided a place for teaching, prayer, and discussion, as well as a meeting place for Sufi *shaikhs*, local leaders, and different religious groups from within and outside the city. Usually, their tombs honored holy figures rather than the rulers and architects entombed in *madrasas*. The increase in the number of dervish lodges relative to *madrasas* reflects in part the incorporation of diverse religious elements into urban life and in part the parallel increase in the isolation of the people and practices associated with the *madrasas*. That dervish lodges offered religious, educational, and social services to a different and usually wider audience than *madrasas* increased the significance of the dervish lodges and their patrons to the changing populations in these cities.

We can see some differences in the target audiences for *madrasas* and dervish lodges by examining *waqfīyas*. The endowment for the Gök Madrasa–lodge in Sivas provided the dervish lodge with funds for feeding and lodging thirty of "those coming and going from among the *sayyids* (chiefs, descendants of the prophet) and *ʿalawīs*," while the *madrasa* was to support a large number of staff and students, including *fuqahāʾ* (scholars of Islamic law), a *mudarris* (professor of Islamic law), an *imām*, and a *muʾadhdhin*.[26] In comparison, the endowment for the Burujiyye Madrasa, built in Sivas during the same time period, supported one *mudarris*, three *muʾids* (tutors), thirty *fuqahāʾ*, four *ḥuffaẓ*, an *imām*, and two *muʾadhdhins* but had no provisions for travelers or wandering dervishes.[27] These provisions illustrate how patrons attempted to shape and control the audiences and practices associated with their buildings.

Dervish Lodges and Tombs

Since modern scholarship has consistently conflated dervish lodges and tombs, it is necessary to explain how I differentiate between the two building types in this study. I categorize as tombs all structures identified as tombs (*mashads*, *qubbas*, *türbes*) on either inscriptions or foundation deeds. Overall, tombs were isolated, single-use structures with domes.[28] They could be extremely large, as is

FIGURE 35
Amasya, Burmalı Minare
Madrasa (left).

FIGURE 36
Amasya, Gök Madrasa, main
entrance (right).

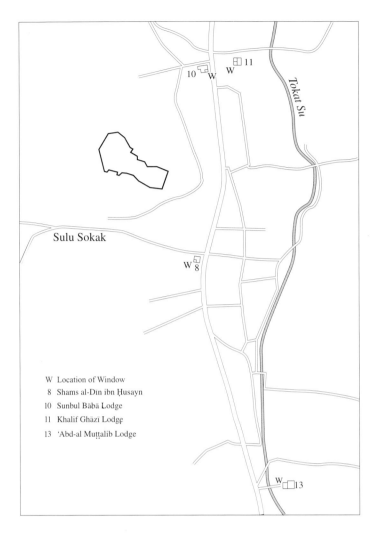

FIGURE 37
Tokat, tomb windows, plan.

W Location of Window
8 Shams al-Dīn ibn Ḥusayn
10 Sunbul Bābā Lodge
11 Khalif Ghāzī Lodge
13 ʿAbd-al Muṭṭalib Lodge

it is an *īwān*-shaped single-unit structure with a cenotaph and, most likely, a crypt below it. The word for a tomb does not appear in the building inscription, which begins with the statement "Built in the time of the reigning sultan" (see fig. 11). Because the endowment deed labels the building an ʿ*imāra* and stipulates as one of its main conditions that the building was to be a site of food distribution to the *fuqarāʾ* (indigents or dervishes),[29] this study includes this building in the category dervish lodge.

Dervish Lodges and Caravansarays

Location, size, wall width, and façade arrangement distinguished caravansarays from dervish lodges. In general, caravansarays were outside city borders or in desolate areas between cities along trade routes. Although there were at least three physical types of caravansarays, all of these were larger than dervish lodges. They included stables, rooms for travelers, and usually small *masjids*. Furthermore, at least parts of the caravansaray were two-story. The façades of caravansarays usually had thick walls, large ornate portals, and no windows. The only feature common to caravansarays and dervish lodges was these large ornate portals.

A main purpose of caravansarays was to provide safe shelter for traders and their animals. When walls were erected to safeguard the region surrounding a caravansaray, its original purpose was lost, and it was put to different use. For example, two caravansarays on the fringes of Sivas were transformed into other buildings when the borders of the city were fortified with walls; one became the Gök Madrasa–lodge; the other was transformed into the Dār al-Rāḥa dervish lodge.[30]

There were also a number of *khāns* in Sivas, Tokat, and Amasya, and though these are no longer extant, they are frequently mentioned in *waqfīyas* and medieval chronicles. They were primarily mercantile buildings with many shops and

the Güdük Minare tomb, or barely large enough to hold a cenotaph.

One of the reasons contemporary scholars often mistakenly associate tombs and dervish lodges is that both were focal points for many of the same services. The veneration of the dead through the reading of sacred texts and the performance of prayer took place in both tombs and dervish lodges. Yet, many small buildings with cenotaphs are not designated tombs in the contemporary record. One example, the Ṭurumṭay dervish lodge in front of Amasya's Gök Madrasa, is often described by scholars as a tomb because

without formalized places for prayer. Unlike dervish lodges, *khāns* were not connected to Sufi activity or endowed as *waqf* property. Because of their location in market areas, they were often built near dervish lodges. Furthermore, patrons who built *khāns* to promote and benefit from mercantile activity endowed nearby dervish lodges to foster a supervised alliance between merchants, traders, and Sufis.

Dervish Lodges and Other Buildings Within the City

Today, the *masjids* (places of worship) and mosques built in Sivas, Tokat, and Amasya between 1240 and 1350 have been destroyed, transformed into nineteenth-century Ottoman mosques, or badly restored. The lack of evidence for these *masjids* and mosques makes a comparison of their physical form with that of dervish lodges impossible.

Generally speaking, though, as noted in the section comparing dervish lodges with *madrasas*, the feature that most clearly distinguished lodges from other buildings of the period was the relationship between interior and exterior space. Dervish lodges combined sections oriented toward the street with more private, internally focused sections. In most cases, dervish lodges had large tomb windows that dominated the façade. These tomb windows and façades were oriented for the most exposure, allowing pedestrians to see and hear into the tomb chamber.

These structural distinctions reflected the more open and inclusive ethos of the dervish lodge, for activities such as Qur'ān readings, discussions, and ritual gatherings held at the lodge were directed at a broader audience than that addressed by the same activities held in other buildings. Furthermore, the siting of the dervish lodges also reflected this ethos, for their placement in popular sites in cities facilitated greater access to them. Thus, the broader composition of the lodges' target audiences was one of the most important factors distinguishing dervish lodges from other buildings.

CONCLUSION

I conclude this chapter with some general observations one can draw about dervish-lodge audiences from the material evidence. At best, this chapter suggests how people recognized dervish lodges as places where they could go for shelter, food, or the observance of some ritual activities. As shown in Chapter 2, only some of these activities were meant to be accessible to the public, and some others would have been audible from rooms with windows (tombs) and rooms without (the main hall, or what later became the *samāʿ* room). From the earliest type of dervish-lodge buildings to the multiunit complexes that they became centers of at the close of the fourteenth century, dervish lodges were visual symbols of dervish activity. In the time period of this study, this meant that these lodges were recognized as welcoming sites by a variety of people who would never have approached a *madrasa*. The high ratio between fenestration and solid wall on lodge façades highlighted the accessibility of these institutions.

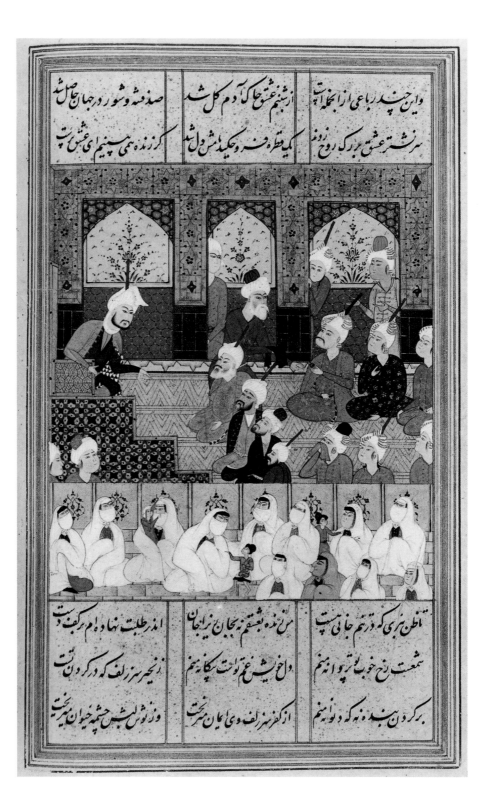

AUDIENCES AND DERVISH LODGES: PROCLAMATIONS AND INTERPRETATIONS

Dervish Lodges and the Transformation of Resident Populations

CHAPTER 5 CHRISTIANS, CRAFTSMEN, AND *AKHĪS*

> *A group of Shaykh Sadruddin's companions were drinking wine with me and said, "Jesus is God as you Christians claim. We know this to be the truth, but we conceal our belief and deny it publicly on purpose in order to preserve the community."*
>
> — Jalāl al-Dīn Rūmī[1]

In thirteenth- and fourteenth-century Anatolia, the mystical movement became linked with the performance of daily commercial and religious activities that were spread from town to town by traders and immigrants. What made these commercial and religious activities so powerful was that the groups that had practiced them previously did so in isolation from each other. As suggested by the statement of Ṣadr al-Dīn's companions in this chapter's epigraph, dervish communities and Christian communities were not exclusive. Some Muslim mystics counted Christians among their followers, and some Christians had Muslim followers.

In addition, this period witnessed the rising popularity of mystic figures who were embraced by Christians and Türkmens alike. Among these holy men were Khiḍr Ilyās, alias Saint George, and Eflatun (Plato), alias Saint Chalambrios, whose stories appeared with increasing frequency during the thirteenth and fourteenth centuries.[2] At the same time, because Christianity began to play a major role in the path to true enlightenment, a number of stories about conversion from or to Christianity were told about some of the more prominent holy men. Dervishes had a crucial role

in bringing Muslims and Christians together. They did this on a number of levels.

Understanding the dramatic nature of Muslim-Christian interactions in Anatolia requires more than a study of the many alliances between Seljuk sultans and their wives. This chapter asks how the activities and people associated with dervish lodges presented Christians and Christianity to a growing community of followers.[3] It thus focuses on how two sources—dervish lodges and dervish biographies—were used to reformulate definitions of what constituted urban communities in central Anatolia. It argues that, in addition to the location and design of the lodges themselves, dervish activities and dervish texts encouraged new communities to form across religious and class lines.

In contrast to the prevalent notion that dervish lodges were solely devoted to pious activities, dervishes cultivated close relations with craftsmen. In many cases, both dervishes and local or traveling merchants or craftsmen were associated with a lodge. Those engaged in the commercial aspects of society represented a necessary part of the dervish-lodge community insofar as they provided the lodge with popular local support and

sometimes with financial support above and beyond *waqf* revenues.[4] Furthermore, a significant proportion of this local support was Christian. Legends about dervish leaders stress their relationship to Christians and place dervish leaders at the heads of emergent communities including both Christians and Muslims. Thus, both the dervishes themselves and the writing about them sought to mold new communities around guidelines that encouraged close associations among Christians, Türkmens, traders, and craftsmen.

Because the study of Christian-Muslim relations is tied up with the topic of conversion—which in Anatolia is part of a broader inquiry into Islamization and Turkification—it may be helpful first to address some of the assumptions that have limited our approach to this topic. The first assumption is that Islamization was performed by dervishes on behalf of a centralized state with a fixed ideology. A brief review of the years after Köse Dağ and before the Ottoman conquest of Constantinople makes it very clear that there was no such centralized system of belief. The second assumption, that conversion was a quick and even superficial act, is equally problematic, since it disregards the large number of mixed communities and the gradual nature of social transformation.

In this study, my approach to the topic of conversion follows the scholarship of recent decades that has focused on accommodation and cooperation between individual communities.[5] By focusing on individual communities—and not the state—scholars have presented a view of the relationship between Christians and Turks in the fourteenth and fifteenth centuries that, having removed conversion from the framework of the state and the subject (or the conqueror and conquered), allows us to examine conversion as a process of mutual adaptations and hybridization. The adoption of a new framework is especially important in examining the role of Sufism in con-

version, since it compels scholars to go beyond the statement that the mystical movement was instrumental in the spread of Islamic culture to the difficult question of how it was spread.

DERVISH LODGES AS RELIGIOUS AND PROFESSIONAL CENTERS

As we saw in the previous two chapters, dervish-lodge activities brought different groups into contact with lodge residents during allotted times and for specific rituals, as stipulated in *waqfīya*. What *waqf* documents do not tell us is what dervishes did when they were not involved in these activities. Although it is usually assumed that they were secluded in prayer, this was not always the case.

To function successfully as a pious institution, members of the dervish lodge performed activities that extended beyond the definition of pious acts. The *Merṣād al-ʿibād* by Najm al-Dīn Rāzī, for example, includes a number of allusions to persons within the dervish lodge who served a distinctly worldly purpose. According to Rāzī, the world was like a hospice "where God is the *shaikh* and the prophet, upon whom be peace, is the steward or servant." In this hospice, "there are two classes of men: those who are served by others and have set their faces to the world of the hereafter, and those who serve."[6] As Rāzī's passage suggests, "those who serve[d]" were responsible for supporting and serving the more spiritual dervishes and, by extension, the dervish lodges in which they lived or congregated. These nonpious acts included collecting rent and cultivating land.

Given that agriculture was one of the two main sources of revenue for many of the *waqf* endowments from Anatolia, dervish-lodge residents had plenty of incentive to add to this revenue by making full use of an endowment's agricultural component.[7] Thus, while *waqf* foundations were also augmented by donations, a well-managed *waqf* grew incrementally from the work of its residents.

In other words, *waqf* foundations were not static institutions. Rents needed to be collected from *waqf* property by people who had enough authority to have them paid. It was incumbent upon these people to adjust rents so that they were high enough to keep the *waqf* functioning and low enough to prevent the populace from rioting. In the same way, members of a dervish lodge could raise revenues from uncultivated land by cultivating that land. Since dervishes in other areas of Anatolia were known to have built mills, planted fruit trees, and brought large areas of land under cultivation, it is likely that those in Sivas, Tokat, and Amasya were also associated with productive activities.[8]

It is also possible that, in some cases, *waqf* foundations may have only partially supported the building and its residents. Inhabitants of dervish lodges acquired funds for their lodges in return for following various religious practices such as prayer, charity, and the celebration of key rituals. Although *waqf* foundations imposed a framework upon the dervishes, it is important not to overemphasize the rigidity of this framework. Attendance at prayer and key rituals represented only a small portion of one's day and year. Stricter and more detailed guidelines, however, no doubt existed for some lodges. In fact, a number of dervish-lodge manuals were written within the walls of these institutions.[9]

Without these guidelines, a *waqf* could be used partially to support a dervish lodge that was engaged in other, more lucrative activities. One example is a dervish lodge in Konya that tanned hides. Known as the dervish lodge (*khānqāh*) of Mas'ūd ibn Sherifshah, its building inscription, as rendered by Ibrahim Konyalı, states that "in the year 637 the weak slave, needy of the mercy of God, built this blessed *khānqāh* . . . and he has endowed and devoted it to the Sufis and the tradespeople, and he has made obligatory in it the scraping of skins and the dispensing of benefits

therefrom among them equally."[10] If Konyalı's reading of the inscription is correct, the building was intended for Sufis and tradespeople organized into a group that was engaged in a commercially profitable craft and partially supported by a *waqf*.[11] An inscription on a dervish lodge in Tokat similarly suggests an alliance between dervishes and craftsmen. The four-line inscription, on the main portal of the Khalif Ghāzī lodge, states that the building (*buq'a*) called *dār al-'ilm wa al-'amal* was founded by Khalif, the son of Sulaymān, under the reign of Mas'ūd II.[12] There is widespread disagreement about the function of this building. Gabriel and Uzunçarşılı assumed that the building was a dervish lodge.[13] Thomas Alexander Sinclair, on the other hand, has offered two other interpretations. Deciding that the inscription on the building meant "roughly" "House of Learning and Practical Knowledge," Sinclair states that "the building very likely housed a library but was not built as a tekke [dervish lodge] at first," but he later amends his conclusion, stating that the building was instead a tomb.[14] The name that appears on the building inscription is undoubtedly a variant of *al-'ilm al-'amalī* from philosophical texts, which designates practical knowledge, comprising ethics, domestic economy, and politics. In this context *'ilm* distinguishes the practical from the theoretical intellect, while *'amalī* means doing good.[15] The inscription, therefore, may refer to the building as a place of vocation under the leadership of a mystic figure. Such an interpretation places dervish-lodge residents in the fields and markets, where they would come in direct contact with craftsmen and farmers.

CRAFTSMEN AND DERVISHES

The close relationship between tradesmen and dervishes is, in fact, frequently alluded to in Sufi literature from the period.[16] For example, the *Merṣād al-'ibād* devotes entire chapters to the behavior of merchants, exhorting them "not to

neglect to remember God with their hearts" and stressing to them the importance of doing the *dhikr* with a knowledgeable *shaikh*.[17] In addition, Aflākī includes descriptions of a number of Jalāl al-Dīn Rūmī's miraculous acts that took place in or outside of caravansarays, where merchants and traders often resided.

The practices and beliefs of Anatolian *akhīs*, however, stand out as one of the most prominent examples of the joining of mystical and mercantile interests. *Akhīs* followed the ideals of *futūwwa*, which loosely translated means ethical perfection through mysticism. Al-Naṣīrī, who wrote a *futūwwa* manual in 1290 in Tokat, described *futūwwa* as a stage in the attainment of mystical oneness in God. In al-Naṣīrī's schema, *futūwwa* was incorporated into the Sufi progression of *sharia'*, *ṭarīqa*, *ma'rifa*, and *ḥaqīqa*, where *futūwwa* was aligned with *ṭarīqa*. *Ṭarīqa* is more precisely defined as the stage when the *murīd* (novice) enters the mystical path and abandons the observance of religious forms, exchanging outward for inward worship. Thus, in late-thirteenth-century Sufi circles, *futūwwa* was a stage that could be attained by those who were unable to reach the ultimate goal of the mystic, the later stages of *ma'rifa* and *ḥaqīqa*, or absolute truth, which the Sufi acquires when he sees God in everything created.[18]

Within *futūwwa*, al-Naṣīrī set up two ranks: the *akhī*, the highest grade of *futūwwa*, and the *terbiye*, the novice who after instruction joins the *fityān* (pl. of *fatā*', "youth") of the dervish lodge (*zāwiya* or *asitane*). Importantly, this division parallels Najm al-Dīn Rāzī's division of dervishes. In addition, from Ibn Baṭṭūṭa's account it would seem that the majority of these *akhī* groups were artisans and craftsmen.

As can be seen by al-Naṣīrī's attempts to incorporate *futūwwa* into the Sufi steps toward mystical union with God, the penetration of Sufi ideals into the circle of *akhī-fityān* was strong during parts of

the thirteenth century.[19] For example, various *akhīs* are mentioned among the immediate companions of the great mystics. The *akhī* Ḥusām al-Dīn succeeded the grand master of the Mawlawīs in Konya as their spiritual leader.[20] *Futūwwa* manuals' descriptions of *akhī* buildings resemble those of dervish lodges in Tokat. According to the *futūwwa* manual of al-Naṣīrī, "The building connected with the *akhīs* should be a place of reunion for people of the *futūwwa* and called *asitane*. It should be in a garden and not connected to any other buildings." Al-Naṣīrī's description was written in the last part of the thirteenth century, when dervish lodges began to be independent structures and not subsidiary parts of multiunit complexes. He goes on to say that "there should not be any animals outside at the door, and for this reason a guard should occupy this space." The surviving *waqfīyas* from Tokat's late-thirteenth-century lodges corroborate al-Naṣīrī's description in that they describe garden settings within the city and include detailed stipulations about doormen.[21]

When we consider Ibn Baṭṭūṭa's (c. 1333) accounts of *akhī* groups he stayed with during his visit to Anatolia, the lines between these and other Sufi groups in the region begin to blur. According to Ibn Baṭṭūṭa, an *akhī* was the head of a group of young men who were responsible for building a hospice and furnishing it. The hospice was supported by the *akhī's* followers, who worked during the day to gain their livelihood and spent their nights entertaining guests.[22]

Michael Rogers had suggested that *akhīs*, rather than actually build buildings, may have inhabited earlier buildings belonging to other patrons.[23] Using Rogers's suggestion, one can argue that *akhīs* and dervishes could have occupied the same structures without themselves being the same. I argue, however, that it seems more reasonable that *akhīs*, much like the companions of Shaikh Ṣadr al-Dīn, assumed different titles in

different communities, in much the same way that Seljuk sultans assumed different titles on different building inscriptions and coins in different contexts. Similarly, the inhabitants of dervish lodges were sometimes named differently in different sources. *Akhī* may simply have been the name associated with dervishes in certain forums. Likewise, the meaning of a term like *misāfir* varied according to context, sometimes referring to a pauper, a dervish, or an *akhī*.[24] In thirteenth- and fourteenth-century Anatolia, some dervishes were wandering mystics known as *fuqarā'*; they saw visions and dressed in animal skins. Other dervishes, like Jalāl al-Dīn Rūmī, counted *qāḍīs* and *wazīrs* as their disciples.[25] Instead of studying the development of each of these dervish groups as unrelated to the others, it may be better to understand them as part of an overall development from wandering dervish to settled dervish, with the dervishes receiving different titles and epithets from different groups they encountered. *Akhī* is just such an epithet. For example, in one Tokat building the patron is referred to as an *akhī*, while the head of the lodge is described as an adept of Jalāl al-Dīn Rūmī.[26]

CHRISTIANS AND CRAFTSMEN

Travelers' accounts consistently link craftsmen and Christians. When Marco Polo visited Anatolia in the thirteenth century, he described Armenians and Greeks [both Christians] who lived with the Türkmens "in towns and villages, occupying themselves with trades and handicrafts."[27] Aside from Marco Polo's reference, Aflākī refers to Christian painters and architects with Greek names. Babken Arakelian has argued that among the Christians were Armenian workmen specializing in various aspects of stone masonry who would join together in groups and build fortresses, monasteries, and other structures. According to him, in the first quarter of the thirteenth century,

these groups worked in cities belonging to the Seljuks. Mason signs inscribed on stones in sultanic caravansarays built between 1230 and 1240 support Arakelian's theory. Apparently, these Armenian workmen were active in Sivas, Tokat, and Amasya, since these mason signs have been found on the main mosque in Sivas and the Turumtay dervish lodge.[28]

CHRISTIANS AS FOLLOWERS

The large number of Christians with which dervishes came into contact on a daily basis helps explain many of the references to Christians in Sufi literature. Like all Sufi literature, these references work on a variety of levels. Sufi authors often include descriptions of Christian followers as a way to stress a figure's holiness and the universality of his message. In Rūmī's main biography, for example, the account of his funeral mentions that there were "Christians, Jews, Greeks, Arabs, Turks, and others. They marched ahead, each holding their sacred books and reading from the Psalms, Torah, and Gospel." When the Christians were asked why they came to Rūmī's funeral, they replied, "In seeing him we have comprehended the true nature of Jesus, of Moses, and of all the prophets. In him we have found the same guidance as that of the perfect prophets about whom we have read in our books." Adding that they recognized him "as the Moses and Jesus of our times," the Christians of Konya joined with the other residents of the city—including Ṣadr al-Dīn Qunawī, who led the procession—in proving Rūmī's statement that "[s]eventy-two sects hear their own mysteries from us. We are like a flute that, in a solo mode, is in accord with two hundred religions."[29]

Likewise, the Sufi literature of the period contains many examples of Christians who were led to convert to Islam by the inspiration and example of Rūmī and other dervish leaders. By the thir-

teenth century, these conversion stories had become a common trope in pious Islamic literature.

THE INCORPORATION OF CHRISTIAN PRACTICES

Ḥājjī Bektāsh's relations with Christians are portrayed as even closer than those of Rūmī. Because of the similar practices and doctrines of Christians and Bektāshīs, many authors have concluded that many of Ḥājjī Bektāsh's followers were Christians.[30] This is not unreasonable, for in light of later practices of the Bektāshī, it would seem that Ḥājjī Bektāsh formed an order based on Christian and ʿalawī practices. A partial list of parallels would include the following: (1) Baptism, as a sign of cleansing and abolition of all sins previously contracted, closely resembles the rite of *abdest*, or ablution. (2) Chrism, or anointing with ointment, is equivalent to the Western sacrament of confirmation. (3) Holy Eucharist: the use of wine and bread as symbols of Christ's body is like the use of both in Bektāshī *aynicem*; in both cases only the confirmed or initiated are allowed to participate in the rite. (4) The priesthood corresponds to the celibate Bābās. The spiritual authority of the priest and especially of the monastic head of the monks is like the spiritual authority of the Bābā acting as *murshid*. (5) Penitence resembles the service of *Baş okutmak*. Excommunication as practiced in the Christian church also finds its parallel in *duskunluk* in Bektāshīism. The prominence of ʿAlī in the trinity of the Bektāshīs, which is made up of Allah, Muhammad, and ʿAlī, underlines the relationship between Bektāshī practices and ʿalawī traditions.[31]

SHARED SANCTUARIES

References to Christians in Sufi literature and practice make sense in the context of the end of the thirteenth century, when many dervish leaders were reaching the peak of their power and Anatolia's Christian population was thriving. The cultural production of Armenian and Greek communities was high. There was an active Armenian scriptorium in Sivas that produced a number of expensive manuscripts.[32] Many churches were built around Cappadocia, and while the number of churches is smaller for Sivas, Tokat, and Amasya, there is ample evidence for a spurt in all sorts of Christian activity in those cities.

As part of this cultural production, popular Christian saints and martyrs began to appear in frescoes on the new churches. Some of these, like the Forty Martyrs of Sebasteia and Saint George, became important variants of Muslim saints. Among these holy men were Khiḍr Ilyās, alias Saint George, and Eflatun (Plato), alias Saint Chalambrios.[33] Stories about these holy men, especially Khiḍr, appeared frequently in the *manāqibs* of thirteenth- and fourteenth-century Anatolia, where they indicate a continuity of local belief.[34]

Building activity around Sivas, Tokat, and Amasya also sought to link Christian traditions with Muslim practices. Prominent examples were the buildings devoted to the Forty Martyrs of Sebasteia (Sivas), Roman soldiers of the Christian faith who died in a lake. Cumont has found remains of the bath associated with their martyrdom, while their graves are reputed to be in an Armenian cemetery.[35] At least one of the churches containing relics of the Forty Martyrs was adopted into Islam under the name Kırklar Tekke (the dervish lodge of the forty). This dervish lodge is located in a village near Tokat.[36] The building houses the tomb of Shaikh Naṣr al-Dīn Ewliya, a fourteenth-century saint. The tomb beneath the lodge contains Byzantine remains, and beneath that lies a crypt known as the burial place of the Forty Martyrs.[37] The Gök Madrasa in Tokat is also called the Kırk Kızlar and is now believed to hold the remains of forty female martyrs. A domed

tomb room in the northwest corner still contains a large number of cenotaphs that are linked to the forty martyrs. In another example of this close relationship between Christians and Muslims, the Sufi Elwan Çelebi, a disciple of Bābā Ilyās Khurāsānī, was buried in a church in Çorum.[38]

Although this syncretism is often understood as a tool of conversion, it may be more beneficial to think of it in terms of hybridization.[39] Hybridization allows us to understand that there was a dynamic and productive Christian population in these cities during this period. As will be shown below, many references to Christians—even in conversion stories—stress Christianity as a necessary stage in true enlightenment. In the late thirteenth and early fourteenth centuries, each tradition benefited from a spate of cultural and literary production that freely borrowed from the other.

CHRISTIANS AS FIGURES OF DIVINE WISDOM

References to Christians as exemplars of divine wisdom illustrate the power of Christians and Christianity in the eyes of dervish communities. One of the best examples of this power is found in Rūmī's interpretation of the contest between a Chinese and a Greek painter. The contest takes place during a ruler's visit to China. The story begins with an argument about whether the Greeks or the Chinese excelled at painting. To resolve the dispute, the Greek and Chinese painters are taken to a vaulted room. They are placed on opposite sides of a curtain that separates one side of the room from the other, and each is told to produce a painting on his side of the room. The artists complete their work in isolation from each other. When the ruler comes to judge the paintings, the curtain between the two sides of the room is raised, and the ruler is astounded to find that the paintings on both sides of the room are

exactly alike. It is only when the curtain is again dropped that the ruler is able to see that only one wall of the room contains a painting, while the opposite wall is a blank surface burnished into a polished mirrorlike surface.

Versions of this story differ both in how this competition is judged and in who does the polishing. In al-Ghazālī's *Iḥyā' 'ulūm al-dīn* and Niẓāmī's *Iskandarnāme*, the Greeks paint a picture, while the Chinese polish and burnish their side. In the Niẓāmī account, the ruler declares a tie, stating that while one side was better in the skill of painting, the other was better in polishing. As Priscilla Soucek points out, in an earlier version by al-Ghazālī, the contest is used to indicate the superiority of mystical knowledge, which is represented by the Chinese artists, who have the benefit of mystical experience instead of acquired knowledge.[40] In the version of the story in the *Mathnawī* of Jalāl al-Dīn Rūmī, written after al-Ghazālī's, it is the Greeks who are given the more esoteric role, while the Chinese are turned into skilled craftsmen.[41] Because Rūmī's audiences associated Greeks with Christians, such a switch illustrates the growing role of Christians (and other non-Muslims) as an esoteric force.

When we survey some of the most famous holy men from Sivas, Tokat, and Amasya, Christianity is often presented as a necessary stage in true mystical attainment. One of the most prominent examples of a figure who followed this path is Baraq Bābā. Baraq Bābā was a Turkish dervish from Tokat who became famous during the Mongol protectorate.[42] He was described as a Seljuk prince who was converted to Christianity by the Greek patriarch and then reconverted to Islam by Ṣari Ṣaltūk.[43] Baraq Bābā's transformation from a Muslim Seljuk to a Christian and finally to a Muslim mystic was a common one among some Anatolian holy men.[44] Embedded in this spiritual trajectory was a criticism of the Seljuk practice of

Islam. What is interesting is that these men could not escape the practices of Seljuk Islam without being converted to Christianity. In Baraq Bābā's story the links between the wrongs of the Seljuks and the salvation offered by Christianity is obvious. In some legends, Baraq Bābā was the son of the Seljuk sultan ʿIzz al-Dīn Kay-Kāʾūs, who sought refuge with the Byzantines from Seljuk intrigue. In these legends, Baraq Bābā was adopted by the patriarch of Byzantium and brought up as a Christian until Ṣari Ṣaltūk restored him to Islam.[45] With each transformation, he moved to a higher level, away from the corrupt religious and social practices of the Seljuks. His story touches upon both the great antagonism between the Seljuks and local dervishes as well as the significance of Christianity within the stages of spiritual growth.

Another dervish believed to have been a Christian and antagonistic to the Seljuks was Bābā Ilyās, who may have been the instigator of the Bābā Rasūl revolt. As noted earlier, most accounts of the revolt stress the relationship between Bābā Ilyās, local Christians, and local Türkmens. A third Muslim holy man connected to non-Muslims was ʿAyn al-Dawla Dede, a disciple of Bābā Ilyās Khurāsānī.[46] Although he did not convert to Christianity, ʿAyn al-Dawla was admired by Christians and Jews, who were reported to have frequented his dervish lodge in Tokat. Just as important, he was feared by the Seljuk sultans, who seized and arrested him in his dervish lodge.[47]

Stories written about these three holy men underline how dervishes and biographers embraced different systems of religious expression and shaped them into a new ideological system that allowed a range of shared beliefs and practices. In this context, politically active Muslim holy men popular with Christians and antagonistic toward the religious and political practices of the Seljuks were potent tools. Even the followers of Jalāl al-Dīn Rūmī disassociated themselves from the religious practices of the Seljuk sultans. For example, as previously mentioned, the *Manāqib al-ʿārifīn* contains a story in which Rūmī mocks a Türkmen who one day managed to look inside the window of a *madrasa* where the *fuqahāʾ* were eating a sumptuous meal. The Türkmen was envious of their food and elaborate dress and set out to become a *mudarris* so that he could attain these earthly delights.[48] The *Manāqib al-ʿārifīn* story, attacking the greedy Türkmen, also indirectly criticizes the practices of the Seljuk sultans and the ʿulamāʾ whom they supported.

CONCLUSION

Patrons, dervish leaders, and dervish followers sought to form communities that cut across the previous religious and class distinctions separating the urban communities of Anatolia. Patrons encouraged mixing between tradespeople and dervishes, Christians and Muslims, by endowing lodges in the most accessible and popular spaces in cities. Dervish followers encouraged interrelationships between dervishes and Christians by incorporating Christian practices into their rituals and measuring the greatness of their masters by the masters' popularity among Christians and tradesmen. For dervishes Christianity was often seen as a transitional phase between a corrupt Islam and the true mystical path. Likewise, as will be discussed in the final chapter, some dervish lodges converted from Christian churches made Christian remnants a focal point of the building, as if to broadcast the Christian genealogy of the structure.

Women as Guarantors of Familial Lines

DERVISH LODGES AND GENDER REPRESENTATION IN PRE-OTTOMAN ANATOLIA

CHAPTER 6

In a recent article on the Yasawī *shaikhs* of the Timurid era, Devin DeWeese described an overlooked phenomenon in Sufi practice in Central Asia, the ties between primarily hereditary Sufi lineages and local communities. Arguing that spiritual succession (*silsila*) has much more to do with the fully developed orders (*ṭarīqa*) of later periods, DeWeese was able to show the enormous impact of alliances between community leaders and the descendants of *shaikhs*. As DeWeese pointed out, when a community leader became a disciple of a *shaikh*, his entire community would pledge allegiance to that *shaikh*. Through the *shaikh's* offspring this alliance would continue into the future. Given the importance of such alliances, it is no wonder that *shaikhs* competed with each other to attract communal leaders as disciples. As this chapter argues, in a period of competing hereditary *shaikhs*, women began to play a critical role as guarantors of familial lines.[1]

In Anatolia, there was a complex relationship between hereditary *shaikhs* and the larger communal followings that formed around them. The stability of local communities in Timurid Central Asia contrasted with the shifting and heterogeneous nature of communities in Anatolia. Such instability from shifting populations and frequent changes in rule meant that, even after attracting communal followings, *shaikhs* found it quite difficult to extend ties between themselves and communities into the future.[2] One way that dervish leaders tried to set up hereditary ties between *shaikhs* and their communities was through marriages between dervish offspring and communal leaders. The importance of these marriages is one of the reasons that Seljuk- and Beylik-period hagiographies often included elaborate details about the descendants of *shaikhs* and community leaders, a sort of social register for future alliances.

A follower of Rūmī wrote the *Manāqib al-ʿārifīn*, which concerns the mystic Jalāl al-Dīn Rūmī and those who influenced or continued his teachings, between 718/1318–19 and 754/1353–54, a period when scholars began to trace Rūmī's ancestry through the maternal line to the caliph Abū Bakr.[3] Although the author focused primarily on the miraculous and pious deeds of this founding figure, he took pains to record Rūmī's genetic and spiritual offspring.[4] Rūmī himself, with his choice of ʿĀrif, his grandson, as successor to the leadership of his order, established a tradition by which the leadership was inherited through his biological descendants.

Through this continuous hereditary line of succession, Rūmī's biography linked the recent past with the historical present. Women served as important links in this newly established chain, connecting Rūmī to Abū Bakr and promising continuation into the future. The book, however, includes many references not only to the wives of Rūmī and of his descendants but also to the wives and daughters of the political figures who

I would like to thank D. Fairchild Ruggles for her help in editing an earlier version of this argument.

supported him. Wives of sultans and other political figures are mentioned in a number of places. They, like the men they married, provided examples of Rūmī's enormous popularity and political clout, and their incorporation into the history of the order honored them and thus encouraged their continued financial support, as well as that of their descendants. The mothers, daughters, and wives of important men were thus, as links to past and future generations, important in themselves. These women are described as friends of the order and patrons. Yet only one of the women mentioned in Rūmī's biography can be securely connected as patron to a building.[5] The biographer's other references to women patrons of architecture are more problematic. For example, he states that Princess Ṣafwat al-Dunyā wa al-Dīn supported a Sufi lodge in Tokat, but though her name appears in the inscription of the Sunbul Bābā lodge in that city, the endowment deed of the same building makes no mention of her.[6] Why women who were not patrons were credited as such and singled out for mention in Rūmī's biography is an important question. We can assume that these women were important links in dynastic chains. In some cases, they may also have stood a good chance of inheriting funds from the Seljuk purse. In other words, in times of great political turmoil with newly emerging dynasties, these women functioned as guarantors of familial lines and, sometimes, recipients of dynastic monies. Rūmī's biographer included references to the generosity of these women to associate the order and its buildings with a range of newly emerging dynasties and wealthy families.

Inscriptions on dervish lodges include references to elite women as puzzling as those in Rūmī's biography. While these references to women would suggest that the women paid for the lodges and that there was a special association between women and mystics, women listed in building inscriptions from the Sufi lodges of thirteenth-century Anatolia did not always pay for the foundation or upkeep of the buildings.[7] Such is the case with the three lodges built in Tokat between the years 689/1289 and 691/1291—the Sunbul Bābā (fig. 38), Shams al-Dīn ibn Ḥusayn (fig. 39), and Khalif Ghāzī (fig. 40)—all of which include women's names in their building inscriptions.[8]

By themselves, these references to women were not unusual. Such famous women as Māhperī Khātūn and Turan Malik supported a number of important buildings that have inscriptions naming them as patrons. But the names of two of the women mentioned on the three inscriptions in Tokat follow the phrase "in the reign of" (*fī āyyām dawlat*), which, according to Michael Rogers, excludes them as founders.[9]

Although they were neither founders nor financial supporters, there are other reasons why the women may have been listed. They may have been regional leaders with some political power of their own, or the wives or mothers of political leaders. In each inscription, the woman's name appears after the name and titles of the reigning Seljuk sultan. Generally, in Anatolian Seljuk building inscriptions, women are referred to by somewhat ambiguous royal titles. As a result, many of these women remain unnamed as individuals.[10] While the royal association is manifest, it is not always clear whether they were wives of the sultan or representatives in their own right.[11]

These Tokat lodges were built after 1277, a time period marked by increasing Ilkhānid control of Seljuk land. As Ilkhānids sought to confiscate the lands that Seljuk sultans had sold to a newly powerful military-bureaucratic elite, these *mulk* lands were rapidly turned into *waqf*. Since these three lodges were built by anonymous patrons from the rising military-bureaucratic elite, the inclusion of the names of royal women gave a stamp of royal legitimation to both the foundation

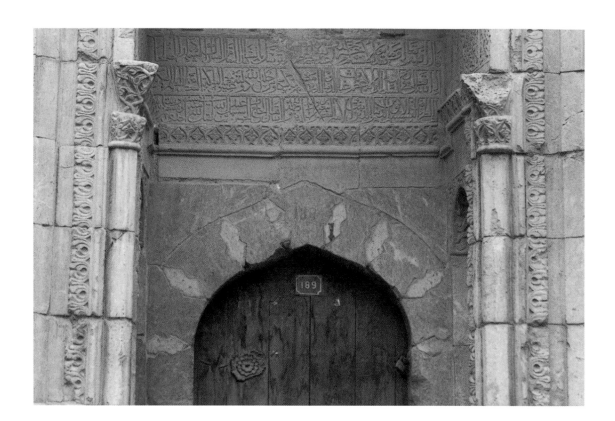

FIGURE 38
Tokat, Sunbul Bābā lodge:
inscription.

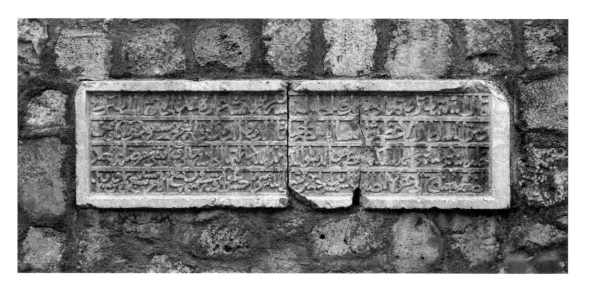

FIGURE 39
Tokat, Shams al-Dīn ibn Ḥusayn
lodge: inscription.

and its patron. The stamp of legitimation was especially important during periods when the Seljuk sultanate was dramatically weakened by Mongol control and local infighting. While the husbands, fathers, and sons of Seljuk women were in danger of losing their lives, the women themselves carried enormous clout as marriage partners because they could always produce a Seljuk heir and often had some control over small amounts of the state treasury.

The case of Ṣafwat al-Dunyā wa al-Dīn, the daughter of Muʿīn al-Dīn Sulaymān Pervāne, a high-ranking Seljuk official, raises important questions about why women's names were used in Sufi epigraphy and biography. Her name appears both on the Sunbul Bābā lodge in Tokat and in Rūmī's biography.[12] In a recent article on the Sunbul Baba lodge, Saim Savaş provides a brief introduction to the difficulties encountered in trying to gather information about the identity of Muʿīn al-Dīn's daughter.[13] She is referred to by different honorific titles (laqab, pl. alqāb) in different sources, and although it was characteristic during this period for a person to be referred to by various names and titles, the way in which references to Muʿīn al-Dīn's daughter are handled is particularly oblique. Because she is generally referred to by title rather than personal name, it is her role as princess and daughter that is articulated and not her identity as an individual outside of these roles. By contrast, her brothers, who wielded considerable political power, are referred to by more distinctive names in addition to their titles.[14] For example, Muʿīn al-Dīn's oldest son was named ʿAlī ibn Sulaymān ibn ʿAlī and had the title Muhazzab al-Dīn. Often, the sources refer to him as Muhazzab ʿAlī.[15] In the building inscription of the Sunbul Bābā lodge, the princess's honorific titles and names, such as Ṣafwat al-Dunyā wa al-Dīn (pure of world and faith) and Malika al-Muatham (magnificent princess), occur in combination with her patronymic title, "daughter of Muʿīn al-Dīn Pervāne." Likewise, in Rūmī's biography she is mentioned once by her patronymic title in combination with the title khāwand-zāde (princess) and elsewhere simply as the daughter of Muʿīn al-Dīn.[16]

There are issues of political and spiritual succession relevant to Muʿīn al-Dīn's daughter that can only be understood within the context of her father's dynastic ambitions in central Anatolia. He came to power at the end of the Seljuk reign. His ability to gain favor with both the Seljuk court and the Mongols allowed him a measure of power in Anatolia that went far beyond that of a sultan's personal assistant. His meteoric rise to power came to an end in 1277, when he was put to death by the Mongols, who suspected him of conspiring against them. Although the standard Seljuk sources give contradictory accounts of Muʿīn al-Dīn's death, it would appear from the amount of attention given to this event that his death was unusually gruesome. Some accounts state that Muʿīn al-Dīn's body was cut in half and eaten. Although the years immediately following his death marked the end of the Muʿīn al-Dīn family's control over his territories, his sons were able to regain some lands and establish a short-lived dynasty around Kastamonu, where, according to some sources, they ruled from 1295 to 1299.[17]

THE INSCRIPTIONS

Three women from this tumultuous period of rising and falling power are named in the building inscriptions on dervish lodges in Tokat. The name of Muʿīn al-Dīn's daughter appears in the building inscription of the Sunbul Bābā Sufi lodge in Tokat. The three-line inscription over the main portal of the Sunbul Bābā lodge (fig. 38) begins with a Qurʾānic quotation and continues:

The ornament of the pilgrimage and of the two sanctuaries, Sunbul ibn ʿAbd Allah, freed slave of the magnificent and pure princess revered for her double ancestry, of noble lineage from mother and father, daughter of the *amīr* worthy of pardon, Muʿīn al-Dīn Pervāne, may God have pity on him and prolong his life, seeks favor with God by the foundation of this blessed place called the house of the pious to God the highest in the reign of the august sultan Ghiyāth al-Dunyā wa Dīn, son of Kay-Kāʾūs, may God protect his empire, in the year 691.

In the inscription, Muʿīn al-Dīn's daughter is given the honorifics Ṣafwat al-Dunyā wa al-Dīn and *malika* and is further identified as the daughter of Muʿīn al-Dīn Pervāne. The inscription also states that she came from two noble lines. Because of the royal title *malika*, scholars have assumed that this daughter of Muʿīn al-Dīn was connected to the ruling house of the Seljuks. It is unlikely that such a title would have been attached to Muʿīn al-Dīn's daughter if her only claim to nobility was through her father, who, though serving as de facto leader of Anatolia, was not of the Seljuk lineage. Various scholars have therefore argued that Muʿīn al-Dīn's daughter must have been either the wife of the Seljuk sultan Ghiyāth al-Dīn Masʿūd II or the child of a marriage between Muʿīn al-Dīn and the daughter of the Seljuk sultan Kaykhusraw II.[18] But even if the inscription does not tell us whether the princess was born into the Seljuk line or married to a Seljuk, it does convey the important information that there was a merger between two noble households and uses the title *malika* to indicate that one of these was royal. The inscription was a prominent way of broadcasting the political rank of her father and his connection to the Seljuks. Thus, while there is disagreement regarding the derivation of the princess's royalty, the inscription brooks no dispute regarding her social status: she is a royal lady who continues the Muʿīn al-Dīn line. In other words, the appearance of a royal female title gave the urban viewer two important pieces of information: one, that the building was associated with a woman connected to the reigning Seljuk sultan and, two, that this royal woman was the daughter of Muʿīn al-Dīn Pervāne, detailing his association with the Seljuk house.

The second honorific, Ṣafwat al-Dunyā wa al-Dīn, has a vast number of royal associations. It is applied in an inscription to Māhperī Khātūn, the mother of the Seljuk sultan Ghiyāth al-Dīn Kaykhusraw II. She was an active architectural patron in Kayseri.[19] The same title also appears on an earlier building in Tokat, the Shams al-Dīn ibn Ḥusayn lodge, dating to 687/1289, four years earlier than the Sunbul Bābā lodge. Because the Shams al-Dīn ibn Ḥusayn lodge is a short distance away from the Sunbul Bābā lodge, it is particularly relevant to this discussion. Its inscription, over the entrance into the building, is largely intact. It begins with a Qurʾānic citation and continues:

> For drawing near God and in the desire of his consent, the foundation of the construction of this blessed *khānqāh*, in the time of the august sultan, the King of magnificent Kings, Ghiyāth al-Dunyā wa al-Dīn Abu al-Fath Masʿūd, son of Kay-Kāʾūs, may God eternalize his empire, in the days of the magnificent *malika* Ṣafwat al-Dunyā wa al-Dīn, may God sustain her empire, by the weak slave in need of pardon Abū al-Ḥasan, son of al-Shams, may God accept this from him and grant him a good end, in the month of *rabīʿ* of the year 687.

As can be seen from the inscription above, the Ṣafwat al-Dunyā wa al-Dīn from the Shams al-Dīn ibn Ḥusayn lodge is also introduced as a princess. She may or may not be the same Ṣafwat al-Dunyā

FIGURE 40
Tokat, Khalif Ghāzī lodge:
inscription.

FIGURE 41
Tokat, bridge inscription.

wa al-Dīn who appears in the inscription of the Sunbul Bābā lodge.[20] Yet, unlike the inscription on the Sunbul Bābā lodge, no information is given about this woman's father. As a result, for a modern student removed from the historical and geographical context, the only key to the identity of this Safwat al-Dunyā wa al-Dīn is her association with royalty, signaled by the term *malika* and the mention of "her" empire. One must assume that this woman was so prominent in Tokat that no additional information was necessary, and indeed historians have speculated that she was the wife of the Seljuk sultan Ghiyāth al-Dīn Kaykhusraw II. It is tempting to conclude that, unlike the Safwat al-Dunyā wa al-Dīn of the Shams al-Dīn ibn Ḥusayn lodge, the one on the Sunbul Bābā lodge was not so well known and that her father's name was added to specify her social and genealogical position. A more politically construed explanation is that both inscriptions referred to the same woman

and that Muʿīn al-Dīn's name was added to the second inscription, put up four years later, to draw attention to the family of Muʿīn al-Dīn in his former territory of Tokat.

The word *malika*, without the added name Safwat al-Dunyā wa al-Dīn, appears in a third inscription, on the Khalif Ghāzī lodge in Tokat (fig. 40). The building was built in 691/1291, the same year as the Sunbul Bābā lodge, and faces it from across the main square (*maidān*). The four-line inscription begins with a line of Ḥadīth (sayings of the Prophet) and then states that

the construction of this *buqʿa*, called the house of faith and work, has been ordered in the days of the empire of the august sultan Ghiyāth al-Dunyā wa al-Dīn Abu al-Fath Masʿūd, son of Kay-Kāʾūs, may God eternalize his empire, and in the days of the empire of the magnificent *malika* . . . Azmat al-Dunyā wa al-Dīn Seljukī

Khwand, daughter of Qilij Arslān, may God support her kingdom, by the weak slave, in need of the mercy of God, Khalif, son of Sulaymān, may God accept this from him, in the year 691.

The inscription from the Khalif Ghāzī lodge, with its careful elaboration of the patronymic of the female princess, stands out for two reasons. First, it proclaims that this woman, who was the daughter of Qilij Arslān and had the title Seljuk *malika*, was linked through her father to the house of the Seljuks. This building marks the first time in Tokat that the exact details of the woman's linkage to the house of the Seljuks were provided in an inscription. Second, with its introductory line of Ḥadīth and statement of foundation, the inscription is unusually long. Such a long, multinamed inscription typically signaled changes in rule to residents of the city of Tokat. For example, one of the most important monuments of the city was the bridge at its entrance, built in 648/1250 to mark the end of a fierce dispute between three Seljuk sultans (fig. 41). The bridge gives the full name and title of each of the sultans as well as the *amīr* who put an end to their fighting. This suggests that, in addition to its length, the Khalif Ghāzī inscription's claims of social prestige based on bloodlines set it apart from the other two Sufi-lodge inscriptions: Seljukī Khātūn's demonstrable royal connections made a final and definitive statement about who had regional rights over Tokat. These inscriptions show how important it was for Seljukī Khātūn to be affiliated with the Seljuk house than with her father, Muʿīn al-Dīn. Ironically, Seljukī Khātūn's real claim to the region came from what was left unnamed in the inscription, her marital connections to the Mongols, who by this time were enforcing their rule over Tokat.

The changes in the format of the building inscriptions are one of the best indications of the sharing of rule in Tokat. In the last decades of the thirteenth century, these semiofficial public texts were considerably lengthened by the inclusion of the names of more than one ruler. The appearance of women's names after those of the reigning sultans in building inscriptions suggests changes in the role of women in dynastic and regional politics. The women in Tokat's inscriptions were meant to be perceived very differently from such earlier Seljuk women as Māhperī Khātūn and Turan Malik, building patrons who supported architecture during a period when the house of Seljuk was relatively strong. In the last quarter of the thirteenth century, Anatolians discerned no single central ruling dynasty. At least in Tokat, public allegiances were constantly shifting between the ambitious Muʿīn al-Dīn and the Seljuks. Although there were no public references to Mongol rule, this period marked a heightened level of Mongol control over Tokat. All of the women named in Tokat's inscriptions were associated with two power groups, the Seljuk dynasty and either the Mongols or Muʿīn al-Dīn. During these decades, power was in the hands of various representatives from these three groups, a state of affairs that has led to the designation of this period as the time of *amīrs*. Although *amīrs* and local officials like Muʿīn al-Dīn had regional control, they could not provide the legitimizing stamp of a dynasty. In this scenario, their names were less important than their actions. The value of royal women's names, however, was at a premium, and the inscriptions from Tokat show how women (or their names) could serve as public symbols of political unity.

To understand the particular visual significance of writing women's names and their titles on Sufi buildings, we need to think about these names as visible objects meant to be seen by an urban public. Building inscriptions were a public text with a number of properties that separated it from other texts and affected the manner in which

it was read. According to Michael Rogers, building inscriptions were semiofficial documents requiring permission of the *qāḍī* (judge).[21] With the authority of religious leaders behind them, inscriptions conveyed important information to the urban public.[22] Collectively, the three lodge inscriptions formed an important urban text whose functions went beyond the semantic purpose of explaining who supported what structure in what year.[23] On one level, the inclusion of women's names could be read as an indication of newly formed dynastic and political alliances. Their uncharacteristic length and the allusion to several figures of local and dynastic stature would have alerted the public reader to the existence of a new settlement between rival factions and the establishment of joint rule over the area. At the same time, inscriptions such as the ones found on the Khalif Ghāzī and Sunbul Bābā lodges included information about how these alignments were formed. Thus, they became genealogical proofs or reminders of family trees.

Returning to Muʿīn al-Dīn's daughter and the Sunbul Bābā lodge, it is clear that the lodge's inscription heralded important changes in political controls that reflect the dynastic ambitions of Muʿīn al-Dīn's family in Tokat. Muʿīn al-Dīn's name had been associated with the city of Tokat since he was given control over it in the mid-thirteenth century. When the Ilkhānids took direct control of the city, Muʿīn al-Dīn formed an alliance that eventually cost him his life. After his death, in 1277, Muʿīn al-Dīn's sons financed building projects closer to the Black Sea, while narrative accounts report that his daughter remained in the city where he had sought rule. Although Muʿīn al-Dīn's family's economic and political interests in Tokat were temporarily displaced, his daughter served as a reminder of Muʿīn al-Dīn's family ties to the region.

THE LITERATURE

References to Muʿīn al-Dīn's daughter and other women in Sufi literature are problematic, for the representation of characters and events in sources like hagiographies, which are meant to celebrate saintly figures, must always strike a balance between the accurate portrayal of historical events and the promotion of a value system based on charismatic leaders of Sufi groups.[24] Moreover, these texts were used to construct these groups, and as such they paid particular attention to the groups' patrons. Often, elite women are mentioned in these sources because of their connections to ruling houses and their roles as guarantors of familial lines: that is, in their capacity as mothers, as producers of sons and, in their capacity as wives, as symbols of accord between political lines. Thus their agency receives some prominence in the historical sources, though it is usually restricted to their biological roles as mothers and wives and does not include control over the dispersion of property and resources.[25]

Hagiographic descriptions of the daughter of Muʿīn al-Dīn are either accompanied by a series of royal titles or, like the inscriptions, contextualized to stress her royal and elite status while obscuring her exact name.[26] In one anecdote about the arrival of Rūmī's spiritual successor, Ulu ʿĀrif Çelebi, in Tokat, the biographer states that the nobles of the city, the wives of the sultan, and the daughter of Muʿīn al-Dīn received him with great honors and appointed him head of a convent that Muʿīn al-Dīn's daughter supported. At the investiture ceremony, Muʿīn al-Dīn's daughter made a speech to the effect that Ulu ʿĀrif deserved a special place in the lodge.[27] Although at first glance this anecdote would suggest that Muʿīn al-Dīn's daughter was an important agent in the development and maintenance of the lodge, a supporting *waqf* endowment drawn up in 725/1325 omits any mention of her.[28] The real patron was her freed slave Ḥājjī Sunbul,

which explains the building's popular title, the Sunbul Bābā lodge.

Mu'īn al-Dīn's daughter, to the extent that she appears in Rūmī's biography, is mentioned not as an architectural patron but as an associate of royal or pious women. These anecdotes about her are directly related to issues of political and spiritual succession. The inclusion of her name in Rūmī's biography, of course, was, by itself, sufficient to mark her as a pious woman, and indeed a reader of the biography would discover that she was pious, did support a dervish lodge in Tokat, and was considered fit company for local royal women. But that reader would find it almost impossible to learn anything more about her, for example, whether Mu'īn al-Dīn had one daughter or two. More significantly, however, the reader would glean a chain of associations that proceeded from Rūmī to his grandson and his grandson's relation to Mu'īn al-Dīn's daughter, to Mu'īn al-Dīn's daughter and the Sufi lodge in Tokat, and finally back to Rūmī. In this way, the biographer used these names and personages to claim contemporary buildings as buildings for the disciples of Rūmī. He would have done this order of a grandson—one who supported more dervish lodges than any other leader—while perhaps bearing in mind the awful fate of Mu'īn al-Dīn. Although Mu'īn al-Dīn's mark on Tokat had been hidden behind our Ṣafwat al-Dunyā wa al-Dīn, it was recovered in the mid-fourteenth century, when the Mongols were gone and the descendants of Mu'īn al-Dīn could remember his accomplishments with pride. This may explain why Rūmī's biographer was able to attribute so many more buildings to Mu'īn al-Dīn than any epigraphic or documentary evidence could suggest.

CONCLUSION

I conclude this chapter with some general observations about understanding gender and agency in medieval Anatolia. I have argued that titulature and epigraphy identify women as critical parts within a more extensive, complex network of political and dynastic affiliations. Naming, however, was not necessarily a sign of power. Indeed, many of the women who are mentioned are deprived of personal names. While this can be true of men as well, the particular anonymity of women, brought out so clearly in the case of Princess Ṣafwat al-Dunyā wa al-Dīn in both the city spaces of Tokat and the literary spaces of Rūmī's biography, could serve to enhance the royal associations of a father's dynastic claims.

A survey of pious foundations (waqfīyas), which would reveal the control of the most prominent source of power, property, shows that they make relatively few references to women. Likewise, women are rarely mentioned as custodians of property and/or managers of pious foundations. Therefore, the frequent appearance of women's names in building inscriptions cannot always be attributable to their having been patrons.

Because of the way that references to these women were constructed, their names became special objects with important legitimizing functions. In the case of Ṣafwat al-Dunyā wa al-Dīn, most modern historians have believed her to be the patron of the Sunbul Bābā lodge, although she was not; more likely, she played a minimal role in the building's construction and endowment. But the use of her name in the foundation inscription on the building did provide a genealogical bridge between past and present and thus connected the lodge with the venerable Rūmī.

Islamization and Building Conversion

EPIC HEROES AFTER THE BĀBĀ RASŪL REVOLT

This study has examined one aspect of the complex relationship between the visual world and religious authority; the previous chapters have considered how buildings aid in projecting this authority through time. The focus on the future and on future generations was also very much in the minds of the people considered in this study. To underline how buildings function within an idealized future, I would like to end with a story about a family and a building. The story is found in the *Dānishmendnāme*, the Anatolian Turkish epic of the Muslim hero Malik Dānishmend.[1]

Although the story takes place in post-Manzikert (1071) Anatolia, it was not written down until 1279, a period described by Cemal Kafadar as a time of reconciliation between the house of the Seljuks and Türkmen warriors.[2] It was also a time of increased Mongol control following the trial and death of Muʿīn al-Dīn. The first extant written version was copied by an Amīr ʿAlī in Tokat around the year 1315.[3]

The story of the *Dānishmendnāme* is set in two locations: the region around Amasya and that around Malatya. These areas had been the main strongholds of the Dānishmendid empire and were the two primary sites of the Bābā Rasūl revolt (see fig. 4).[4] The action of the story follows that of the revolt, as it begins in Malatya and ends in Amasya.

THE TEXT

The *Dānishmendnāme* falls within the parameters of Ghāzī literature in that it is a story about a warrior who fights to expand the borders of the Islamic world and to gain converts. The story opens with an account of the inhabitants of the city of Malatya, who have just buried Sayyid Baṭṭāl Ghāzī and are gathered in the Friday mosque in desperate search of another *ghāzī* warrior.[5] As they search for the aunts and cousins of the other *ghāzīs* who had brought fame to their city, a messenger comes and tells them about a strong, intelligent, and wise man named Malik Dānishmend, an offspring of the brother of Sayyid Baṭṭāl Ghāzī, one of the early Arab fighters against the Byzantines (eighth century).[6] In addition to an impressive lineage that ties him to the local Anatolian landscape, Malik Dānishmend also has had a vision of the Prophet and bears presents from the caliph in Baghdad, all signs of legitimation to his contemporaries.

The people of Malatya respond to this messenger by sending an emissary to bring Malik Dānishmend back to their city. Successful in this venture, they are then able to store his caliphal honors while Dānishmend fights the infidels of Rūm.

In the first part of his journey to expand the borders of Islam, Dānishmend encounters a non-Muslim young man named Artuḥī.[7] Although the encounter begins on a hostile note, Artuḥī and Dānishmend become friends and sit down to

exchange their stories. Artuḥī tells of the trials and tribulations of his quest to win the hand of Efru-miye, the daughter of the Christian governor of Amasya, while Dānishmend speaks of his mission to fight for Islam. Out of his respect for his new friend, Artuḥī converts to Islam, swearing to aid Dānishmend in his battles for the faith if Dānish-mend can help him win the hand of Efrumiye.

The major portion of the text takes the reader through various battles and the joining of Artuḥī and Efrumiye. Malik Dānishmend and his two companions are successful in spreading the faith. They take Amasya from Efrumiye's wicked father. Efrumiye and Artuḥī name their child Khalif Ghāzī, and in a final act of conquest, the church of Efrumiye's father is converted into the Khalif Ghāzī Madrasa.`

USES OF ARCHITECTURE

Within the *Dānishmendnāme*, acts of architec-tural transformation and rebuilding punctuate the conquest of each city and the conversion of its populace to Islam. At each major point in the story—from the Friday mosque in Malatya to the convent of the ascetic Harkil—the reader is told detailed information about local buildings. Such details allow the reader to place the story of the battles of Malik Dānishmend Ghāzī against Byzantine rulers and infidels into a local landscape.

Religious buildings also play a significant role in marking divisions in the sequence of events in the *Dānishmendnāme*. The three sections of the text—the introduction of Dānishmend and his meeting with Artuḥī; the interconnected battles, which form the body of the text; and the conclu-sion of the work, which reintegrates Dānishmend into a long list of past and future heroes of Islam—are marked by detailed descriptions of religious buildings. A large church enclosed within a *ribāṭ* marks the passage from the first section to the

second. Inside the church, Artuḥī speaks to an Armenian monk named Harkil, who, after recog-nizing the greatness of Malik Dānishmend and Islam, tells Artuḥī how to win Efrumiye. The bat-tles that they wage against Efrumiye's father, the governor of Amasya, form the actions of the epic and the body of the text. Thus, this building is the frame for a scene that represents the true begin-ning of the epic, and reminds the reader that a new and different sequence will occur. The reader is brought to the end of the last battle and the beginning of a new sequence by the transforma-tion of Efrumiye's father's church into the Khalif Ghāzī Madrasa by Khalif Ghāzī, the son of Artuḥī and Efrumiye. This transformation marks the end of the epic of the *Dānishmendnāme* and the end of the time of the Dānishmendids.

Within the two stories that constitute the *Dānishmendnāme*—Dānishmend Ghāzī's battles of conquest and conversion and Artuḥī's attempts to win the love of Efrumiye, the destruction and rebuilding of Efrumiye's father's church and its transformation into the Khalif Ghāzī Madrasa functions also as the resolution of the infatuation that begins the first part of the story. The conquest of Efrumiye and Amasya are conflated with the birth of Khalif Ghāzī, who continues the con-quests of Artuḥī and Dānishmend Ghāzī. The conversion of the church of Khalif Ghāzī's grand-father, the Christian governor who did so much to prevent his parents' marriage, epitomizes the Mus-lim conquest of Amasya. In this way, both Khalif Ghāzī's life and his *madrasa* become emblematic of the union achieved against the wishes and power of the Christian enemy of the great Malik Dānishmend.

The *Dānishmendnāme* is, like many other medieval Anatolian epics, a tale that organizes its sequence of events around a basic theme of acts of conquest and conversion, within which past, pres-ent, and future time conflate. As oral tales these

epics praise past and present heroes at the same time that they speak to the larger purpose of praising Islam and its rulers.[9] In the case of the *Dānishmendnāme*, each successful conquest and conversion achieved by Malik Dānishmend and his fellow warriors argues for the superiority and righteousness of both the Dānishmendids and a distinct line of Islamic Ghāzī rulers who fought against the Byzantines. When the Seljuks commissioned a written copy of the text, the line beginning with Sayyid Baṭṭāl Ghāzī was extended beyond the Dānishmendids to end with the Seljuks.[10]

The *Dānishmendnāme* forms a history that both completes activities of the past, the battles begun by Sayyid Baṭṭāl through the conquests of Malik Dānishmend, and prefigures the future by its link to present heroes. The conclusion of the *Dānishmendnāme* mentions a long list of pre-Islamic Persian rulers. These rulers are embedded within a cycle of life and death that compares life to a caravansaray stop, where people come and go without cease. Having the 1315 edition end with the Seljuks, the dynasty that conquered the Dānishmendids and also patronized the first written copy of the *Dānishmendnāme*, makes the Seljuks the dynasty that fulfilled Sayyid Baṭṭāl's destiny and implies they would be the ones to carry this legacy into the future.

Within this epic, the Khalif Ghāzī Madrasa signals both the beginning and completion of the epic, serving as the textual device that links the past, the Dānishmendid warriors, with the future Seljuk leaders whose rule is made legitimate by this link. In this way, the *Dānishmendnāme* shows how the transformation of the Khalif Ghāzī Madrasa, from a church to a *madrasa*, is meant to be read. Likewise, the *Dānishmendnāme*'s explanations for the reconfiguration of the physical space of a Muslim city ultimately affected how and why both the building and the manuscript were funded and embellished in later periods.

BUILDING CONVERSION IN ISLAMIC STUDIES

Unfortunately, it is rare to find a detailed context for every act of building conversion. In addition to the paucity of certain kinds of source materials, most explanations for the transformation of urban sites in the Islamic context have concentrated on major buildings such as mosques and *madrasas*. More important, modern scholars generally have presented building conversion as a single dramatic act of construction expressing the power and legitimacy of a new religious and dynastic order.[11] Furthermore, they have largely argued that this architectural program signaled elite dominance to largely undifferentiated masses rendered subservient by military and economic reversals. This framework fails to ask basic questions about the composition of these audiences and how various segments of the population might have reacted to the conversion of their cities. It thus ignores the active and dynamic nature of these audiences. Finally, these studies understand religious conversion as a complete and final act and avoid dealing with the fluid nature of religious belief in some parts of the medieval world.

In the scholarship of the architecture of pre-Ottoman Anatolia, few detailed accounts exist of the reuse of Byzantine structures.[12] Monographs on Turkish art usually ignore the implications of the reuse of earlier buildings and building materials, tending to dismiss this reuse as motivated only by utilitarian concerns. With few exceptions, classicists and Byzantine historians searching only for the remains of antiquity have not tried to explain why and how certain materials were reused by later patrons. This makes it difficult for art historians to study trends in the reuse of building materials and establish why some materials were reworked while others were given places of honor, such as around main portals or the tombs of holy men. Yet the reuse of former building materials

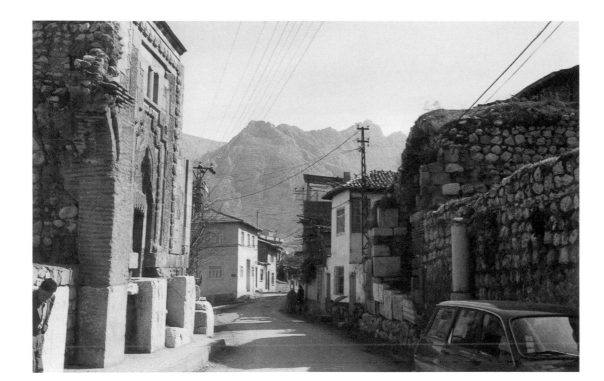

FIGURE 42
Amasya, Khalif Ghāzī Madrasa
and lodge.

was an important component a Seljuk style of architecture that took into account the mixed audiences of central Anatolia.

Remnants of the Khalif Ghāzī Madrasa complex can still be seen in a neighborhood on the southwestern border of the city of Amasya, outside the original walls, across from the citadel and the Pontic tombs. The building structure has suffered enormously from Amasya's large number of earthquakes. Although today's Khalif Ghāzī complex is little more than an octagonal tomb with a pyramid-shaped roof resting on an earlier foundation, remnants of the adjoining *madrasa* could still be seen in the early twentieth century, attached to the western end of the tomb. The façade of the *madrasa* contained a series of arcades. These arcades, part of the previous Byzantine church, were filled in with rubble and covered, either with stucco or another material, to form the façade of the Khalif Ghāzī Madrasa.[13] A third building, located on the southern side of the tomb, is also

connected to the Khalif Ghāzī Madrasa and linked to the Khānqāh Mesʿūdī, a dervish lodge understood by some authors as an important site of the so-called Bābā Rasūl revolt (fig. 42).[14]

The Khalif Ghāzī complex presents us with some prominent and perplexing examples of the reuse of buildings and building materials. It was built on a Christian site, within a church structure. A number of notable remnants are displayed or incorporated in the structure. The Khalif Ghāzī tomb, for example, contains an ancient sarcophagus, believed to mark the site of the body of Khalif Ghāzī. It is decorated with, among other things, Dionysian images and has been dated to the early Christian period.[15] Furthermore, travelers from the nineteenth and early twentieth centuries noted three slabs of white marble, fragments of an architrave, deeply inscribed with Greek letters, forming the portal of the *madrasa*.[16]

The choice to use these inscribed marble fragments in a prominent location over the entrance to

the *madrasa*, especially when later juxtaposed with a building inscription in Arabic script, is significant. For it was well within the range of the Seljuk craftsmen to have covered these remnants, making the Greek script indistinguishable. However, according to Hamilton and Cumont, these craftsmen instead worked the pieces of architrave, along with other remnants of antique buildings, such as architraves, friezes, and cornices, into a display on the façade. The Greek inscriptions were part of a sequence of inscriptions that formed a single text or decree. A fourth part of the inscription was displayed on the walls of the citadel, as part of a doorway. Broken up, the Greek inscription on the Khalif Ghāzī complex had a different semantic content than the Arabic one, which stated that the patron had endowed this blessed *madrasa* in the year 606/1209–10. However, it is important to look beyond the semantic message of the inscription, since a large part of the population of medieval Amasya was semiliterate and read neither Arabic nor Greek. Read one way, the Arabic and Greek inscriptions were signs that designated ownership. In the public spaces of Amasya, Arabic was used not only for foundation inscriptions but to provide details of sales of various sections of the city. Juxtaposed with Greek writing, the inscriptions addressed a larger audience, detailing a genealogy of ownership.

According to the building inscription, the *madrasa* was built by the *amīr* Mujahid al Mubariz al-Dīn Khalif Alp ibn Ṭūsī in the reign of the Seljuk sultan Kaykhusraw.[17] Khalif Alp, the patron of the building, was not Khalif Ghāzī, child of a Dānishmendid warrior, but a Seljuk *amīr* descended from property owners from the southwestern part of the city.[18] However, although he was not the man buried in the tomb, he did fulfill the promise prefigured by Khalif Ghāzī. As a warrior of the Seljuks he was, according to a building foundation deed of 1222, able to support the *madrasa* with Christian properties. A large portion of the funds were used to produce a select group of Hanafī scholars.[19]

THE KHALIF GHĀZĪ COMPLEX AND THE BĀBĀ RASŪL REVOLT

Less than twenty years after this endowment was made, Amasya was seized by the Bābā Rasūl revolt. For a time, the city was controlled by the followers of Bābā Ilyās, who, according to Hüseyin Hüsameddin, spread his propaganda from the Khānqāh Mesʿūdī, the dervish lodge that may have been attached to the Khalif Ghāzī Madrasa.

Shortly after the revolt was quashed, visible signs of the relationship between Christians and Türkmens were removed from the city. A second church in the southwestern end of Amasya was converted into a mosque-*madrasa*. Efforts were once again made to disguise the cultural contradictions encountered by every resident of the city and, though not parallel, also presented by the urban topography. The leader of the revolt was killed and hung from the tower of the citadel, where all could see his body. The Seljuk sultan patronized a written copy of the *Dānishmendnāme* to inscribe a Türkmen hero into a long line of pre-Islamic rulers and close the distance between the Türkmens, who formed the majority of the rebels, and the Seljuks. The book reasserted the link between the Dānishmendids and Seljuks by reemphasizing the relationship between Khalif Ghāzī and the *amīr* buried in his tomb.

According to a later building foundation deed, the dervish lodge attached to the Khalif Ghāzī Madrasa restricted its membership to the followers of Jalāl al-Dīn Rūmī, a man known for his hostility toward Türkmens. Furthermore, this was not the last of the changes that would be made in its reli-

gious affiliations, for these continued to be altered through the tangled and contradictory histories of medieval Anatolia.

Although legends such as the *Dānishmendnāme* helped turn buildings into pilgrimage sites, these were not the only causes. The details of how Sivas, Tokat, and Amasya became pilgrimage centers on the north-south route illustrate much about Sufism and religious transformation in Anatolia. Prior to the Muslim conquest, there were a number of Saint George shrines and other Christian sites on the north-south route. By the time Ibn Baṭṭūṭa traveled along this route in the fourteenth century, these shrines had been rededicated to the semi-legendary Muslim prophet Khiḍr.[20] There was a Khiḍr mountain in Merzifon, a Khiḍr Ilyas dervish lodge in Amasya, a Khidirlik bridge in Tokat, and a column named after Khiḍr in the main mosque of Sivas.[21] The process by which Saint George and other Christians became associated with and were eventually replaced by Khiḍr and Khiḍr variants was fueled by the accounts of dervishes whose stories and legends filled the *manāqibs* of the period. For example, Khiḍr plays a large role in Elwan Çelebi's *manāqib*. The dervishes associated with his tomb also describe the site as a place Khiḍr visited.[22] As important, these Khiḍr sites in Sivas, Tokat, and Amasya were easily linked to Khiḍr sites on the southern end of the route in Syria and Iraq.

After the Seljuk defeat at Köse Dağ, two *amīrs* who were able to form quasi-independent dynasties, Fakhr al-Dīn ʿAlī and Muʿīn al-Dīn Pervāne, altered the landscape under their control to secure their rule. These two *amīrs* and their offspring supported building activity along the routes through their lands. Fakhr al-Dīn ʿAlī, to appeal to a new political base of Christians and Türkmens, built along the former eastern border of the Seljuk regime, while Muʿīn al-Dīn built in the north.[23]

Through their efforts, new routes were developed from Sinope through Sivas, Tokat, and Amasya to Kayseri, Konya, and out toward the Mediterranean ports or Syria.

Another pilgrimage attraction in Sivas was the rediscovered graves of early Arab warriors. These graves were rediscovered on or near famous Christian monasteries, further encouraging interchanges between Christians and Muslims. In the early thirteenth century, the grave of Sayyid Baṭṭāl was "discovered" by the Seljuk sultan ʿAlāʾ al-Dīn, who had built a "castle of the Messiah" six miles south of Eskişehir, after the completion of which his mother had dreamed that Sayyid Baṭṭāl was buried in the building. The site of this castle lies on the pilgrimage route from Constantinople to Mecca and must have attracted large numbers of pilgrims. According to Hasluck, it was built on a Christian holy site and incorporated ruins of a Byzantine monastery.[24] Al-Baṭṭāl was reputed to have taken part in the Arab raids of the eighth century and was killed at Afyon Kara Hisar. He was popularized during Seljuk times through a text about his life that exalted another Arab warrior named ʿAbd al-Wahhāb. In 1325 Ahmed ibn Cakirhan built a tomb dedicated to ʿAbd al-Wahhāb two kilometers east of Sivas, in what could be construed as an effort to attract pilgrims from further east.

Thirteenth- and fourteenth-century dervish lodges endowed in Sivas, Tokat, and Amasya provided sites for all of the different audiences traveling along pilgrimage, migration, and caravan routes. Building up these cities moved routes farther west and north. More important, these dervish lodges and the cities in which they were founded supported reformulated communities drawn from these groups of travelers; they were also part of a larger phenomenon in which the base of political support shifted to an urban and immigrant ele-

ment that had once been successfully excluded from government. In this way, dervish lodges in Sivas, Tokat, and Amasya helped to redefine and present a historical past that forged a cultural alignment between Mongols, Turkish tribes, Christians, and dervish orders.

Within the visual topography of Sivas, Tokat, and Amasya, dervish lodges served a dual function, one within the city and one tied to other cities connected by the trade and immigration routes. Thirteenth-century dervishes succeeded in doing what scholars connected with *madrasas* could not: they successfully assimilated different forms of religious expression and formed them into a new ideological system that allowed for a plurality of shared beliefs and practices. The inclusion and coexistence of different beliefs, especially Christian ones, was in dramatic contrast to the practices of the *madrasa*. This symbolic system was represented by a specific treatment of building remnants and a shared visual vocabulary that sought to displace and separate itself from the *madrasa*.

Epilogue

Come, come again.
Come again, whatever you are.
If you are an infidel, worshiper of fire or of idols,
come again.
Our court is not the threshold of despair.
If you have broken your repentance vows a hundred times, come again.
— JALĀL AL-DĪN RŪMĪ[1]

I end this study with a passage displayed on the wall of Rūmī's tomb in Konya. Although its message of welcome is evident in the English translation, within the original Persian text there are a number of allusions to wandering and return. The word *bāz*, which begins the passage, is often, as here, translated as "to come back again and again." Yet, the word also means "falcon," and its inclusion here suggests that, like the falcon, those who have wandered from their source can find their way home. In the passage, the place designated as this home is described as the threshold of a court, indicated by the word *dargāh*, which, although it usually means "court" or "threshold," is also used to designate a dervish lodge.

Writing from the United States in the year 2002, it seems impossible to understand how these meanings translated into the experience of the medieval Anatolian city, where so many people had neither the context nor the content to comprehend their new homes. In *Recognizing Islam*, Michael Gilsenan describes the sense of moving through a new city, with "spaces that others define in ways that the wanderer only dimly intuits and which seem sometimes frightening,

sometimes so full as to be overwhelming."[2] As he points out, some of the strength of this experience comes from wondering both how and where to walk. I wrote this book with the thoughts of all who faced relocation to a new city where the organization of space was not only unknown to them but in a state of flux. This book is modeled on their journeys and attempts to understand what it might have meant for them to find a place where they could reinvent their world.

The cities that these Sufis inhabited presented different faces to each traveler. All we need do is compare the accounts of Sivas written by two travelers from the first half of the fourteenth century to understand the sentiment behind Gilsenan's words. Ibn Baṭṭūṭa, who was met at the gates of the city by two *akhī* groups fighting to offer him shelter, wrote fondly of Sivas. Whereas when al-Qazwīnī visited, he wrote of a city overrun by Türkmens and sin, a city in which he encountered a *muḥtasib* (market inspector) drinking wine.[3]

For those who settled in these cities and found a community, the process by which they founded their new homes was tied up with their roles as interpreters of these homes. Their imprint on

these cities is expressed throughout hagiographies and other written works. Rūmī's biographer begins his account of Rūmī and his circle with a description of Rūmī's father's inspection of Konya's new fortifications. In his role as interpreter of forms, Rūmī's father tempered his praise for the strength of the walls by noting that they were little protection against "the sighs and moans of the oppressed, which leap a thousand walls." He finished his tour by advising the sultan that "the real stronghold was the blessing of his subjects."[4]

After 1243, when the Seljuks of Rūm lost the Battle of Köse Dağ to the Mongols, political authority was increasingly claimed by local rulers who needed to gain the blessing of their subjects through alliances with Sufi *shaikhs*. To many of the Sufis who relocated to Anatolia, the *madrasa* represented a worldliness that stood in the way of God. In challenging conventional religious practices and the buildings associated with them, Rūmī even wrote that "unless the *madrasas* and minarets perish, the wandering dervish can reach no state he can cherish."[5] Although there is some danger in interpreting Sufi poetry too literally, there is little question that Sufis were developing new ideas about spaces for religious thought and practice.

The location of these dervish lodges was dramatically different from that before 1240, when they had been found in small villages or on roads between cities. The placement and orientation of these dervish lodges altered the organization of space within Sivas, Tokat, and Amasya. Before 1240, the ruling dynasties had supported a spatial order that divided the urban core into two separate areas. The first area was defined by the Muslim ruling dynasty, which confined itself to the environs of the citadel, isolating itself from the subject non-Muslim and non-Turkish population. The second area, the remainder of the urban core, inhabited by the non-Muslim and non-Turkish

population, was, in turn, divided into separate communities that could be viewed by the Dānishmendid or Seljuk rulers from a safe distance. Through this placement of buildings, the governing elite maintained and elaborated a physical distance of itself from the heterogeneous market district and population. Looked at another way, the support of institutions, like mosques and *madrasas*, in which the language of instruction and worship was alien to the local populace, reinforced the social and political distance between the local populace and the governing elite. With some exceptions, mosques and *madrasas* were located only in the citadel area. In the rare instances when Seljuk patrons built dervish lodges before 1240, they located them next to such official constructions as citadels, *madrasas*, or mosques. Placed in such proximity to the official constructions, the single dervish lodges built in Sivas and Tokat became as elite and selective as mosques or *madrasas*.

Mixing the activities of dervish lodges with the rhythms of city life brought a new audience to the lodges, people who may not have set out looking for these buildings but were drawn to them because of what they saw and heard. Yet, even though dervish lodges were accessible structures, residents and travelers of medieval Anatolia did not share a standard definition of their function and meaning. As I have argued, there were too many groups with too many differing views of these buildings for such a definition to be possible.

In thirteenth- and fourteenth-century Anatolia, various groups tried to control and define these buildings against the backdrop of a dramatically changing world. For patrons, dervish lodges functioned as pious institutions that could be registered as *waqf*. As such, they were a viable form of investment. Because the initial investment required for a dervish lodge could be less than that for other pious buildings, lodges represented one of the

cheapest of protected endowments. Besides these financial incentives, patrons also wanted to be associated with the prestige and piety of such popular charismatic figures as Jalāl al-Dīn Rūmī and Fakhr al-Dīn ʿIrāqī. Through the building of dervish lodges, patrons created permanent monuments to their close relationship with Sufi *shaikhs*.

The story of these patrons was only part of the process that made these buildings so significant to the history of late Seljuk and early Beylik Anatolia. The support, function, meaning, and location of these lodges were crucial in establishing hierarchies of authority in the rapidly changing cities of the period, and the formal and institutional methods through which these lodges communicated that authority were integral to the period's spiritual revival. Not only did these buildings become the homes to some of the greatest leaders in Sufi thought, but in these institutions many of the pivotal works of Sufi philosophy and literature were written.

The growth of various structures for Sufis was, like many Sufi practices, an innovation. As buildings and institutions, medieval dervish lodges had little or no connection to what had been understood as a legally established pious institution. For this reason, communities centered around individual dervishes, dynastic groups, and legal formations all used a variety of terms for designating and describing individual and generic dervish lodges. All these things—the multiple terminology and the controversial status—meant that dervish lodges were in many ways incomplete. As buildings they stood out in city spaces as orphan children bearing long and detailed instructions about their use and care.

The lack of intellectual and legal categories for dervish lodges found its material equivalent in the very structure of these buildings. Unlike other buildings, in which the lines between public and private were distinctly drawn, medieval Anatolian dervish lodges were distinguished by a number of semiopen spaces. Qur'ān chanters sat by large tomb windows that opened onto main thoroughfares allowing access into the tomb. On market days, the outside of these buildings became an extension of the interior space in offering food and other charity.[6] Such structural flexibility may be one of the reasons many of the buildings in this study continued to be adapted and used well into the nineteenth century.

The dervish lodges of Sivas, Tokat, and Amasya became central sites in community formation both because of this structural and institutional flexibility and in reaction to it. In these cities the Bābā Rasūl revolt became one of the defining moments in the history of dervish lodges and, concurrently, Türkmen-Seljuk-Christian relations. As a brief history of Sivas, Tokat, and Amasya reveals, the revolt initiated a cycle of events that led to a marked increase in the number and importance of dervish lodges in these cities. The revolt also added a new definition to dervish lodges as sites of political revolt.

In disparate accounts of the revolt, Bābā Rasūl was described as everything from a Christianized Seljuk to a Türkmen from Kefersud who allied with an ʿulamāʾ from Khurāsān. Although this range of descriptions may at first appear perplexing, it reflects the many-sided face of religious revolt in Anatolia. The only consistency in these accounts is their description of the antagonism toward the Seljuks.

This study problematizes the widely accepted belief that dervish lodges worked in acculturating immigrants and non-Muslim residents to the beliefs and codes of a Muslim Turkish state. In contrast, it places dervish-lodge communities outside of any central government or religious structure and focuses on the centrality of these buildings in community formation. This approach also challenges what has been understood about

the fast pace of Islamization and Turkification in Anatolia. We actually know very little about how or even whether large-scale conversions took place at this time. This does not mean, however, that Anatolia remained unchanged from 1240 to 1350. The increased pace of Turkish Muslim immigration to Anatolia ushered in a period of massive social and political change that, among other things, resulted in new mixes of Christians and Muslims and an increasing concern with religious boundaries.

Sufism flourished in the dynamic intellectual environment of medieval Anatolia. At the same time, larger developments in Sufism occurred during this period. Although Sufism has always included individual travelers, it was not until the medieval period that the mystic path was codified into a set of practices and rituals followed by communal groupings around mystic leaders. During the period of this study, these communities began to write manuals and hagiographies describing steps, stages, and notable travelers along the mystic path. The hagiographies written in thirteenth- and fourteenth-century Anatolia incorporated a number of Sufi lodges and other building sites into their descriptions of the mystic path, creating a sacred landscape in which buildings served as places where group identities were constructed and communicated. By doing this, these writers set up dialogues between written texts and buildings. These dialogues were crucial to the formation of Sufi communities, which coalesced around the texts and interpretations of Sufi saints. One crucial element that held these communities together was a shared understanding of the landscape in which the saints and their disciples performed their great deeds. In providing these communities with a common vision of the landscape around them, the writers of these texts ensured that a specific audience was constantly using that same landscape to reenact the history and destiny of a growing number of followers.

Preface

1. Gaston Bachelard, *The Poetics of Space*, trans. Maria Jolas (Boston: Beacon Press, 1969), 15.

2. For an excellent summary of the "Rūmī growth industry" in the United States, see Franklin D. Lewis, *Rumi: Past and Present, East and West: The Life, Teachings, and Poetry of Jalâl al-Din Rumi* (Oxford: Oneworld, 2000), pt. 5.

3. Şahabettin Uzluk, *Mevlevilikte resim resimde mevleviler* (Ankara: Türk Tarih Kurumu, 1957), chap. 1.

Introduction

1. Ḥājjī Bektāsh, *Vilâyet-Nâme: Manâkıb-ı Hünkâr Hacı Bektâş-ı Velî*, with commentary and modern Turkish translation by A. Gölpınarlı (Istanbul: Inkilâp Kitabevi, 1958), 55. This passage was translated from the German by Speros Vryonis Jr., *The Decline of Medieval Hellenism in Asia Minor and the Process of Islamization from the Eleventh Through the Fifteenth Century* (Berkeley and Los Angeles: University of California Press, 1971), 377–78 n. 75. For a recent and comprehensive account of the historical life of Ḥājjī Bektāsh, see Irène Mélikoff, *Hadji Bektach: Un mythe et ses avatars: Genèse et évolution du soufisme populaire en Turquie* (Leiden: E. J. Brill, 1998), and John K. Birge, *The Bektashi Order of Dervishes* (Hartford, Conn.: Hartford Seminary, 1937), 40–50.

2. In thirteenth- and fourteenth-century Anatolia, dervish lodges were known by a variety of terms. It was not uncommon for three different terms to be applied to the same building. The inscriptions on dervish lodges identify them variously as *khānqāhs*, *zāwiyas*, *dār al-siyyādas*, *dār al-ṣulaḥā's*, *buqʿas*, or *ʿimāras*. Medieval chroniclers as well as modern scholars, further complicating the issue, use other terms for the same buildings. The Sunbul Bābā dervish lodge in Tokat, for example, is identified as a *dār al-ṣulaḥā'* on its building inscription, a *khānqāh* in the written building foundation, and a *zāwiya* by Albert Gabriel, a leading historian of Turkish Islamic architecture (*Monuments turcs d'Anatolie*, vol. 2 [Paris: E. de Boccard, 1934]). To avoid a maddening and pointless jumble of these overlapping labels, I will subsume them under the term "dervish lodge."

3. Little information exists on the dervish lodges built before 1240. Two are discussed by Aptullah Kuran, "Anatolian-Seljuk Architecture," in *The Art and Architecture of Turkey*, ed. Ekrem Akurgal (New York: Oxford University Press, 1980), 89. On the Ashab al-Kahf dervish lodge, see Mithat Sertoğlu, "Eshab-i Kehf (mağara yaranı) vakıflarına dair orijinal bir belge," *Vakıflar dergisi* 10 (1975): 129–31. On the Yaghi Basan lodge in Sivas, see M. Cevdet, "Sivas darüşşifası vakfiyesi ve tercümesi," *Vakıflar dergisi* 1 (1938): 35–38. For early dervish lodges in Amasya, see Refet Yinanç, "Selçuklu medreselerinden Amasya Halifet Gazi medresesi ve vakıfları," *Vakıflar dergisi* 15 (1982): 5–23. For information about a dervish lodge built in Niksar in 1165, see Osman Turan, *Selçuklular zamanında Türkiye: Siyâsi Tarih Alp Arslan'dan Osman Gazi'ye (1071–1328)*, 5th ed. (Istanbul: Boğaziçi, 1998), 117. There is also an unpublished *waqf* document (defter 581, no. 349) for the building in the Vakıflar Genel Müdürlüğü Archives (Directorate of Waqf Archives) in Ankara.

4. The distance between Sivas and Tokat is 109 kilometers, and from Tokat to Amasya 118 kilometers. According to an eighteenth-century traveler, Joseph Pitton de Tournefort, the distance between these three cities could be covered on horseback in five days: two from Amasya to Tokat and another three from Tokat to Sivas. Joseph Pitton de Tournefort, *Relation d'un voyage du Levant*, pt. 2 (Lyon: Anisson et pou posuel, 1717), 432.

5. In this book, the term "Iran and Central Asia" is used to describe a territory comprising the modern states of Iran, Turkmenistan, Azerbaijan, and Afghanistan.

6. This statement is based on a study of *waqf* registers for these cities.

7. For general information on Seljuk architecture, see Gabriel, *Monuments turcs d'Anatolie*; Oktay Aslanapa, *Turkish Art and Architecture* (New York: Praeger, 1971), 92–161; Ülkü Bates, "Architecture," in *Turkish Art*, ed. Esin Atil (Washington, D.C.: Smithsonian Institution, 1980), 43–76; Kuran, "Anatolian-Seljuk Architecture"; and Metin Sözen, *Anadolu medreseleri, Selçuklu ve Beylikler devri*, 2 vols. (Istanbul: Istanbul Teknik Üniversitesi, 1970). For information on the spatial order of these cities, see İsmail Hakkı Uzunçarşılı, *Kitabeler* (Istanbul: Milli Matbaası, 1927–29), 1–148, and for Sivas and Tokat, Thomas Alexander Sinclair, *Eastern Turkey: An Architectural and Archaeological Survey* (London: Pindar Press, 1989), 2:294–323.

8. I would like to thank Leslie Peirce for her suggestions regarding dervish lodges and authority.

9. Christopher Tilley describes phenomenology as "the understanding and description of things as they are experienced by a subject." For more on this approach, see his *Phenomenology of Landscape: Places,*

Paths, and Monuments (Oxford: Berg, 1994), 11–12.

10. Much of this argument is based on the writing of Michel de Certeau. See especially his *Practice of Everyday Life*, trans. Steven F. Rendall (Berkeley and Los Angeles: University of California Press, 1984), "Spatial Practices," pt. 3, "Walking in the City," and chap. 7, 91–110.

11. Bernard Tschumi, *Architecture and Disjunction* (Cambridge, Mass.: MIT Press, 1994), 19.

12. There is a long history to almost all of these terms. For *khānqāh*, see Jacqueline Chabbi, "Khānkāh," in *Encyclopaedia of Islam*, 2d ed., 4:1025–26. A summary of the use of many of these terms is found in Leonor Fernandes, *The Evolution of a Sufi Institution in Mamluk Egypt: The Khanqah* (Berlin: Klaus Schwarz Verlag, 1988), 10–16. In recent years, the building terminology used for structures associated with mystic practices has received a great deal of attention. For Mamlūk Egypt, in particular, see Th. Emil Homerin, "Saving Muslim Souls: The Khānqāh and the Sufi Duty in Muslim Lands," *Mamlūk Studies Review*, pt. 3 (1999): 59–83; Donald P. Little, "The Nature of Khānqāhs, Ribāts, and Zāwiyas Under the Mamlūks," in *Islamic Studies Presented to Charles J. Adams*, ed. Wael B. Hallaq and Donald P. Little (Leiden: E. J. Brill, 1991), 91–105; Jonathan Berkey, *The Transmission of Knowledge in Medieval Cairo* (Princeton: Princeton University Press, 1992), 130–32; and the author's review of *The Evolution of a Sufi Institution in Mamluk Egypt: The Khankah*, by Leonor Fernandes, *MESA Bulletin*, July 1992.

13. Bruce Lawrence, "Khānagāh," in *Encyclopedia of Religion*, ed. Mircea Eliade (New York: Macmillan, 1987), 8:278–79.

14. On the development of the *samāʿ* in the Mawlawī order, see Tahsin Yazıcı, "Mawlawiyya," in *Encyclopaedia of Islam*, 2d ed., 6:883–86, and Jamal Elias, "Mawlawīyah," in *Oxford Encyclopedia of the Modern Islamic World*, vol. 3, ed. John

L. Esposito (Oxford: Oxford University Press, 1995).

15. J. S. Trimingham points out that a central function of these buildings was to provide institutional support for the evolution of Sufi groups. J. Spencer Trimingham, *The Sufi Orders in Islam*, 2d ed. (Oxford: Oxford University Press, 1998), 5–11; see especially the foreword by John Voll, vii–xvii.

16. For a discussion of the role of saints' tombs as places where "narratives were collected," see Devin DeWeese, "Sacred Places and 'Public' Narratives: The Shrine of Aḥmad Yasavī in Hagiographical Traditions of the Yasavī Ṣūfī Order, 16th–17th Centuries," *Muslim World* 90 (special issue: *Sufi Saints and Shrines in Muslim Society*, ed. Jamal Elias), nos. 3–4 (2000): 356.

17. Halil Berktay, "The Feudalism Debate: The Turkish End," *Journal of Peasant Studies* 14, no. 3 (1987): 320–21 n. 1. Much of this work was centered around the formation of the Ottoman Empire. Mehmet Fuad Köprülü, *Les origines de l'Empire Ottoman* (Paris: Boccard, 1935), 95–120.

18. In 1922, Köprülü wrote a groundbreaking article entitled "Anadolu'da islāmiyet: Türk istilāsından sonra Anadolu tarihi-i dinisine bir nazar ve bu tarihin menbaları" (Islam in Anatolia: A review of the religious history of Anatolia after the Turkish invasion and the sources for this history). An English translation with updated notes and commentary was published by Gary Leiser under the title *Islam in Anatolia After the Turkish Invasion* (Salt Lake City: University of Utah Press, 1993). Köprülü wrote this to criticize Franz Babinger's "Der Islam in Kleinasien: Neue Wege der Islamforschung," *Zeitschrift der Deutschen Morgenlandischen Gesellschaft*, n.s (1922), 126–52.

For a detailed and insightful discussion of Köprülü's argument and the role of Paul Wittek in forming the "Holy War ideology" thesis, see Cemal Kafadar, *Between Two*

Worlds: The Construction of the Ottoman State (London: University of California Press, 1995), xi–xiii and chap. 1.

19. Contemporary Sufi sources, however, often refer to the frequent exchanges between Rūmī and Ṣadr al-Dīn Qunawī. The synthesis of these different traditions was one reason for the great achievements of thirteenth-century Anatolia. For more on this relationship, see Omid Safi, "Did the Two Oceans Meet? Connections and Disconnections Between Ibn al-ʿArabī and Rūmī," *Journal of the Muhyiddin Ibn ʿArabi Society* 26 (1999): 56, 60–64.

20. For an insightful discussion of theories on the ethnic nature of the Ottoman Empire and how that pertained to its success, see Kafadar, *Between Two Worlds*, chap. 1.

21. Ahmet T. Karamustafa, "Early Sufism in Eastern Anatolia," in *Classical Persian Sufism: From Its Origins to Rumi*, ed. Leonard Lewisohn (London: Khaniqahi Nimatullahi, 1993), 177.

22. See Mehmet Fuad Köprülü, *Influence du chamanisme turco-mongol sur les ordres mystiques musulmans* (Istanbul: Mémoires de l'Institut de Turcologie de l'Université de Stanboul, 1929), and idem, *Türk edebiyati'nda ilk mutasavvıflar*, 2d ed. (Ankara: Ankara Üniversitesi, 1966), 183–255.

23. Ömer Lutfi Barkan, "İstila devirlerinin kolonizatör Türk dervişleri ve zaviyeler," *Vakıflar dergisi* 2 (1942): 279–304. Semavi Eyice, "İlk Osmanlı devrinin dinî-içtimaî bir müessesesi: Zâviyeler ve zâviyeli-camiler," *İktisat Fakültesi mecmuası* 23 (1963): 1–80.

24. The culmination of this plan was the Ottoman *külliyes* built during the time of Sultan Süleyman the Magnificent. Such a developmental scheme figures prominently in Aptullah Kuran's *Mosque in Early Ottoman Architecture* (Chicago: University of Chicago Press, 1968).

25. Sedat Emir, a Turkish scholar in Izmir, is publishing a series that critiques

Eyice's model by arguing that the initial plan came from the Mongols and not the Central Asian Turks. He does, however, refer to these buildings as colonizer buildings. His multivolume study begins with the dervish lodges of Tokat, which are described as the first major step in the form that culminated in the *külliyes* of the Ottoman sultans. See his *Erken Osmanlı mimarlığında çok-işlevli yapılar: Kentsel kolonizasyon yapıları olarak zâviyeler*, vol. 1 (Izmir: Akademi Kitabevi, 1994). His second volume, which also came out in 1994, focuses on the early Ottoman period, examining buildings in Bursa, Iznik, and other areas controlled by the early Ottomans. Although Emir makes a compelling case for a continuity in the treatment of building divisions in the ʿAbd al-Muṭṭalib lodge in Tokat and these later buildings, the formal relationship between the dervish lodges in these different areas remains inconclusive.

26. By linking these scholars together, I do not mean to imply that Köprülü was in agreement with Barkan and Eyice. Other scholars, such as Trimingham, *Sufi Orders in Islam*, 23, and Vryonis, *Decline of Medieval Hellenism*, 351–402, based much of their argument on Köprülü's earlier works. See especially his *Türk edebiyati'nda ilk mutasavvıflar*. Ömer Barkan's article "İstila devirlerinin kolonizatör Türk dervişleri ve zaviyeler," *Vakıflar dergisi* 2 (1942): 279–304, also appears to have played a formative role in Trimingham's and Vryonis's understanding of the activities of the Sufi orders in Anatolia.

For a recent critique of the application of this theory in the Islamization of the Mongols, see Reuven Amitai-Preiss, "Sufis and Shamans: Some Remarks on the Islamization of the Mongols in the Ilkhanate," *Journal of the Economic and Social History of the Orient* 42, no. 1 (1999): 27–46.

27. Ahmet T. Karamustafa, *God's Unruly Friends: Dervish Groups in the Islamic Later Middle Period, 1300–1550* (Salt Lake City: University of Utah Press, 1994); Amitai-Preiss, "Sufis and Shamans," 27–46; Devin DeWeese, "The Mashā'ikh-i Turk and the Khojagān: Rethinking the Links Between the Yasavī and Naqshbandī Sufi Traditions," *Journal of Islamic Studies* 7, no. 2 (1996): 180–207.

28. Karamustafa talks about the relationship between scholarship's categorization of these two groups and "a big and little tradition in Sufi scholarship." See his "Early Sufism in Eastern Anatolia," 175–79.

29. Many practices of the Qalandars were based on the life of Jamāl al-Dīn Savī. On his work, see Karamustafa, *God's Unruly Friends*. There is also a great deal of information on the Qalandars in Ahmet Yaşar Ocak, *Osmanlı imparatorluğunda marjinal sûfîlik: Kalenderîler (XIV–XVII. Yüzyıllar)* (Ankara: Türk Tarih Kurumu, 1992). Although Ocak continues to categorize these dervishes as heterodox and as carriers of Central Asian beliefs, his study is extremely valuable for the wide range of information on these figures from the Sufi texts from this period. He sticks to Köprülü's model. In *The Bektashi Order*, 265, Birge uses "Qalandar" as a descriptive term for nonurban Sufis. For the use of "Qalandar" as a literary trope, see Katherine Pratt Ewing, *Arguing Sainthood: Modernity, Psychoanalysis, and Islam* (Durham, N.C.: Duke University Press, 1999), chap 8, 230–52.

30. For the life and work of Fakhr al-Dīn ʿIrāqī, see William Chittick, *Fakhruddin ʿIraqi: Divine Flashes* (New York: Paulist, 1982), 1–62; Edward G. Browne, *Literary History of Persia, 1265–1502* (Cambridge: Cambridge University Press, 1964), 3:125–38. For references to ʿIrāqī in Aḥmad Aflākī's *Manāqib al-ʿārifīn*, see, in the volume edited by Tahsin Yazıcı (Ankara: Türk Tarih Kurumu, 1976), 360, 399, 400 and 594. The account of the dervish lodge appears on page 400 and mentions that ʿIrāqī was made *shaikh* of the lodge.

31. Chittick, *Fakhruddin ʿIraqi*, 1–62.

32. According to Trimingham, various stages in the history of Sufism culminate with fully developed orders, or *ṭarīqas*. One of the earliest institutional phases in this development is the "*khānqāh*" phase, which is defined as a period in which a communal life is formed around a mystic leader. In Trimingham's model, Sufism moves from a focus on buildings as the center of communal life to a new focus on a man as the center.

In Marshall G. S. Hodgson's discussion, these *ṭarīqas*, or formal orders, center around *dhikr* worship and a sequence of teachers (*silsilahs*). See his *Venture of Islam* (Chicago: University of Chicago Press, 1974), 2:212–14.

33. Ali Bey, ed., *Aşikpaşazade Tarihi* (Istanbul: Matbaʿa-i Âmire, 1332 [1914]), 201.

34. Victoria Holbrook dates the foundation of the Mawlawī *ṭarīqa* to the generation of Ulu ʿĀrif Çelebi, the grandson of Jalāl al-Dīn Rūmī. Using the extensive information found in the many studies by Abdülbâki Gölpınarlı, Holbrook points out that it was Ulu ʿĀrif Çelebi who devoted himself to documenting and spreading Rūmī's teaching and building lodges for Rūmī's followers. See Holbrook, "Diverse Tastes in the Spiritual Life: Textual Play in the Diffusion of Rumi's Order," in *The Legacy of Medieval Persian Sufism*, edited by Leonard Lewisohn (London: Khaniqahi Nimatullahi, 1992), 99–120. By contrast, Tahsin Yazıcı claims that the order was systematized under Sultan Walad, the son of Jalāl al-Dīn Rūmī. Yazıcı's argument is based on the development of a distinctive Mawlawī *samāʿ*. See his "Mevlānā devrinde semāʿ," *Şarkiyat mecmuası* 5 (1964): 135–59.

35. Sinclair, *Eastern Turkey*, 2:164–65, 366.

36. Stephen Mitchell, *Anatolia: Land, Men, and Gods in Asia Minor*, vol. 2, *The Rise of the Church* (Oxford: Clarendon Press, 1995), 68–70.

37. The term "Rūm," or "Rome," refers to the Greek West and is used to distinguish

the Seljuks of Anatolia (or Rūm) from the Great Seljuks of Iran. On the Rūm Seljuk conquest of the Dānishmendids, see Claude Cahen, *Pre-Ottoman Turkey: A General Survey of the Material and Spiritual Culture and History, c. 1071–1330,* trans. J. Jones-Williams (New York: Taplinger, 1968), 96–106; Vryonis, *Decline of Medieval Hellenism,* 119; İsmail Hakkı Uzunçarşılı, *Anadolu beylikleri ve Akkoyunlu, Karakoyunlu devletleri* (Ankara: Türk Tarih Kurumu, 1988), 96; Turan, *Selçuklular zamanında Türkiye,* 148–90.

38. In the *Dānishmendnāme,* the protagonist finds Sivas in ruins and reconstructs it. For more on other cities, see Irène Mélikoff, *La geste de Melik Dānişmend* (Paris: Dépositairea Maisonneuve, 1960), 1:107–15.

39. Vryonis, *Decline of Medieval Hellenism,* 473–75.

40. For an important discussion of the inclusive nature of Muslim-Christian relations in the *Dānishmendnāme,* see Kafadar, *Between Two Worlds,* 67–69. In a recent interpretation of the text, Michel Balivet has presented a slightly different point, arguing that the author of the text knew little more than the most basic stereotypes about Christianity. See Balivet, *Romanie byzantine et pays de Rûm turc: Histoire d'un espace d'imbrication gréco-turque* (Istanbul: Isis, 1994), 53.

41. The east-west route appears to have moved south in the fourteenth century, passing through Tokat instead of Sivas. See Sinclair, *Eastern Turkey,* 2:295.

42. I use the word "urban" to distinguish these projects from the caravansarays located between Seljuk cities.

43. It is interesting to note that the Artukids, like the Dānishmendids, continued to issue coins with Christian imagery after they conquered the Byzantines. Yet, when the Artukids were annexed by the Seljuks, the Christian coin type disappeared. See Vryonis, *Decline of Medieval Hellenism,* 473–75; for an explanation of why and how Christian imagery was used,

see Nicholas Lowick, "The Religious, the Royal, and the Popular in the Figural Coinage of the Jazira," in Julian Raby, *The Art of Syria and the Jazira, 1100–1250,* Oxford Studies in Islamic Art 1 (London: Oxford University Press, 1985), 159–74, and Vryonis, *Decline of Medieval Hellenism,* 119. For a brief period, bilingual coins were issued in Sis. See Rudi Paul Lindner, "The Challenge of Kılıç Arslan IV," in *Near Eastern Numismatics, Iconography, Epigraphy, and History: Studies in Honor of George C. Miles,* ed. Dickran K. Kouymjian (Beirut: American University of Beirut, 1974), 411–18, and Halit Erkiletlioğlu and Oğuz Güler, *Türkiye Selçuklu sultanları ve sikkeleri* (Kayseri: Erciyes Üniversitesi Matbaası, 1996), 115, 127, 128–29, 143.

44. According to V. L. Ménage, Sivas remained predominantly Christian as late as the early decades of the sixteenth century. See his "Islamization of Anatolia," in *Conversion to Islam,* ed. Nehemia Levtzion (New York: Holmes & Meier, 1979), 53.

45. Gary Leiser, "The Madrasa and the Islamization of the Middle East: The Case of Egypt," *Journal of the American Research Center in Egypt* 22 (1985): 29–47.

46. Vryonis, *Decline of Medieval Hellenism,* 63 and 182–83.

47. Ibn al-Bībī, Nasir al-Dīn, *El Evāmirü'l-ʿalāʾiyye fīʾl umūriʾl-ʿalāʾiyye,* ed. Adnan Sadık Erzi (Ankara: Türk Tarih Kurumu, 1956), 498–501, from here on referred to as Ibn Bībī-Erzi.

48. Discussions of the identity of the leader of the Bābā Rasūl revolt include Claude Cahen, "Baba Ishaq, Baba Ilyās, Hadjdji Bektash et quelques autres," *Turcica* 1 (1969): 53–64; Gregory Abū al-Faraj [Bar Hebraeus], *Abûʾl Farac tarihi,* Turkish translation by Ömer Riza Doğrul (Ankara: Türk Tarih Kurumu, 1987), 2:539–40; Köprülü, *Türk edebiyatıʾnda ilk mutasavvıflar,* 175–78; Ahmet Yaşar Ocak, *XIII Yüzyılda Anadoluʾda Baba Resûl (Babaîler) isyanı ve Anadoluʾnun İslâmlaşması tarihindeki yeri* (Istanbul: Dergâh Yayınları, 1980); Elwan Çelebi,

Menâkibuʾl-kudsiyye fî menâsibiʾl-ünsiyye, ed. İsmail E. Erünsal and Ahmet Yaşar Ocak, 2d ed. (Ankara: Türk Tarih Kurumu, 1995).

49. *Tārikh-i Āl-i Sāljūq dar Ānātoli: Anadolu Selçukluları devleti tarihi III,* trans. Feridün Nafiz Uzluk (Ankara: Örnek Matbaası, 1952), 31 and 64; Ibn Bībī-Erzi, 498. Ahmet Yaşar Ocak, who wrote his doctoral thesis on the Bābā Rasūl revolt, claims that the main cause of the revolt was the policies of Kaykhusraw II. See Ocak, *La révolte de Baba Resul ou la formation de l'hétérodoxie musulmane en Anatolie au XIIIe siècle* (Istanbul, 1973), chap. 2, and his *XIII Yüzyılda Anadoluʾda Baba Resûl.* An excellent summary of the revolt is found in Ahmet T. Karamustafa, "Early Sufism in Eastern Anatolia."

50. Hüseyin Hüsameddin, *Amasya tarihi* (Istanbul: Najm Istiqbāl Matbaası, 1329–32), 2:263–373. In addition, the leading historian of the revolt, Ahmet Yaşar Ocak, has argued that both Türkmen and Christian groups were deeply influenced by the leader of the revolt. See Ocak, *La révolte de Baba Resul,* 59, 73.

51. In a recent interpretation, Irene Beldiceanu-Steinherr questions whether the revolt was intended to overthrow the Seljuk sultan. Using information found in Ottoman registers on where the descendants of Bābā Rasūl settled, she argues that scarcity of land led to rivalries between Türkmens and Christians, which in turn led to the events of the revolt. Because the perception of this revolt was as important to the history of Anatolian cities as the actual events, her interpretation does not change the fact that historians living close to the time of the revolt saw it as an uprising against the Seljuk sultan. See her "La 'révolte' des Baba'i en 1240: Visait-elle vraiment le renversement du pouvoir seldjoukide?" *Turcica* 30 (1998): 99–118.

52. Ibn Bībī-Erzi, 498–501.

53. According to Ḥamd Allāh Mustawfī Qazwīnī, the sultanate of Rūm was divided among the dynasties of the ten *amīrs* who

succeeded the Seljuks. See his *Nuzhat al-Qulub*, trans. Guy Le Strange, E. J. W. Gibb Memorial Series, vol. 23 (London: Luzac & Co., 1915–19), pt. 1, 258.

54. Vryonis, *Decline of Medieval Hellenism*, 138–39; for more on the *beylik* and Ottoman periods, see Mehmet Fuad Köprülü, *The Origins of the Ottoman Empire*, trans. Gary Leiser (Albany: State University of New York Press, 1992); Uzunçarşılı, *Anadolu beylikleri ve Akkoyunlu*, 162–68; Yaşar Yücel, *Eretna devleti: Kadi Burhaneddin Ahmed ve devleti, mutahharten ve Erzincan emirliği* (Ankara: Türk Tarih Kurumu, 1989); Paul Wittek, *La formation de l'Empire Ottoman* (London: Variorum, 1982); and Halil Inalcik, *The Ottoman Empire: The Classical Age, 1300–1600*, trans. Colin Imber and N. Itzkowitz (New York: Praeger, 1973).

55. Osman Turan, "Le droit terrien sous les Seldjoukides de Turquie," *Revue des études islamiques* 16 (1948): 25–49.

56. He is sometimes also credited with building a *dār al-siyāda* in Sivas. But according to a letter from Rashid al-Dīn, the building was built by Ghazan Khan. See Browne, *Literary History of Persia*, 83.

57. Monika Gronke, "Les notables Iraniens a l'époque mongole: Aspects économiques et sociaux d'après les documents du sanctuaire d'Ardebil," in *Documents de l'Islam médiéval: Nouvelles perspectives de recherche: Actes de la table ronde*, ed. Yusuf Ragib (Cairo: Institut français d'archéologie orientale, 1991), 117–20, and idem, *Derwische in Vorhof der Macht* (Stuttgart: F. Steiner Verlag, 1993).

58. Shams al-Dīn Aḥmad al-ʿĀrifī al-Aflākī, *Manāḳib al-ʿārifīn*, ed. Tahsin Yazıcı, 2 vols. (Ankara: Türk Tarih Kurumu, 1976). Yazıcı's Turkish translation is referred to by its title, *Ȃriflerin menkıbeleri*, 2 vols. (Istanbul: Hürriyet, 1973). From this point on, Yazıcı's edition of the Persian text will be referred to as Aflākī-Yazıcı. Occasional references to Huart's translation will be referred to as Aflākī-Huart. See Shams al-Dīn Aḥmad

al-ʿĀrifī al-Aflākī, *Les saints des derviches tourneurs* [*Manāḳib al-ʿārifīn*], trans. Clement Huart (Paris: E. Leroux, 1918–22). Rūmī is known by a number of names: for example, Mawlānā ("Our Master") in Persian and Mevlānā in Turkish. To avoid showing deference to one tradition or another, this study uses Rūmī, the most popular title for this figure.

59. An example of the close relationship between Christians and dervishes can be found in the practices of the Bektāshī dervishes.

Chapter 1

1. Children of mixed marriages.

2. Aflākī-Yazıcı, 1:236.

3. These dates are not exact. For a description of Bahā' al-Dīn's journey to Konya, see Annemarie Schimmel, *I Am Wind You Are Fire: The Life and Work of Rumi* (Boston: Shambhala, 1992), 11–17, and Jalāl al-Dīn Rūmī, *Kitāb-ī fīhi mā fīhi*, trans. W. M. Thackston Jr. as *Signs of the Unseen: The Discourses of Jalaluddin Rumi* (Putney, Vt.: Threshold, 1994), vii–viii. Lewis, *Rumi: Past and Present*, 55–74, has an excellent discussion of scholarship on Bahā's journey. The primary sources for Rūmī's biography are the *Ibitidānāme* by his son Sultan Walad and edited by Jalāl Humāʾī (Tehran 1357 [1938–39]); Farīdūn ibn Aḥmad Sipahsālār's *Risālah-i Farīdūn ibn-i Ahmad Sipahsālār dar ahvāl-i Mawlānā Jalāluddīn Mawlawī*, ed. Saʿīd Nafīsī (Tehran: Iqbāl, 1325 [1984]); and Aflākī's *Manāqib al-ʿārifīn*.

4. Cahen, *Pre-Ottoman Turkey*, 258.

5. For Seljuk caravansarays, see Kurt Erdmann, *Das anatolische Karavansaray des 13. Jahrhunderts*, 2 vols. (Berlin: Verlag Gebr. Mann, 1962). Osman Turan discusses the function and funding of these buildings in his article "Seljuk Kervansaraylari," *Belleten* 10 (1946): 471–95. In recent years many more caravansarays have been found. The best source on these new caravansarays and on new ways to interpret their function is Aysil Tükel Yavuz; see her

"Concepts That Shape Anatolian Seljuq Caravanserais," *Muqarnas* 14 (1997): 80–95, and "Anadolu Selçukuklu dönemi hanları ve posta-menzil-derbent teşkilâtları," in *Profesör Doğan Kuban'a Armağan* (Istanbul: Eren, 1966), 25–38. On the endowment deed of the caravansaray of Jalāl al-Dīn Qarāṭay, see Osman Turan, "Selçuk devri vakfiyeleri," *Belleten* 12 (1948): 17–171.

6. Cahen, *Pre-Ottoman Turkey*, 158–59, citing Ibn Saʿīd and Abu al-Fidā. For a recent study of the Rūm Seljuk's conception of landscape, see Scott Redford, *Landscape and the State in Medieval Anatolia: Seljuk Gardens and Pavilions of Alanya, Turkey*, BAR International Series (Oxford: Archaeopress, 2000).

7. Early in his reign, Kay-Qubād was forced to put down a rebellion by his *amīrs*. *Tārikh-i Āl-i Sāljūq*, 45–46; Ibn Bībī-Erzi, 113.

8. For a discussion of this style, see Ethel Sara Wolper, "Portal Patterns in Seljuk and Beylik Anatolia," in *Aptullah Kuran İçin Yazılar: Essays in Honour of Aptullah Kuran*, ed. Çiğdem Kafescioğlu and Lucienne Thys-Şenocak (Istanbul: Yapı Kredi Yayınları, 1999), 65–80. On the city walls of Sivas and Konya, see Naṣīr al-Dn Ibn al-Bībī, *Die Seltschukengeschichte des Ibn Bībī*, trans. Herbert W. Duda (Copenhagen: Munksgaard, 1959), 110. For a complete list of Kay-Qubād's patronage, including bridges, castles, and palaces, see Howard Crane, "Notes on Saldjūq Architectural Patronage in Thirteenth Century Anatolia," *Journal of the Economic and Social History of the Orient* 36 (1993): 26–28. A detailed discussion of the building stages of the mosque in Konya is found in Scott Redford, "The Alâeddin Mosque in Konya Reconsidered," *Artibus Asiae* 51, nos. 1–2 (1991): 54–72.

9. The discussion between the previous sultan and the famous Andalusian mystic Ibn al-ʿArabī was recorded by later historians. On this meeting, see Karīm al-Dīn Maḥmud ibn Muḥammad al-Aqsarāyī, *Musâmeretü'l ahbâr ve musâyarat al-akhyār*,

ed. Osman Turan (Ankara: Türk Tarih Kurumu, 1944), 327–28.

10. Unlike some of the other religious elites that migrated to Anatolia, Bahā' al-Dīn left Khurāsān before the Mongol conquest. Lewis, *Rumi: Past and Present*, 60.

11. Najm al-Dīn Rāzī, *Merṣād al-ʿebād men al-mabdāʾ elāʾl-maʿād: The Path of God's Bondsmen from Origin to Return*, Persian Heritage Series, no. 35, trans. Hamid Algar (Delmar, N.Y.: Caravan Books, 1982), 42–46.

12. For a list of the positions under the Seljuk sultan Kaykhusraw, see al-Aqsarāyī, *Musâmeretü'l ahbâr ve musâyarat al-akhyār*, 89–91. The number of deragotary comments about Ṣadr al-Dīn's followers in Rūmī's writing suggests that there was some tension between the two figures.

13. Despite the multiple connotations of the term "Türkmen," this book will use the word only to designate nomadic groups. Thus, Türkmens differ from the Seljuks of Rūm and other settled dynastic populations such as the Dānishmendids.

14. These communities were, of course, in addition to the Türkmen principalities formed after the second half of the thirteenth century.

15. Aflākī-Yazıcı, 1:146 (no. 3/60). In this passage, Rūmī is speaking about the Seljuk sultan Rukn al-Dīn. In Aflākī, the *shaikh*'s name is Marandī. A similar account by Sipahsālār refers to the *shaikh* as Bozāghu; see his *Risālah-i . . . dar ahvāl-i Mawlānā Jalāluddīn Mawlawī*, 84–85.

16. Although there are other regions and eras in which buildings were visual markers of religious prestige, medieval Anatolia was somewhat unusual in the greater variety of its patrons and objects of patronage.

17. One of the leading figures in the study of these texts is Ahmet Yaşar Ocak. See his *Kültür tarihi kaynağı olarak menâkıbnâmeler* (Ankara: Türk Tarih Kurumu, 1992).

18. Arthur J. Arberry, *Sufism: An Account of the Mystics of Islam*, 2d ed. (New York: Harper & Row, 1970), chap. 1.

19. Aflākī-Yazıcı, 1:28–29.

20. My definition of "interpretive community" is largely based on what Brian Stock calls a "textual community": a microsociety organized around a common understanding of a script. See his *Listening for the Text: On the Uses of the Past* (Baltimore: Johns Hopkins University Press, 1990) and *The Implications of Literacy: Written Language and Models of Interpretation in the Eleventh and Twelfth Centuries* (Princeton: Princeton University Press, 1983). However, I use the term "interpretive community," and not "textual community," because the latter is often used to signal a broad change in how people thought about their world. In the Islamic world, such a type of textuality, where people began to think in terms of texts, had occurred before the time period of this study. "Interpretive community" also allows me to speak about the communities bound together through reference to a range of interpretive structures that do not fit neatly into the category "text." Some of these, like the layout of cities, were culturally coded systems that were not related to any textual sources but were just as prominent in giving people a sense and a referent. For an interesting critique of Stock, see Patrick Geary, particularly his *Phantoms of Remembrance: Memory and Oblivion at the End of the First Millennium* (Princeton: Princeton University, 1994), who emphasizes that texts were developed through the interaction between the oral and the written.

21. See Clement Huart, "De la valeur historique des mémoires des derviches tourneurs," *Journal asiatique*, 2d ser., 19 (1922): 308–17, and, for his translation, *Les saints des derviches tourneurs*.

22. Holbrook, "Diverse Tastes in the Spiritual Life."

23. Köprülü, *Origins of the Ottoman Empire*, 57.

24. On these texts, see al-Naṣīrī, *Der anatolische Dichter Nasiri (um 1300) und sein Futuvvetname*, ed. Franz Taeschner (Leipzig: F. A. Brockhaus, 1944). Excerpts are published in Taeschner's "Beiträge zur

Geschichte der Achis in Anatolien (14.–15. Jhdt.) auf Grund neuer Quellen," *Islamica* 4 (1929): 1–47.

25. For a recent discussion of the *akhīs* in Turkey, see the collection of essays from the 1985 symposium *Türk kültürü ve ahilik: XXI ahilik bayramı sempozyumu tebliğleri, 13–15 Eylül 1985* (Istanbul: Yaylacık Matbaası, 1986), 153–69, and Mikâil Bayram, *Ahi Evren ve ahi teşkilâti'nin kuruluşu* (Konya: Damla Matbaacılık ve Ticaret, 1991), 73–96.

26. Ibn Bībī-Erzi, 186.

27. Al-Naṣīrī, *Der anatolische Dichter Nasiri*.

28. Vincent Cornell, *Realm of the Saint: Power and Authority in Moroccan Sufism* (Austin: University of Texas Press, 1998), 10–11. Cornell cites David S. Powers's major work on Malikī law, "The Maliki Family Endowment: Legal Norms and Social Practices," *International Journal of Middle Eastern Studies* 25, no. 3 (1993): 396.

29. For a study of recent approaches to this institution, see Miriam Hoexter, "Waqf Studies in the Twentieth Century: The State of the Art," *Journal of the Economic and Social History of the Orient* 41, no. 4 (1998): 474–95.

30. Additionally, *waqf* documents for some of the extant buildings from these cities are missing. Possibly, some of these missing *waqfīyas*, especially those for Ilkhānid-sponsored buildings, may be in Russian or Iranian archives; it is also possible that, as Lisa Golombeck has suggested, some *shaikhs* did not want to accept *waqf* endowment for fear that it would compromise the integrity of the lodge. She makes this point in her excellent article "Cult of Saints and Shrine Architecture in the Fourteenth Century," in *Near Eastern Numismatics, Iconography, Epigraphy, and History*, 419–30. A similar point is made by Leonard Lewisohn in *Beyond Faith and Infidelity: The Sufi Poetry and Teachings of Mahmud Shabistari* (Richmond, Surrey: Curzon, 1995).

31. Stock, *Implications of Literacy*, 45.

Chapter 2

1. Aflākī-Yazıcı, 1:398.

2. In his work on Maḥmūd Shabistarī, Leonard Lewisohn argued that beginning in the twelfth century Sufis from the Iranian world complained about the institutionalization of Sufi life and the restraints of life in the *khānqāh*. See his *Beyond Faith and Infidelity*, 116–18.

3. For a recent discussion of these tensions, see Frederick de Jong and Bernd Radtke's introduction to *Islamic Mysticism Contested: Thirteen Centuries of Controversies and Polemics*, ed. de Jong and Radtke (Leiden: E. J. Brill, 1999), 1–21, and, from the same volume, Josef Van Ess, "Sufism and Its Opponents: Reflections on Topoi, Tribulations, and Transformations," 23–44.

4. Some Sufis dismissed those associated with dervish lodges (*khānqāhs*) as "lesser" Sufis. See Devin DeWeese, "Khojagānī Origins and the Critique of Sufism: The Rhetoric of Communal Uniqueness in the *Manāqib* of Khoja ʿAlī ʿAzīzān Rāmītanī," in *Islamic Mysticism Contested*, 494 and 503.

5. In a recent study on Aleppo, Yasser Tabbaa has provided extensive documentation on some of the dervish lodges in Syria. For the citations, see his *Constructions of Power and Piety in Medieval Aleppo* (University Park: Pennsylvania State University Press, 1997), 164.

6. The Hanbalī scholar ʿAbd al-Raḥman Ibn al-Jawzī was one of the first to complain. See his *Talbīs Iblīs* (Beirut: Dār al-Kutub al-ʿIlmiyya, n.d.), 175. For more on Ibn Taymīya, see Muhammad Umar Memon, *Ibn Taymiya's Struggle Against Popular Religion* (The Hague: Mouton, 1982); Th. Emil Homerin, "Ibn Taymīya's al-Sufiyah wa al-fuqarā'," *Arabica* 32 (1985): 219–44; and idem, "Sufism and Its Detractors in Mamluk Egypt: A Survey of Protagonists and Institutional Settings," in *Islamic Mysticism Contested*, 225–47.

7. Tāqī al-Dīn Abī al-ʿAbbās Aḥmad ibn ʿAlī al-Maqrīzī, *Al-Mawāʿiz wa-al-iʿtibār bi dhikr al-khitat wa-al-athār* (Baghdad, 1970), 2:415–16.

8. For an excellent survey of this phenomenon, see Carl F. Petry's *Civilizational Elite of Cairo in the Later Middle Ages* (Princeton: Princeton University Press, 1981), 139.

9. In Anatolia, as in other parts of the medieval Islamic world, dervish lodges began to perform many of the same functions as other buildings. Berkey, *Transmission of Knowledge in Medieval Cairo*, 130–32; idem, "Culture and Society During the Middle Ages," in *The Cambridge History of Egypt*, vol. 1, edited by Carl F. Petry (Cambridge: Cambridge University Press, 1998), 375–411, especially 401; Muhammad M. Amīn, *Al-Awqāf wa al-Hayāt al-Ijtimāʿīyah fī Misr, 648–923 H./1250–1517 M.* (Cairo: Dār al-Nahda al-ʿArabiyya, 1980), 204; and Michael Chamberlain, *Knowledge and Social Practice in Medieval Damascus, 1190–1350* (Cambridge: Cambridge University Press, 1994), 54.

10. According to Howard Crane, rich *amīrs* took over the patronage of buildings in Anatolia. See his "Notes on Saldjūk Architectural Patronage in Thirteenth Century Anatolia," 22–24.

11. For more on *waqf*, see Mehmet Fuad Köprülü, "Vakıf müessessesinin hukukî mahiyeti ve tarihî tekâmülü," *Vakıflar dergisi* 2 (1942): 1–36; Johansen, *Islamic Law on Land Tax and Rent*, 81; and Claude Cahen, "Economics, Society, Institutions," in *The Cambridge History of Islam* (Cambridge: Cambridge University Press, 1977), 519.

12. For a detailed discussion of *iqtāʿ*, see Ann K. S. Lambton, "Reflections on the Iqta," in *Arabic and Islamic Studies in Honor of Hamilton A. R. Gibb*, ed. G. Makdisi (Leiden: E. J. Brill, 1965), 358–76.

13. Most discussions of the transfer of the sultan's lands to private hands are based on the account of Ibn Bībī. See Ibn Bībī-Erzi, 642. The best summary and discussion of Ibn Bībī's account are found in Osman Turan's article "Le droit terrien sous les Seldjoukides de Turquie." For a general discussion of this development, see Cahen, *Pre-Ottoman Turkey*, 173–88.

14. Turan, "Le droit terrien," 30. The transformation of *mulk* into *waqf* and the corresponding rise of land-owning families were phenomena that occurred within lands that followed Hanafi practices. With rare exceptions, the Seljuks followed the Hanafi *madhab*. On the relationship between the Hanafi *madhab* and changes in the peasants' relation to the land, see Baber Johansen, *The Islamic Law on Land Tax and Rent* (New York: Croom Helm, 1988), chap. 1, "The Birth of the Kharāj Payer," 7–24, and chap. 2, "The Contract of Tenancy (Ijāra): The 'Commodification' of the Productive Use of Land," 25–50. The transformation of *mulk* land into *waqf*, however, is different from the land-revenue system of *mālikāne-dīvānī*, which many scholars argue began as early as the time of the Seljuks of Rūm and became increasingly popular during Ottoman rule. This revenue system divided collectible shares between the state and the property holder. It is usually argued that the system was set up as a check on the growing power of Türkmen families. Its popularity in the Sivas-Tokat-Amasya region was due to the prominence of these families in that area. See Oktay Özel, "Limits of the Almighty: Mehmed II's 'Land Reform' Revisited," *Journal of the Economic and Social History of the Orient* 42, no. 2 (1991): 222–46; Irene Beldiceanu-Steinherr, "Fiscalité et formes de possession de la terre arable dans l'Anatolie pré-ottomane," *Journal of the Economic and Social History of the Orient* 19 (1976): 241–77; and Halil Inalcik, *An Economic and Social History of the Ottoman Empire* (Cambridge: Cambridge University Press, 1997), 1:129.

15. "Sāldjuks of Rum," in *Encyclopaedia of Islam*, 2d ed., 7:956.

16. The word *nāzir* is used in some documents, while *mutawallī* (*mütevelli*) is used in others, to name the person with final discretion over the disposal of funds. While some pre-1250 *waqfīyas* mention both a *nāzir* and *mutawallī*, this is not the case for those written in Anatolia after 1250.

17. Dervish lodges did not require positions like a *mudarris* or *faqīh*, which were filled by individuals trained in Islamic sciences through a *madrasa* education. Furthermore, Anatolian *waqfīyas* often state that *qāḍīs* (religious judges) were to step in and control the foundation only when a family died out and no relative remained to oversee the endowment.

18. See Yakup Pasha Evkaf, defter 608, no. 23, VGM, and Muhiddin bini Abdullah Evkaf, defter 608, no. 63, VGM.

19. Many of these local elites were the freed slaves of Seljuk princesses. For more on their role in the dervish lodges of Amasya, Tokat, and Sivas, see Chapter 6. For a detailed focus on one of these princesses, see Ethel Sara Wolper, "Princess Safwat al-Dunyā wa al-Dīn and the Production of Sufi Buildings and Hagiographies in Pre-Ottoman Anatolia," in *Women, Patronage, and Self-Representation in Islamic Societies*, ed. D. Fairchild Ruggles (Albany: State University of New York Press, 2000), 35–52.

20. In the *waqfīya* for the *madrasa* of Shams al-Dīn Altun Aba in Konya, the highest paid official was the *mudarris*, who was allotted 800 silver dinars per year, while the *mutawallī* received 400, the *imām* 200, and the *mu'adhdhin* 100. Vryonis, *Decline of Medieval Hellenism*, 353.

21. See Ahmet Temir, *Kırşehir emiri Caca Oğlu Nur El-Din'in 1272 tarihli Arapça-Mogolça vakfiyesi* (Ankara: Türk Tarih Kurumu, 1959), 99–100.

22. Crane, "Notes on Saldjūq Architectural Patronage in Thirteenth Century Anatolia," 8–24 and entries 31, 37, and 71.

23. For examples, see Aflākī-Yazıcı, 1:108–9 and 133–34.

24. "Gök" means "blue."

25. See Yakup Pasha Evkaf, defter 608, no. 23, VGM.

26. Two of these lodges, the Yaʿqūb Pasha lodge in Amasya and the ʿAbd al-Muṭṭalib lodge in Tokat, were large institutions.

27. Beyler Çelebi bini Tacüddin Muhammad Çelebi Evkaf (hereafter Beyler Çelebi), defter 484, no. 309, BA.

28. Şemseddin B. Hüseyin Evkaf (162/19), BA. Similar phrases appear in the *waqfīya* of Aḥmad ibn Rāḥa, defter 578, no. 3, VGM, and the Yakup Pasha Evkaf, defter 608, no. 23, VGM.

29. See Aḥmad ibn Rāḥa, defter 575, no. 3, VGM, and Yakup Pasha Evkaf, defter 608, no. 3, VGM.

30. For example, the endowment deed of the Shams al-Dīn Ḥusayn lodge states that only five Sufis were allowed in the building during prayer time. See Şemseddin B. Hüseyin Evkaf (162/19), BA.

31. Salaries for *mu'adhdhins* are included in the *waqfīyas* of Aḥmad ibn Rāḥa, defter 578, no. 3, VGM; Beyler Çelebi, defter 484, no. 309, VGM; Muhiddin bini Abdullah, defter 608, no. 63, VGM; Abdusselam oğlu Torumtay, defter 490, no. 100, VGM; Yakup Pasha, defter 608, no. 23, VGM; and Şemseddin B. Hüseyin (162/19), BA.

32. The *mu'adhdhin* salary was often as generous as that of the *ḥāfiz*. In the Shams al-Dīn ibn Ḥusayn *waqf*, for example, each *ḥāfiz* received 120 *dirhams* a year, the same amount received by the *mu'adhdhin*. See Şemseddin B. Hüseyin Evkaf (162/19), BA.

33. The *waqfīya* for the Shams al-Dīn ibn Ḥusayn lodge, for example, allows entrance to adherents of Sufism (*taṣawwuf*) who wear the dress of Sufis and know Sufi etiquette. Şemseddin B. Hüseyin Evkaf (162/19), BA.

34. Muʿīn al-Dīn Pervāne wrote to the Ilkhānid *wazīr* Rashid al-Dīn, complaining about the depredations from the Türkmens in his province. Browne, *Literary History of Persia*, 85.

35. Şemseddin B. Hüseyin Evkaf (162/19), BA.

36. Beyler Çelebi, defter 484, no. 309, VGM.

37. Abdusselam oğlu Torumtay Evkaf, defter 490, no. 100, VGM. There are some problems in distinguishing between such terms as *faqīr* and *miskin*, since each is used for a range of meanings in both literal and mystical contexts.

38. For example, the Shams al-Dīn ibn Ḥusayn *waqfīya* required that two tables and a large kettle be included in the building's equipment. The inclusion of these items indicates, of course, that dervishes and their guests sat at long tables while eating food prepared in a large kettle. See Şemseddin B. Hüseyin Evkaf (162/19), BA.

39. *Madrasas* also provided lodging, but they welcomed a much more circumscribed group. *Waqfīyas* for some *madrasas* and caravansarays even included funds for converting Christians to Islam. For example, the *waqf* that Shams al-Dīn Altun Alba set up for his *madrasa* and caravansaray set aside one-fifth of the income from an eighteen-room *khān* to pay for converts to Islam. By contrast, no building deeds for dervish lodges forbade non-Muslims from staying in the building. The Dār al-Rāḥa lodge in Sivas, for example, provided services for the people of religion (*ahl al-dīn*). Vryonis, *Decline of Medieval Hellenism*, 353.

40. Ibn Baṭṭūṭa, *The Adventures of Ibn Battuta: A Muslim Traveler of the 14th Century*, trans. Ross E. Dunn (Berkeley and Los Angeles: University of California Press, 1989), 148–49.

41. For a detailed examination of this topic in relation to the prophetic figure Khiḍr, see Ethel Sara Wolper, "Khiḍr, Elwan Çelebi, and the Conversion of Sacred Sanctuaries in Anatolia," *Muslim World* 90, nos. 3–4 (special issue: *Sufi Saints and Shrines in Muslim Society*, ed. Jamal Elias) (2000): 309–22.

42. By itself, *dhikr* (the repetition of the names of God) was a form of devotion available to all Muslims and not requiring a group setting.

43. Trimingham, *Sufi Orders in Islam*, 302. I was fortunate to attend a *dhikr* of the Khalwatī dervishes of Istanbul, who perform the *dhikr* in group settings, using music and rhythmic incantations.

44. Rāzī, *Merṣād al-ʿebād men al-mabda' elā'l-ma'ād*, 477–78.

45. Aflākī-Yazıcı, 2:716–18. Speros Vryonis Jr., "The Muslim Family in

13th–14th Century Anatolia as Reflected in the Writings of the Mawlawi Dervish Eflaki," in *The Ottoman Emirate (1300–1389): Halcyon Days in Crete, 1*, ed. Elizabeth Zachariadou (Rethymon: Crete University Press, 1993), 221.

46. Trimingham, *Sufi Orders in Islam*, 310.

47. Aflākī-Huart, 1:190.

48. Beyler Çelebi, 725.

49. Sunbul Bābā, for example, was eventually incorporated into the Bektāshī line. By the seventeenth century, the Sunbul Bābā dervish lodge in Tokat was called a Bektāshī lodge by Evliya Çelebi, *Evliyâ Çelebi seyâhatnâmes*, trans. Zuhuri Danişman (Istanbul: Kardeş, 1970), 7:60.

50. Ridwan Nafiz and İsmail Hakkı Uzunçarşılı, *Sivas şehri* (Istanbul: Dergâh, 1928), 108.

51. See Şemseddin B. Hüseyin Evkaf (162/19), BA, for a list of markets on site.

52. Homerin, "Saving Muslim Souls," 59–83.

53. Cahen, *Pre-Ottoman Turkey*, 280–92.

54. See "Lemeat," Süleymaniye Library, Istanbul, no. 2703, 17–35.

55. Aflākī-Yazıcı, 1:400.

56. Chittick, *Fakhruddin 'Iraqi*, 51, citing excerpts from *Kulliyat-i Iraqi*.

57. Ibid.

58. Aflākī-Yazıcı, 1:68–69.

59. Ibid., 2:792.

60. *Âriflerin menkıbeleri*, 3/333.

Chapter 3

1. I would like to express my sincere thanks to Cemal Kafadar and the University of California Press for generously allowing me to use his translation of this poem. Kafadar, *Between Two Worlds*, vii.

2. For more information on the Dānishmendids, see Irene Mélikoff, "Danişmendids," in *Encyclopaedia of Islam*, 2d ed. For more detailed information, see idem, *La geste de Melik Dānişmend*, vol. 1.

3. Even in cities like Tokat, where there were no walls, *waqfīyas* refer to property as being "inside" or "outside" the city.

4. Christian, Jewish, and Kurdish villages formed a sizeable share of *waqf* property. For the best study of this phenomenon, see Vryonis, *Decline of Medieval Hellenism*, chap. 3, 143–287.

5. Because of the importance of Sivas as a trading center with Europe, it was not uncommon to find foreign communities living outside the city. According to George Bratianu, there were Genoese and Venetian communities in Sivas. See Bratianu, *Recherches sur le commerce genois dans la mer noire au XIIIe siècle* (Paris: P. Geuthier, 1929), 168–98.

6. Sinclair, *Eastern Turkey*, 1:130.

7. Ibid., 295.

8. For the most complete history of post-Seljuk Sivas, see İsmail Hakkı Uzunçarşılı, "Sivas ve Kayseri hükümdarı Kadi Burhaneddin Ahmed," *Belleten* 32 (1968): 191–245, and idem, *Anadolu beylikleri ve Akkoyunlu*, 155–61.

9. The Dominican missionary William of Rubruque found the alum trade in the hands of a Genoese, Nicolo of San Siro from Syria, and a Venetian, Bonifacio of Molinos from Cyprus. Together, they exercised a monopoly. Cahen, *Pre-Ottoman Turkey*, 320–22.

10. Ibid., 323.

11. A number of sources state that the mosque was a converted Armenian church. See Gabriel, *Monuments turcs d'Anatolie*, 2:143–46, and Robert Ker Porter, *Reisen in Georgien, Persien, Armenien, dem alten Babylonien usw. im Laufe der Jahre 1817–1820* (Weimar: Verlage des Landes-Industrie, 1823–33) 2:681. For the most detailed reconstruction, see H. Edhem and Max Van Berchem, *Matériaux pour un Corpus Inscriptionum Arabicarum*, vol. 3, pt. 1, *Sivas et Divriği* (Cairo: L'institut français d'archéologie orientale, 1917), 12–21, henceforth referred to as *CIA*, as well as Uzunçarşılı, *Kitabeler*, 145–46.

12. Although this building is no longer extant, it is mentioned in an Ottoman copy of the *waqfīya* for the hospital of the Seljuk sultan, now in a defter at the Vakıflar Genel Müdürlüğü. It has been published and translated into Turkish by M. Cevdet, "Sivas darüşşifası vakfiyesi ve tercümesi."

13. For a description of the construction of Sivas's walls, see Ibn Bībī-Erzi, 252–56.

14. The *waqfīya* lists the Yaght Basān *khānqāh* as one of the borders of the hospital. For the published *waqfīya*, see Cevdet, "Sivas darüşşifası vakfiyesi ve tercümesi," 35.

15. Aslanapa, *Turkish Art and Architecture*, 139.

16. Mustafa Cezar, *Typical Commercial Buildings of the Ottoman Classical Period and the Ottoman Construction System* (Ankara: Türkiye İş Bankası, 1983), 49–51, and Osman Turan, "Selçuklular zamanında Sivas şehri," in *Ankara Üniversitesi Dil ve Tarih Cografya Fakültesi dergisi*, vol. 9 (Ankara: Türk Tarih Kurumu, 1951), 447–57.

17. For more on this hospital, see Gönül Cantay, *Anadolu Selçuklu ve Osmanlı darüşşifaları* (Ankara: Türk Tarih Kurumu, 1992), 45–50.

18. Sultan Evkaf, defter 588, no. 334, VGM.

19. According to İsmet Kayaoğlu, the caravansaray was outside the walled city; see İsmet Kayaoğlu, "Rahatoğlu ve vakfiyesi," *Vakıflar dergisi* 13 (1981): 1–29.

20. Cezar, *Typical Commercial Buildings*, 49–51.

21. Nafiz and Uzunçarşılı, *Sivas şehri*, 60.

22. According to Turan's reading of the *waqfīya* for the Gök Madrasa, among these *khāns* were the Sahtiyan (Morrocan leather) Khān, Pamuk (cotton) Khān, Şekerçiler (sweeteners) Khān, and Bezzazlar (cloth) Khān, and other *khāns* connected to political figures such as Najm al-Dīn Jandar, Taj al-Dīn Mahmoud, Nizam al-Dīn Hursid, Kamāl al-Dīn Mansur, Zahir al-Dīn Illi, and Kamāl al-Dīn. Turan, "Selçuklular zamanında Sivas şehri," 451.

23. Anatolian trade made vast fortunes available to Ilkhānid representatives. For

more on this topic, see Gronke, "Les notables Iraniens," 119.

24. Juwaynī was even bold enough to omit the name of the reigning Seljuk sultan from the building inscription.

25. Double minarets were also found on the *madrasas* of the Great Seljuks in Iran and Baghdad. In Anatolia, double minarets were found on *madrasas* in Konya, Kayseri, and Akşehir that were built by *amīrs* in support of Sunni religious scholars. After 1250, royal patronage declined, and *amīrs* became the new patrons of architecture. Unlike the sultans' efforts, which were concentrated on fortifications, caravansarays, and mosques, a large portion of the *amīrs'* patronage was directed at *madrasas*. See Crane, "Notes on Saldjūq Architectural Patronage in Thirteenth Century Anatolia," 20–22.

26. Some of these terms, such as *'alawī*, may have been inserted by an Ottoman copyist.

27. According to Michael Rogers, the Mongol occupation did not have a major effect on Seljuk society, because *amīrs* took over the former responsibility of the sultan in providing a center for Sunni Islam. Rogers, "Recent Work on Seljuk Anatolia," *Kunst des Orients* 6 (1962): 161.

28. Although this was the site of an earlier lodge, today the dervish lodge is connected to the *shaikh* Shams al-Dīn Sivasī, who was buried behind the Ulu Cami (Friday mosque). For the location, see Sözen, *Anadolu medreseleri*, 2:40.

29. Ibn Bībī refers to a *ribāṭ* of Iṣfahānī known in that time also as the *ribāṭ* of Kamāl al-Dīn Aḥmad Rāḥa. Ibn Bībī-Erzi, 418–19.

30. *CIA*, 37. On the connection between Shaikh Hasan and the prominent *wazīr* Fakhr al-Dīn 'Alī, who built the Gök Madrasa in Sivas, see Nafiz and Uzunçarşılı, *Sivas şehri*, 95.

31. According to an A.H. 687 *waqfīya*, which I have not seen, 'Alā' al-Dīn 'Alī, an *amīr* who was the son of Kamāl al-Dīn Aḥmad, built a dervish lodge (*zāwiya*) called Dār al-Rāḥa. I was not able to find any reference in the Vakıflar Genel Müdürlüğü to this 687 *waqfīya*, which both Gabriel and Edhem mention. See Gabriel, *Monuments turcs d'Anatolie*, 2:67, and *CIA*, 38.

32. Gabriel, *Monuments turcs d'Anatolie*, 2:67, and Nafiz and Uzunçarşılı, *Sivas şehri*, 95.

33. From almost any vantage point above a few feet, the building looked like an Armenian church.

34. There are no archival or archaeological records for other major building activity between 1325 and 1350.

35. The Shahneh tomb was a single structure without a dome. I have not included a discussion of this tomb in this discussion because, unlike the Gök Madrasa dervish lodge, it did not provide housing and nourishment to travelers.

36. After he and his descendants lost power, a group of *akhīs* inhabited Fakhr al-Dīn 'Alī's dervish lodge in Sivas and, possibly, his *madrasa* in Akşehir. Ibn Baṭṭūṭa mentioned a *dār al-siyāda* near the Gök Madrasa. See Ibn Baṭṭūṭa, *Riḥlat Ibn Baṭṭuṭah* (Cairo, 1958), 296. According to Metin Sözen, this may have been one of the two places where Ibn Baṭṭūṭa stayed during his stay in Sivas. See Sözen, *Anadolu medreseleri*, 1:40.

37. Sinclair, *Eastern Turkey*, 2:293.

38. Tokat is 118 kilometers from Amasya and 108 kilometers from Sivas.

39. Cezar, *Typical Commercial Buildings*, 43.

40. In 1249 a small Seljuk *masjid* and dervish lodge were added to the same area, between the road and the citadel (see fig. 16, no. 16).

41. According to its inscription, the bridge was completed after 1240. It was likely, however, that the bridge was in operation years before the inscription was put up. Thus, I have included it in the first map for Tokat.

42. Sinclair, *Eastern Turkey*, 2:310.

43. Many of the bridges indicated in Gabriel's maps of the city were Ottoman constructions.

44. A. Süheyl Ünver believes that this was the site of a Dānishmendid dervish lodge. Unfortunately, Ünver does not explain why he believes this. See Ünver, *Selcuk tababeti* (Ankara: Türk Tarih Kurumu, 1940), 79–83.

45. There are a number of sources on building activity in Tokat. Most of these, however, remain unpublished and can only be found in Turkish archives. The best published source is still Uzunçarşılı's *Kitabeler*, 1–57.

46. According to Michael Rogers, the building was founded by a female patron married to a Mongol *amīr*. Rogers, "The Date of the Çifte Minare Medrese at Erzurum," *Kunst des Orients* 8 (1972): 94.

47. For more on Amīr Ḥusayn, see 'Aziz ibn Ardashīr Astarābadī, *Bezm u rezm*, trans. Mürsel Öztürk (Ankara: Kültür Bakanlığı Yayınları, 1990), 386 and 404.

48. Yash Maidān, a term found in the original *waqfīya*, literally means "the wet place."

49. Ersal Yavi, *Tokat (Comana)* (Istanbul: Güzel Sanatlar Matbaası, 1987), 50.

50. For more on the architectural patronage of Mu'īn al-Dīn Pervāne's children, see İsmail Hakkı Uzunçarşılı, "Kastamonu ve Sinop'ta Pervanezadeler," *Doğu mecmuası* 7 (1957): 27–31; M. Zeki Oral, "Durağan ve Bafra'da iki türbe," *Belleten* 20 (1956): 387–88; Crane, "Notes on Saldjūq Architectural Patronage in Thirteenth Century Anatolia," no. 12.

51. *Evliyâ Çelebi seyâhatnâmesi*, 7:60.

52. Gabriel, *Monuments turcs d'Anatolie*, 2:88.

53. Sinclair, *Eastern Turkey*, 2:318–19, and Maria de Carcaradec, "Un monument inédit a Tokat: Seyh Meknun Zaviyesi," *Turcica* 9/1 (1977): 111–19.

54. Yavi, *Tokat*, 47.

55. A number of these patrons were associated with royal women. For more on this topic, see Chapter 6.

56. See Astarābadī, *Bezm u rezm*, 304.

57. Beyler Çelebi, defter 484, no. 309, VGM.

58. The best history of Amasya is Hüseyin Hüsameddin's *Amasya tarihi*, 4 vols. (Istanbul: Hikmet Matbaası Islamiyesi, 1911–35). The Amasya Belediyesi Kültür Yayınları has recently published a modern Turkish edition of the first volume, translated by Ali Yilmaz and Mehmet Akkus (Ankara, 1986).

59. Both mosques were destroyed in the 1939 earthquake. On the walls of the city, see Franz Cumont, *Studia Pontica* (Brussels: H. Lamertin, 1910), 3:112–13.

60. Most of these constructions date from the reign of the Seljuk sultan Mas'ūd (1116–56). All of them are no longer extant.

61. Ocak, *La révolte de Baba Resul*, 47–70.

62. Ibn Bībī-Erzi, 499; Hüsameddin, *Amasya tarihi* (1911–35), 1:235; Ocak, *Anadolu'da Baba Resûl*, 124–25; Elwan Çelebi, *Menâkibu'l-kudsîyye*, 295–501; and Gregory Abu al-Faraj [Bar Hebraeus], *Abû'l Farac Tarihi*, trans. Ömer Riza Doğrul (Ankara: Türk Tarih Kurumu, 1950), 2:539.

63. Hans Dernschwam, *Tagebuch einer Reise nach Konstantinopel und Kleinasien (1553/55)*, ed. Franz Babinger (Munich: Duncker & Humblot, 1923), 220.

64. Gabriel, *Monuments turcs d'Anatolie*, 2:57; Halife Elb Gazi bini Kuli, defter 610, no. 37, VGM; and Refet Yinanç, "Selçuklu medreselerinden Amasya Halifet Gazi medresesi ve vakıfları," *Vakıflar dergisi* 15 (1982): 5–23.

65. Hüsameddin, *Amasya tarihi* (1986), 1:189. This history, similar to the Ottoman work on which it is based, provides a wealth of information but no documentation, and for this reason it is of limited use. Other accounts place the famous dervish lodge in a small village outside of Amasya. Elwan Çelebi, *Menâkibu'l-kudsîyye*, xlvi and 24–44 (lines 295–501).

66. For more on Baraq Bābā, see Ocak, *Osmanlı imparatorluğunda marjinal sûfîlik*, 68–69.

67. These new construction projects were further supported from the village named after Bābā Ilyās, Ilyās Koyu.

68. According to Hüseyin Hüsameddin, the Armenians claimed that the Ṭurumṭay buildings were the site of a church and patriarchate. See *Amasya tarihi* (1986), 1:34–35. Archaeological evidence indicates that the structure, size, and location of the two buildings correspond to plans of Armenian churches and chapels.

69. Yakup Pasha Evkaf, defter 608, no. 32, VGM.

70. Hüsameddin, *Amasya tarihi* (1986), 1:199–200. For a connection between this *pervâne* and Mu'in al-Dīn Pervâne from Tokat, see Uzunçarşılı, "Kastamonu ve Sinop'ta Pervanezadeler," and idem, *Anadolu beylikleri ve Akkoyunlu*, 149.

71. See Uzunçarşılı, "Kastamonu ve Sinop'ta Pervanezadeler," 27–31, and Oral, "Durağan ve Bafra'da iki türbe," 387–88.

72. The *waqf* of Ya'qūb Pasha mentions a Mawlawī lodge in Amasya. See Yakup Pasha Evkaf, defter 608, no. 23, VGM.

73. The founder of the Mawlawī dervishes, Jalāl al-Dīn Rūmī, made Konya his center, and many of his disciples continued to live in Konya.

74. See Yakup Pasha Evkaf, defter 608. no. 23, VGM.

75. Ibid.

76. Other Beyler Çelebi endowments from the Cevdet Evkaf collection are the *waqf* of Beyler Çelebi Ibn-i Taceddin Mahmut in Osmancık (162/8) and the *waqf* of Beyler Çelebi Ibn-i Taceddin Mahmut in Çorum (162/17).

77. Ahmet Yaşar Ocak, "Zaviyeler," *Vakıflar dergisi* 12 (1978): 269.

Chapter 4

1. Robert Hillenbrand's *Islamic Architecture* (New York: Columbia University Press, 1994) has two pages devoted to the *khānqāh*, 219–20. The few regional studies of these buildings outline their major features, such as the prayer window and main room. The only significant exceptions to this rule are the many excellent works on the Sufi lodges of Ottoman Anatolia. Although most of these works focus on

buildings in Istanbul, a number of important studies treat Sufi lodges in central and western Anatolia. For studies on Ottoman Istanbul, see the many excellent entries by M. Baha Tanman in *Dünden bügune İstanbul ansiklopedisi*, vols. 1–8 (Istanbul: Kültür Bakanlığı Yayınları, 1993–).

2. In his discussion of the *khānqāh*, Hillenbrand wrote that "[i]nsofar as a standard layout existed, its essentials were a central courtyard flanked by cloisters on to which rows of individual cells opened, with a large hall on the *qibla* side." Hillenbrand, *Islamic Architecture*, 220. General discussions of Seljuk and pre-Ottoman art include statements of limited value such as "the ubiquitous element in dervish lodges is a domed room leading to a barrel-vaulted hall." See Kuran, "Anatolian-Seljuk Architecture," 89.

3. In the *waqf* of Aḥmad ibn Ḥusayn, a *hammam* (bathhouse) and *'imāra* (dervish lodge) are mentioned. See Fahrettin Ali bini Hüseyin Evkaf, defter 604, no. 67, VGM.

4. The Gök Madrasa in Tokat has been heavily restored. There is some controversy concerning the building remains to its north. Evliya Çelebi and other seventeenth-century travelers referred to a building in front of the Gök Madrasa (between its main portal and the *maidān*) that may have been the site of Mu'in al-Dīn's dervish lodge.

5. For the most recent publication of this site, see Cantay, *Anadolu Selçklu ve Osmanlı darüşşifaları*, 60–66. According to Cantay, the building attached to the northern side of the Gök Madrasa was part of the hospital. His thesis is based on the accounts of later travelers. For other dervish lodges in Tokat, see Emir, *Erken Osmanlı*, vol. 1, and Işık Aksulu and Ibrahim Numan, "Tokat Gök Medrese darü's-sülehası'nın restitüsyono," in *Aptullah Kuran için yazılar: Essays in Honour of Aptullah Kuran*, ed. Çiğdem Kafescioğlu and Lucienne Thys-Şenocak (Istanbul: Yapı Kredi Yayınları, 1999), 43–54.

6. Aksulu and Numan, "Tokat Gök Medrese darü's-sülehası'nın restitüsyono."

7. Hüsameddin, *Amasya tarihi* (1986), 1:35.

8. Although this lodge is usually classified as a tomb because it is a single-unit structure containing a number of sarcophagi, an inscription on the window facing the Gök Madrasa does not mention any building title and begins with the generic "was built" (*imara*).

9. Aptullah Kuran, *Anadolu medreseleri* (Ankara: Türk Tarih Kurumu, 1969), 1:96, and Barbara Brend, "The Patronage of Fakhr ad-Dīn ʿAlī ibn al-Ḥusain and the Work of Kalūk ibn ʿabd Allāh in the Development of the Decoration of the Portals in 13th C. Anatolia," *Kunst des Orients* 10 (1975): 360–82.

10. A. Süheyl Ünver, "Buyuk Selçuklu imparatorluğu zamanında vakif hastahanelerin bir kismina dair," *Vakıflar dergisi* 1 (1941): 17–24.

11. As cited in note 9 to Chapter 1, the letter containing Ibn al-ʿArabī's advice is reproduced by al-Aqsarāyī and forms the last section of the *Musāmerat al-akhbār*. The harsh note of the advice stands apart from Ibn al-ʿArabī's general tolerance toward Christians. See William Chittick, *Imaginal Worlds: Ibn al-ʿArabī and the Problem of Religious Diversity* (Albany: State University of New York Press, 1994).

12. Evliya Çelebi, *Evliyâ Çelebi seyâhatnâmesi*, 7:23.

13. Although one could argue that Tokat's location near the ancient site of Comnenan would have made it logical for Sunbul Bābā's builders to borrow material from the ruins, since they were building at a frantic pace, it would have been just as easy for them to cover the cornice so that it was not visible at one of the main focal points of the building. For more on materials in the lodge, see Hakkı Önkal, *Anadolu Selçuklu türbeleri* (Ankara: Türk Tarih Kurumu, 1996), 296–97.

14. Sometimes adjoining buildings were included in the foundation. Adjoining houses (*bait*) are mentioned as part of the *waqfīya* for the dervish lodge of Shams al-Dīn ibn Ḥusayn. See Şemseddin B. Hüseyin Evkaf (162/19), BA.

15. The exception to this is the Shams al-Dīn ibn Ḥusayn lodge.

16. Although Emir's plan does not indicate a tomb window for the Shaikh Majnūn lodge, it appears on other plans and is located in the northern wall of the tomb. On my visit to the lodge in 2000, the window still existed.

17. For more on the relationship between women and the Sunbul Bābā lodge, see Chapter 6.

18. Emir, *Erken Osmanlı*, vol. 1.

19. The *waqfīya* for the Shams al-Dīn ibn Ḥusayn lodge, the earliest surviving lodge in Tokat, includes a reference to neighboring apartments, which must have served as some kind of residence.

20. By contrast, many dervish lodges were required to have unobstructed entrances. See Chapter 5.

21. Sheila Blair has suggested that a saint's tomb was recognizable by the ratio of dome to building. See her "Sufi Saints and Shrine Architecture in the Early Fourteenth Century," *Muqarnas* 7 (1990): 35–49

22. These windows, called prayer windows (*niyaz penceresi*), became a standardized feature of Ottoman dervish lodges. For more on these windows in the Ottoman period, see Raymond Lifchez, "The Lodges of Istanbul," in *The Dervish Lodge: Architecture, Art, and Sufism in Ottoman Turkey* (Berkeley and Los Angeles: University of California Press, 1992), 75.

23. These large street-oriented tomb-chamber windows are also found in Mamlūk and Ottoman architecture. By the Ottoman period they had become a standardized feature, known as the *niyaz penceresi*. Işık Aksulu, "Fetihten Osmanlı dönemi'ne kadar Tokat şehri anıtları" (unpublished doctoral dissertation, Gazī Üniversitesi, Ankara, 1994), plan 72.

24. The idea of a fixed *madrasa* curriculum has been challenged by Michael Chamberlain, who focuses on the role that learned behavior had in reproducing the *ʿulamāʾ* as a class. See his *Knowledge and Social Practice in Medieval Damascus.*

25. Leiser, "The Madrasa and the Islamization of the Middle East."

26. The use of the word *ʿalawī* in a document from this date is perplexing and could support suspicions that the Ottoman copyist of the Gök Madrasa *waqfīya* (Fahrettin Ali bini Hüseyin Evkaf, defter 604, no. 67, VGM) took certain liberties.

27. Excerpts from the foundation act were inscribed on the walls of the *madrasa*. CIA, 91.

28. To the best of my knowledge there was only one double-unit tomb in this region, the ʿAbd al-Wahhab tomb, located on a hill called Akkaya two kilometers east of Sivas.

29. Abdusselam oğlu Torumtay Evkaf, defter 490, no. 100, VGM.

30. Kuran, *Anadolu medreseleri*, 1:96. According to Gabriel, "les murs construits au-dessus des portiques et des cellules sont d'époque récente, mais ils ont remplace, sans doute, une installation plus ancienne." Gabriel, *Monuments turcs d'Anatolie*, 2:157–58.

Chapter 5

1. Rūmī, *Signs of the Unseen*, 130.

2. See Ahmet Yaşar Ocak, "XIII–XV Yüzyillarda Anadolu'da Türk-Hiristiyan dini etkileşimler ve Aya Yorgi (Saint George) kültü," *Belleten* 55 (1992): 661–75.

3. The best sources on these marriages are by Osman Turan, "Les Seldjoukides et leurs sujets," *Studia Islamica* 1 (1953): 65–100, and "L'islamisation dans le Turquie du Moyen Âge," *Studia Islamica* 10 (1959): 111–36. These articles also include much information regarding the role of Christian slaves in the Seljuk state.

4. According to Vryonis, the membership of dervish associations generally included the dervishes themselves and "lay brethren" who were engaged in secular

occupations. *Decline of Medieval Hellenism*, 363.

5. For a recent evaluation of some of these new approaches to the topic of conversion, see Elizabeth A. Zachariadou, "Co-Existence and Religion," *Archivum Ottomanicum* 15 (1997): 119–30. In recent decades, issues of accommodation and cooperation between religious communities have provided a new focus for studies on conversion. In Anatolia, especially, a group of scholars, including Michel Balivet and Colin Imber, have published important examples of what Elizabeth Zachariadou has called "symbiosis, syncretization of the old and new elements, mutual influence and acculturation."

6. Rāzī, *Merṣād al-ʿebād men al-mabdaʾ elāʾl-maʿād*, 485–86.

7. Agriculture was described as *mazraʿ* (lit. "arable land").

8. Vryonis, *Decline of Medieval Hellenism*, 392. For more on the close relationship between pious endowments and agricultural production, see Maria Eva Subtelny, "A Timurid Educational and Charitable Foundation," *Journal of the American Oriental Society* 111, no. 1 (1991): 38–61.

9. See Shihab al-Dīn ʿUmar al-Suhrawardī, *ʿAwarif al-maʿārif*, trans. W. J. Clarke (Lahore: Ashraf, 1991).

10. According to Ibrahim Konyalı, the *waqfīya* stated that Masʿūd ibn Sherifshah "founded the *khānqāh* as a crude leather factory and established it for the *akhīs*." Konyalı argues that the *waqf* foundation was set up to help legists and Sufis support themselves and thus overcome their status as parasites. Ibrahim H. Konyalı, *Konya Tarihi* (Konya: Yeni Kitap, 1964), 387. I wish to thank Edward Mitchell for helping me with this passage.

11. Unfortunately, Konyalı does not provide a photo of the inscription.

12. According to Crane, "Notes on Saldjūq Architectural Patronage in Thirteenth Century Anatolia," 56, the inscription reads, "dār al-ʿilm wa ʿamil." Yet, ʿamil

refers to an agent or worker, which does not make sense in the context of the first part. I would translate the last term as ʿamal, which means "act" or "deed."

13. Gabriel, *Monuments turcs d'Anatolie*, 2:102–3, and Uzunçarşılı, *Kitabeler*, 12.

14. Sinclair, *Eastern Turkey*, 2:317 and addenda and corrigenda, 528.

15. According to L. Gardet, Al-Ghāzali defined ʿamal (and its plural aʿmāl) as "works." See L. Gardet, "ʿAmal," in *Encyclopaedia of Islam*, 2d ed., 1:427.

16. The most obvious example of a mystic connected with guilds is Akhī Yusuf, who is often called the patron saint of the tanners. His center of activity was Kırşehir.

17. Rāzī, *Merṣād al-ʿebād men al-mabdaʾ elāʾl-maʿād*, 477–78.

18. Deodaat Anne Breebart, "The Development and Structure of the Turkish Futuwwah Guilds" (Ph.D. diss., Princeton University, 1961), 111–34.

19. According to Breebart, Sufi ideals had a dramatic effect on the *futūwwa*. See ibid., 67.

20. Ibid., 110.

21. Abdülbâki Gölpınarlı, "Islam ve Türk ellerinde futuvvet teşkilati ve kaynakları," *Istanbul Üniversitesi İktisat mecmuası* 2 (1948–50): 334. For more on al-Naṣīrī, see the rest of Gölpınarlı's article.

22. Ibn Baṭṭūṭa, *The Travels of Ibn Baṭṭūṭa*, vol. 2 (A.D. 1325–1354), trans. H. A. R. Gibb (Cambridge: Cambridge University Press, 1962), 418.

23. Rogers, "Recent Work on Seljuk Anatolia."

24. For example, the fifteenth-century historian Ashikpashazade calls the *akhīs* *misāfir*, while Paul Wittek believes that the term, defined allegorically, can mean "warriors of Islam." Ashikpashazade lists three other groups of *misāfir* besides *akhīs*. See Friedrich Giese's edition, *Die altosmanische Chronik des Aşikpaşade* (Leipzig: O. Harrassowitz, 1929), and Paul Wittek, "Deux chapitres de l'histoire des Turcs de Roum," *Byzantion* 11 (1936): 285–319.

25. Raymond Lifchez, *The Dervish Lodge: Architecture, Art, and Sufism in Ottoman Turkey* (Berkeley and Los Angeles: University of California Press, 1992), 1.

26. The *wāqif* of the ʿAbd al-Muṭṭalib dervish lodge was Muḥyī al-Dīn ʿabd Allah, whose name also appears on the main portal and over the window of the tomb. According to Uzunçarşılı, he was an *akhī*, and the tomb was known as the Akhī Muḥyī al-Dīn tomb. See Uzunçarşılı, *Kitabeler*, 17–18.

27. Marco Polo, as cited by Vryonis, *Decline of Medieval Hellenism*, 235.

28. On mason signs, see Babken Arakʾelian, *The Cities and Crafts in Armenia Between the 9th and 13th Centuries* (in Armenian) (Ereven, 1958), 192, and Toros Tʾoramanian, *Material for the History of Armenian Architecture* (in Armenian) (Yerevan, 1942), cited in Katharina Otto Dorn, "Figural Stone Reliefs on Seljuk Sacred Architecture in Anatolia," *Kunst des Orients* 12 (1978–79): 105. On the use of mason signs on caravansarays, see Erdmann, *Das anatolische Karavansaray*, 1.88, 112, 105, 177.

29. Aflākī-Yazıcı, 2:592–93.

30. Köprülü rejected the idea that Christian and Bektāshī doctrines were similar and maintained that many Bektāshī elements went back to pre-Christian practices in Anatolia. See his "Les Origines du Bektachisme," in *Actes du Congrès international d'histoire des religions* (Paris, 1925), 11:463. As Vryonis points out, however, it is meaningless to state that Bektāshī ritual is pre-Christian, because most of Christian folk practice is itself pre-Christian. Vryonis, *Decline of Medieval Hellenism*, 371 n. 60.

31. Adapted from Birge, *The Bektashi Order*, 215–16.

32. Der Nersessian, Sirarpie, *L'art arménien*, 2d ed. (Paris: Flammarion, 1989).

33. For a recent study of Khiḍr Ilyās/Saint George in Anatolia, see Ocak, "XIII–XV Yüzyıllarda Anadolu'da Türk-Hiristiyan dini etkileşimler ve Aya Yorgi (Saint George) kültü."

34. See Wolper, "Khiḍr, Elwan Çelebi, and the Conversion of Sacred Sanctuaries in Anatolia."

35. Cumont, *Studia Pontica*, 2:225. According to Frederick Hasluck, Ainsworth visited the "Monastery of the Forty" at Sivas, which was probably Armenian. Hasluck, *Christianity and Islam Under the Sultans* (Oxford: Clarendon, 1929; reprint, New York: Octagon Books, 1973), 2:393–94 n. 8.

36. Eugene Bore, *Correspondance et mémoires d'un voyageur en Orient* (Paris: Olivier-Fulgence, 1840), 360, and Cumont, *Studia Pontica*, 2:225.

37. Hasluck, *Christianity and Islam Under the Sultans*, 1:49.

38. Semavi Eyice, "Çorum'un Mecidozu'ne Âşik Pasa oğlu Elvan Çelebi zaviyesi," *Türkiyat mecmuası* 15 (1969): 217, and Franz Taeschner, "Das Heiligtum des Elvan Çelebi in Anatolien," *Wiener Zeitschrift für die Kunde des Morgenlandes* 56 (1960): 227–31.

39. For a discussion of hybridization, see Zachariadou, "Co-Existence and Religion," 119–29.

40. Different accounts of this story are reproduced and analyzed by Priscilla P. Soucek in "Nizāmī on Painters in Painting," in *Islamic Art in the Metropolitan Museum of Art*, ed. Richard Ettinghausen (New York, 1979), 206–8.

41. The *Mathnawī* incorporates well-known parables from Muslim, Christian, and Jewish sources; it comes as no surprise to see Rūmī's retelling of the contest between a Chinese painter and a Greek one.

42. According to Ocak, there was a Kalandariyya center in a village near Tokat, and Baraq Bābā was a *shaikh* there. See Ocak, *Osmanlı imparatorluğunda marjinal sûfîlik*, 69–74.

43. Karamustafa, *God's Unruly Friends*, 62; Abdülbâki Gölpınarlı, *Yunus Emre: Hayati ve bütün Şiirleri* (Istanbul: Altın Kitaplar, 1971), 20–22; Bernard Lewis, "Barak Baba," in *Encyclopaedia of Islam*, 2d ed.,

2:1031–32, and Hamid Algar, "Baraq Baba," in *Encyclopedia Iranica*, 4:851.

44. A similar story of transformation is told about Ṣari Ṣaltūq and Bābā Ilyās; see Hasluck, *Christianity and Islam Under the Sultans*, 2:429–39, and Hüsameddin, *Amasya tarihi* (1329–32), 2:471.

45. Algar, "Baraq Baba," 851, and Aflākī-Yazıcı, 2:848–60.

46. Elwan Çelebi, *Menâkibu'l-kudsîyye*, lxxii.

47. Ocak, citing Elwan Çelebi, *Menâkibu'l-kudsîyye*, 82.

48. Aflākī-Huart, 2:311.

Chapter 6

1. For a discussion of Mamlūk women as guarantors of familial lines, see Carl F. Petry, "Class Solidarity Versus Gender Gain: Women as Custodians of Property in Later Medieval Egypt," in *Women in Middle Eastern History: Shifting Boundaries in Sex and Gender*, ed. Nikki R. Keddie and Beth Baron (New Haven, Conn.: Yale University Press, 1992), 122–42.

2. Devin DeWeese, "Yasavī Sayhs in the Timurid Era: Notes on the Social and Political Role of Communal Sufi Affiliations in the 14th and 15th Centuries," *Oriente Moderno* 2 (1996): 173–88.

3. Holbrook, "Diverse Tastes in the Spiritual Life," 104–5. Conversely, Arberry claims that Rūmī was related to Abū Bakr through paternal descent. A. J. Arberry, *Discourses of Rumi* (London: John Murray, 1961), 1.

4. In his article on the Muslim family, Speros Vryonis points out that Rūmī's biographer ended his book with a section entitled "Names of Children and Successors of Our Great Master Baha al-Dīn Balkhī." Vryonis cites Aflākī-Yazıcı, 2:994–1000. See Vryonis, "The Muslim Family," 213–23.

5. Gurju Khātūn, a widow of the Seljuk sultan Kaykhusraw, gave financial support to the tomb of Jalāl al-Dīn Rūmī in Konya. There is some speculation that she still had access to money from the Seljuk treasury, which allowed her to provide

significant financial backing for this project. Michael Rogers, "Waqf and Patronage in Seljuk Anatolia: The Epigraphic Evidence," *Anatolian Studies* 26 (1976): 89, and Aflākī-Huart, 2:26.

6. A photocopy of the *waqfīya* is included in Saim Savaş, "Tokat'ta Hoca Sünbül zaviyesi," *Vakıflar dergisi* 24 (1993): 206–7. I was able to consult the original text, defter 484, no. 309 (725), Beyler Çelebi bini Tacüddin Muhammad Çelebi Evkaf, at the Vakıflar Genel Müdürlüğü, Ankara.

7. Royal women descended from such Türkmen dynasties as the Dānishmendids and Mangujaks do appear in inscriptions from buildings in Anatolia, suggesting they may have offered some support to the architecture. Among these were Atsuz Elti Khātūn, who was a descendant of Yāghī Basān, and Turan Malik, who was a daughter of Bahram Shāh, the last Mangujak ruler of Erzincan. See Crane, "Notes on Saldjūq Architectural Patronage in Thirteenth Century Anatolia," 12.

8. The standard source on these inscriptions is Etienne Combe et al., *Répertoire chronologique d'épigraphie arabe* (Cairo: Institut français d'archéologie orientale, 1938), nos. 4959 (Sunbul Bābā), 4903 (Shams al-Dīn ibn Ḥusayn), 4960 (Khalif Ghāzī). I was able to study these inscriptions in situ in 1990.

9. Rogers, "Waqf and Patronage in Seljuk Anatolia," 71.

10. Ibid.

11. In the inscription on the Shams al-Dīn ibn Ḥusayn lodge, Malika Ṣafwat al-Dunyā wa al-Dīn is introduced by the phrase "in the days of" (*fī āyyām*). By contrast, the Seljuk sultan is introduced with the phrase "in the time [reign] of" (*fī zaman*). Rogers assumes that the handling of the inscription means that Malika was the wife of the sultan, yet he does not explain why he makes that judgment. For more on the distinction between *āyyām* and *zaman*, see F. Rosenthal, "The 'Time' of Muslim Historians and Muslim Mystics," *Jerusalem Studies in Arabic and Islam* 19 (1995): 5–35.

12. References to Mu'īn al-Dīn's daughter and her connection to the Sunbul Bābā lodge appear in Crane, "Notes on Saldjūq Architectural Patronage in Thirteenth Century Anatolia," 53; Halil Edhem, "Anadolu'da Islami kitabeler (Tokat)," *Tarih-i Osmanı encümeni mecmuası*, pt. 35 (1327): 650–53; Gabriel, *Monuments turcs d'Anatolie*, 2:103; Hüsameddin, *Amasya tarihi* (1927), 3:23; Rogers, "The Date of the Çifte Minare Medrese at Erzurum," 79; Savaş, "Tokat'ta Hoca Sünbül zaviyesi"; E. Yurdakul, "Tokat vilâyetinde bilinmeyen bir Selçuklu hanikâhı," *Önasya* 5, nos. 59–60 (1970): 9–10.

13. Savaş, "Tokat'ta Hoca Sünbül zaviyesi," 200.

14. For more information on the building activity of Mu'īn al-Dīn's sons, see Uzunçarşılı, "Kastamonu ve Sinop'ta Pervanezadeler"; and Oral, "Durağan ve Bafra'da iki türbe," 387–88.

15. For full titles, see Crane, "Notes on Saldjūq Architectural Patronage in Thirteenth Century Anatolia," 29. Other sources on Mu'īn al-Dīn's sons are Nejat Kaymaz, *Pervâne Muînü'd-dîn Süleyman* (Ankara: Ankara Üniversitesi Basımevi, 1970), and Uzunçarşılı, *Anadolu beylikleri ve Akkoyunlu*, 148–49.

16. The confusion over her names and titles, coupled with the scanty source material available on the Seljuks, adds to the difficulty in investigating this woman. See Rogers, "The Date of the Çifte Minare Medrese at Erzurum," 82 n. 14.

17. Cahen, *Pre-Ottoman Turkey*, 280–92.

18. Mu'īn al-Dīn was married to Gurju Khātūn, the widow of the Seljuk sultan Kaykhusraw. It is not clear if the daughter mentioned in the building inscription was Gurju Khātūn's daughter. In any case, Gurju Khātūn also had a daughter, called 'Ayn al-Dīn, who was married to an Atabeg. See Kaymaz, *Pervâne Muînü'd-dîn Süleyman*, 366–67.

19. Māhperī Khātūn was the wife of 'Alā' al-Dīn Kay-Qubād. An inscription on

the sarcophagus in her tomb states, "This is the tomb of the lady . . . Ṣafwat al-Dunyā wa al-Dīn Mahperi Khātūn, mother of Sultan" (Ülkü Bates, "The Anatolian Mausoleums of the 12, 13, and 14th Centuries" [Ph.D. diss., University of Michigan, 1970], 144–45).

20. Howard Crane suggests that she might have been the wife of Sultan 'Alā' al-Dīn Kay-Qubād. Crane, "Notes on Saldjūq Architectural Patronage in Thirteenth Century Anatolia," 53.

21. Rogers, "Waqf and Patronage in Seljuk Anatolia," 71.

22. In one of the earliest works on women as patrons in Turkey, Ülkü Bates studied buildings bearing women's names for information on their role in society. See Bates, "Women as Patrons of Architecture in Turkey," in *Women in the Muslim World*, ed. Lois Beck and Nikki Keddic (Cambridge, Mass.: Harvard University Press, 1978), 245–60.

23. Building inscriptions were a type of "public text." I use this definition here to imply that public texts by nature of their highly visible location and the force of authority behind them provided a suitable forum for reinforcing or altering messages about sovereign power. For a discussion of "public text," see Irene Bierman, "The Art of the Public Text: Medieval Islamic Rule," in *World Art: Themes of Unity in Diversity*, ed. Irving Lavin (University Park: Pennsylvania State University Press, 1989), 2:283–90, and idem, *Writing Signs: The Fatimid Public Text* (Berkeley and Los Angeles: University of California Press, 1998), 1–27.

24. Holbrook, "Diverse Tastes in the Spiritual Life," 99–120.

25. Although it is beyond the scope of this chapter to discuss the representation of women in all Seljuk sources, there is some need to address the representation of Seljuk women in historical sources. The paucity of source material available on the Seljuks of Anatolia has, for example, led some scholars to look to the rich material available for

the Seljuks of Iran, or Great Seljuks, in search of material on Seljuk women. The problem with this approach is that Anatolian court life developed under a number of local influences and did not duplicate that of either the Seljuks of Iran or the Ilkhānids. For information on some of the more notable women from these dynasties, see Ann K. S. Lambton, *Continuity and Change in Medieval Persia: Aspects of Administrative, Economic, and Social History, 11th–14th Century* (Albany, N.Y.: Bibliotheca Persica, 1988), 258–96.

26. There is even some speculation that Mu'īn al-Dīn had two daughters associated with the order.

27. Aflākī-Yazıcı, 2:951–53.

28. A copy of this *waqfīya* is published in Savaş, "Tokat'ta Hoca Sünbül zaviyesi," 206–9.

Chapter 7

1. For a study of Malik Dānishmend's life in the context of medieval Anatolia, see Claude Cahen, "La première pénétration Turque en Asie-Mineure," *Byzantion* 18 (1946–48): 5–67. For information on the *Dānishmendnāme*, see Mélikoff, *La geste de Melik Dāniṣmendid*, vol. 1. Material cited from the *Dānishmendnāme* is taken from her edition of the text.

2. Kafadar, *Between Two Worlds*, 66.

3. The 1315 copy was similar to the 1279 copy, written for the Seljuk sultan Kay-Kā'ūs, in that it praised the house of Seljuk.

4. For more on these sites, see Ocak, *La révolte de Baba Resul*, 58–72.

5. For more on Sayyid Baṭṭāl, see Irène Mélikoff, "Al-Baṭṭāl (Sayyid Baṭṭāl Ghāzī)," in *Encyclopaedia of Islam*, 2d ed., 1:1103–4.

6. As Mélikoff points out, legends about the Arab-Byzantine wars were adopted by the Turks, who incorporated these legends into stories about the conquest of Anatolia. Ibid., 1:1104. Sayyid Baṭṭāl Ghāzī was particularly popular during the Seljuk period; his shrine had been "discovered" by the Seljuks. See Kafadar, *Between Two Worlds*, 65.

7. Aside from his Christianity, little is known about the ethnic identity of Artuḥī. It is tempting to label him Armenian because of the frequent presence of Armenian companions in stories of Turkish heroes. Balivet, *Romanie byzantine et pays de Rum turc*, 61–64.

8. Khalif Ghāzī may also have been a *wazīr* of Malik Dānishmend's successor. Mélikoff, *La geste de Melik Dāniṣmend*, 455.

9. In his work on Seljuk sources, Köprülü described the *Dānishmendnāme* as a *manāqib* because it functioned as a type of praise literature. See Köprülü, *Origins of the Ottoman Empire*, 38–43.

10. Sayyid Baṭṭāl Ghāzī was a champion of the Arabs in the early wars against Byzantium. His epic story, the *Baṭṭālnāme*, was transformed into a Turkish romance, and he himself was incorporated into the epic cycle of Malatya. After the Dānishmendid conquest of Malatya in 1102, they and the other Turkish dynasties adapted this figure to their own epic cycles and traced their heroes back to him. Vryonis, *Decline of Medieval Hellenism*, 273.

11. The primary example in the field of Islamic art history is Oleg Grabar's discussion of building activity as the symbolic appropriation of land. See especially Grabar, *The Formation of Islamic Art* (New Haven, Conn.: Yale University Press, 1987), 43–71.

12. Exceptions to this rule are Scott Redford, "The Seljuqs of Rum and the Antique," *Muqarnas* 10 (1993): 148–56, and Gonul Öney, "Anadolu Selçuk

mimarisinde antik devir malzemesi," *Anadolu* 12 (1968): 17–38.

13. The same type of workmanship is also seen in the main domed room of the Sunbul Bābā dervish lodge in Tokat. Gabriel, *Monuments turcs d'Anatolie*, 2:57–59, and Cumont, *Studia Pontica*, 1:49.

14. Hüsameddin, *Amasya tarihi* (1327–30), 1:189.

15. Cumont, *Studia Pontica*, 1:169–70.

16. This portal was still evident in Albert Gabriel's photo, where it is in the center of the façade, and in another photograph by Franz Cumont. Gabriel, *Monuments turcs d'Anatolie*, 2:57–59; Cumont, *Studia Pontica*, 1:169–70 and 3:139, 147.

17. For more on this figure, see Ibn Bībī-Erzi, 502–4.

18. Yinanç, "Selçuklu medreselerinden Amasya Halifet Gazi medresesi ve vakıfları."

19. Ibid.

20. Ocak, *Islam-Türk ınançlarinda Hizir yahut Hizir-Ilyas kültü* (Ankara: Ankara Universitesi Basimevi, 1985), 129.

21. Ibid., 126–28.

22. Elwan Çelebi, *Menâkibu'l-kudsîyye*, lxxiii, and Ahmet Yaşar Ocak, "Emirci Sultan ve zaviyesi," *Tarih Enstitüsu dergisi* 9 (1978): 132–80. According to a recent article by Peter Wilson, it may be more accurate to understand Khiḍr as "both St. George and the dragon in one figure." See Wilson, "The Green Man: The Trickster Figure in Sufism," *Gnosis Magazine* (1991): 23. For a more general discussion of Khiḍr in Islam, see Irfan Omer, "Khiḍr in the Islamic Tradition," *Muslim World*

83, nos. 3–4 (1993): 279–94, and W. M. Thackston Jr., *The Tales of the Prophets of al-Kisa'i* (Boston: Kazi, 1978).

23. Uzunçarşılı, *Anadolu beylikleri ve Akkoyunlu*, 149.

24. Hasluck, *Christianity and Islam Under the Sultans*, 2:702–5.

Epilogue

1. I would like to thank Omid Safi for this translation and for his help in its interpretation. For a slightly different translation, see Mehmet Önder, *Mevlâna Jelaleddin Rûmî* (Ankara: Culture Ministry, 1999), vi.

2. Michael Gilsenan, *Recognizing Islam: Religion and Society in the Modern Arab World* (New York: Pantheon, 1982), 269.

3. Ibn Baṭṭūṭa, *Travels*, 418, and Zakāriyya' ibn Muḥammad al-Qazwīnī, *Athār al-bilād ve akhbār al-ʿibād* (Beirut: Dār Bairūt, 1960), 537–38.

4. Aflākī-Yazıcı, 1:54.

5. Talât Sait Halman and Metin And, *Mevlana Celaleddin Rumi and the Whirling Dervishes* (Istanbul: Dost Yayınları, 1983), 21.

6. I would like to thank Nasser Rabat for his suggestions regarding the lack of intellectual and physical borders for dervish lodges.

7. The concepts of "place" and "space" are articulated in Tuan Yi Fu, *Space and Place: The Perspective of Experience* (St. Paul: University of Minnesota Press, 1977), and Tilley, *Phenomonology of Landscape*.

Main Archival Sources

Prime Minister Archives, Istanbul (Başbakanlık Arşivinde) (= BA)
Cevdet Collection
Ibn'ul Emin Collection
Directorate of Waqfs, Vakıflar Genel Müdürlüğü, Ankara (= VGM)

Other Primary Sources

Abū al-Faraj, Gregory [Bar Hebraeus]. *Abû'l Farac tarihi*. 2 vols. Translated by Ömer Riza Doğrul. Ankara: Türk Tarih Kurumu, 1987.

al-Aflākī, Shams al-Dīn Aḥmad al-ʿĀrifī. *Manāḳib al-ʿārifīn*. Edited by Tahsin Yazıcı. 2 vols. Ankara: Türk Tarih Kurumu, 1976.

——. *Âriflerin menkıbeleri*. Translated by Tahsin Yazıcı. 2 vols. Istanbul: Hürriyet, 1973.

——. *Les saints des derviches tourneurs*. Translated by Clement Huart. Paris: E. Leroux, 1918–22.

al-Aqsarāyī, Karīm al-Dīn Maḥmud ibn Muḥammad. *Musâmeretü'l ahbâr ve musâyarat al-akhyār*. Edited by Osman Turan. Ankara: Türk Tarih Kurumu, 1944.

ʿĀşiqpaşa-Zāde. *Aşıkpaşa-zāde tarihi*. Edited by Ali Bey. Istanbul: Matbaʿa-i âmire, 1332 (1914).

Astarābadī, ʿAzīz ibn Ardashīr. *Bezm u rezm*. Turkish translation by Mürsel Öztürk. Ankara: Kültür Bakanlığı Yayınları, 1990.

Bektāsh, Ḥājjī. *Vilâyet-Nâme: Manâkıb-ı Hünkâr Hacı Bektâş-ı Velî*. Translated by A. Gölpınarlı. Istanbul: Inkilâp Kitabevi, 1958.

Comnena, Anna. *The Alexiad of Anna Comnena*. Translated by E. R. A. Sewter. Harmondsworth, Middlesex: Penguin, 1969.

Elwan Çelebi. *Menâkıbu'l-kudsîyye fî menâsibi'l-ünsiyye*. Edited by İsmail E. Erunsal and Ahmet Yaşar Ocak. 2d ed. Istanbul: Türk Tarih Kurumu, 1995.

Evliya Çelebi. *Evliyâ Çelebi seyâhatnâmesi*. Translated by Zuhuri Danişman. Istanbul: Kardeş, 1970.

Fakhruddin ʿIraqi. *Fakhruddin ʿIraqi: Divine Flashes*. Translated by William Chittick and Peter Lamborn Wilson. New York: Paulist, 1982.

Ibn Baṭṭūṭa. *Riḥlat Ibn Baṭṭūtah*. Cairo, 1958.

——. *The Adventures of Ibn Battuta: A Muslim Traveler of the 14th Century*. Translated by Ross E. Dunn. Berkeley and Los Angeles: University of California Press, 1989.

——. *The Travels of Ibn Baṭṭūṭa*. Vol. 2 (A.D. 1325–1354). Translated by H. A. R. Gibb. Cambridge: Cambridge University Press, 1962.

Ibn al-Bībī, Naṣīr al-Dīn. *El Evāmirü'l-ʿalāʾiyye fī'l umūrī'l-ʿalāʾiyye*. Edited by Adnan Sadık Erzi. Ankara: Türk Tarih Kurumu, 1955.

——. *Die Seltschukengeschichte des Ibn Bībī*. Translated by Herbert W. Duda. Copenhagen: Munksgaard, 1959.

Ibn Fadl Allah al-Umari. *Al-Umari's Bericht über Anatolien in seinem Werke Masalik al-absar fi mamalik al-amsar*. Edited by Franz Taeschner. Leipzig: Harrassowitz, 1929.

al-Naṣīrī. *Der anatolische Dichter Nasiri (um 1300) und sein Futuvvetname*. Edited by Franz Taeschner. Leipzig: F. A. Brockhaus, 1944.

Qazwīnī, Ḥamd Allāh Mustawfī. *The Geographical Part of the Nuzhat al-Qulub Composed by Hamd-allāh Mustawfī of Qazwīn in 740 (1340)*. E. J. W. Gibb Memorial Series, vol. 23, pts. 1 and 2. Edited and translated by Guy Le Strange. London: Luzac & Co., 1915 (pt. 1, text) and 1919 (pt. 2, translation).

——. *Tarih-i Güzide*. Translated by Edward G. Browne. Leiden: E. J. Brill, 1910.

al-Qazwīnī, Zakāriyyaʾ ibn Muḥammad. *Athār al-bilād ve akhbār al-ʿibād*. Beirut: Dār Bairūt, 1960.

Rāzī, Najm al-Dīn. *Merṣād al-ʿebād men al-mabdaʾ elā'l-maʿād: The Path of God's Bondsmen from Origin to Return*. Persian Heritage Series, no. 35. Translated by Hamid Algar. Delmar, N.Y.: Caravan Books, 1982.

Rūmī, Jalāl al-Dīn. *Kitāb-ī fīhi mā fīhi*. Translated by W. M. Thackston Jr. as *Signs of the Unseen: The Discourses of Jalaluddin Rumi*. Putney, Vt.: Threshold, 1994.

——. *The Mathnawī of Jalálu'ddín Rúmí*. Translated by R. A. Nicholson. 8 vols. London: Luzac & Co., 1926–34.

Sipahsālār, Farīdūn ibn Aḥmad. *Risālah-i Farīdūn ibn-i Ahmad Sipahsālār dar ahvāl-i Mawlānā Jalāluddīn Mawlawī.* Edited by Saʿīd Nafīsī. Tehran: Iqbāl, 1325 (1984).

Tārikh-i Āl-i Sāljūq dar Ānātoli: Anadolu Selçukluları devleti tarihi III. Translated by Feridün Nafiz Uzluk. Ankara: Örnek Matbaası, 1952.

Secondary Sources

Acun, Hakkı. "Sivas ve çevresi tarihi eserlerinin listesi ve turistik değerleri." *Vakıflar dergisi* 20 (1988): 183–220.

Akçay, İ. "Tokat tekkeleri (Tokat)." *Ülkemiz* 3–4 (1967): 19–24.

Aksulu, Işık. "Fetihten Osmanlı dönemi'ne kadar Tokat şehri anıtları." Unpublished doctoral dissertation, Gazī Üniversitesi, Ankara, 1994.

———. "The Restitution of the Halef Gazi Zawiya in Tokat." In *The 10th International Congress of Turkish Art,* 53–59. Geneva: Foundation Max Van Berchem, 1999.

Aksulu, Işık, and Ibrahim Numan. "Tokat Gök Medrese darü's-sülehası'nın restitüsyono." In *Aptullah Kuran için yazılar: Essays in Honour of Aptullah Kuran,* edited by Çiğdem Kafescioğlu and Lucienne Thys-Şenocak, 43–54. Istanbul: Yapı Kredi Yayınları, 1999.

Amitai-Preiss, Reuven. "Sufis and Shamans: Some Remarks on the Islamization of the Mongols in the Ilkhanate." *Journal of the Economic and Social History of the Orient* 42, no. 1 (1999): 27–46.

Arberry, Arthur J. *Sufism: An Account of the Mystics of Islam.* 2d ed. New York: Harper & Row, 1970.

Aslanapa, Oktay. *Turkish Art and Architecture.* New York: Praeger, 1971.

Bachelard, Gaston. *The Poetics of Space.* Translated by Maria Jolas. Boston: Beacon Press, 1969.

Bakhtiar, Laleh. *Sufi Expressions of the Mystic Quest.* New York: Thames and Hudson, 1976.

Balivet, Michel. *Romanie byzantine et pays de Rûm turc: Histoire d'un espace d'imbrication gréco-turque.* Istanbul: Isis, 1994.

Barkan, Ömer Lutfi. "İstila devirlerinin kolonizatör Türk dervişleri ve zaviyeler." *Vakıflar dergisi* 2 (1942): 279–304.

Bates, Ülkü. "The Anatolian Mausoleums of the 12, 13, and 14th Centuries." Ph.D. diss., University of Michigan, 1970.

———. "Architecture." In *Turkish Art,* edited by Esin Atil, 43–136. Washington, D.C.: Smithsonian Institution, 1980.

———. "The Impact of the Mongol Invasion on Turkish Architecture." *International Journal of Middle Eastern Studies* 15 (1978): 23–32.

———. "Women as Patrons of Architecture in Turkey." In *Women in the Muslim World,* edited by Lois Beck and Nikki Ked-die, 245–60. Cambridge, Mass.: Harvard University Press, 1978.

Bayram, Mikâil. *Ahi Evren ve ahi teşkilâti'nin kuruluşu.* Konya: Damla Matbaacılık ve Ticaret, 1991.

Bayram, Sadi, and Ahmet Hamdi Karabacak. "Sahib Ata Fahrü'd-dîn Ali'nin Konya, imaret ve Sivas Gök Medrese vakfiyeleri." *Vakıflar dergisi* 13 (1981): 31–69.

Beldiceanu-Steinherr, Irene. "Fiscalité et formes de possession de la terre arable dans l'Anatolie pré-ottomane." *Journal of the Economic and Social History of the Orient* 19 (1976): 241–77.

———. "La 'révolte' des Baba'i en 1240: Visait-elle vraiment le renversement de pouvoir seldjoukide?" *Turcica* 30 (1998): 99–118.

Berkey, Jonathan. *The Transmission of Knowledge in Medieval Cairo.* Princeton: Princeton University Press, 1992.

Bierman, Irene. "The Art of the Public Text: Medieval Islamic Rule." In *World Art: Themes of Unity in Diversity,* edited by Irvin Lavin, 2:283–90. University Park: Pennsylvania State University Press, 1989.

———. *Writing Signs: The Fatimid Public Text.* Berkeley and Los Angeles: University of California Press, 1998.

Bilgin, Ilhami. "Über die Tekke-Architektur des 13 Jahrhunderts in Anatolien." In *Fifth International Congress of Turkish Art,* edited by G. Feher, 183–89. Budapest: Akademiai Kiado, 1978.

Birge, John K. *The Bektashi Order of Dervishes.* Hartford, Conn.: Hartford Seminary, 1937.

Blair, Sheila. "Sufi Saints and Shrine Architecture in the Early Fourteenth Century." *Muqarnas* 7 (1990): 35–49.

Bore, Eugene. *Correspondance et mémoires d'un voyageur en Orient.* Paris: Olivier-Fulgence, 1840.

Breebart, Deodaat Anne. "The Development and Structure of the Turkish Futuwwah Guilds." Ph.D. diss., Princeton University, 1961.

Brend, Barbara. "The Patronage of Fakhr ad-Dīn ʿAlī ibn al-Ḥusain and the Work of Kalūk ibn ʿabd Allāh in the Development of the Decoration of Portals in 13th C. Anatolia." *Kunst des Orients* 10 (1975): 360–82.

Browne, Edward G. *Literary History of Persia, 1265–1502.* Vol. 3. Cambridge: Cambridge University Press, 1964.

Bulliet, Richard W. "Numismatic Evidence for the Relationship Between Tughril Beg and Chaghri Beg." In *Near Eastern Numismatics, Iconography, Epigraphy, and History: Studies in Honor of George C. Miles,* edited by Dickran K. Kouymjian, 289–96. Beirut: American University of Beirut, 1974.

Cahen, Claude. "Baba Ishaq, Baba Ilyās, Hadjdji Bektash et quelques autres." *Turcica* 1 (1969): 53–64.

——. "Ibn Saʿid sur l'Asie Mineure seldjuqide." *Tarih araştırmaları dergisi* 6 (1968): 41–50. Reprinted in Claude Cahen, *Turcobyzantina et Oriens Christianus*, London: Variorum Reprints, 1974.

——. "Mouvements populaires et autonomisme dans l'Asie musulmane du Moyen Âge." *Arabica* 5 (1958): 225–50, and 6 (1959): 25–56 and 233–65.

——. *Pre-Ottoman Turkey: A General Survey of the Material and Spiritual Culture and History, c. 1071–1330*. Translated by J. Jones-Williams. New York: Taplinger, 1968.

Cantay, Gönül. *Anadolu Selçklu ve Osmanlı darüşşifaları*. Ankara: Türk Tarih Kurumu, 1992.

Carcaradec, Marie de. "Un monument inédit a Tokat: Seyh Meknun Zaviyesi." *Turcica* 9/1 (1977): 111–19.

Cevdet, M. "Sivas darüşşifası vakfiyesi ve tercümesi." *Vakıflar dergisi* 1 (1938): 35–38.

Cezar, Mustafa. *Typical Commercial Buildings of the Ottoman Classical Period and the Ottoman Construction System*. Ankara: Türkiye İş Bankası, 1983.

Chamberlain, Michael. *Knowledge and Social Practice in Medieval Damascus, 1190–1350*. Cambridge: Cambridge University Press, 1994.

Chittick, William. *Fakhruddin ʿIraqī: Divine Flashes*. New York: Paulist, 1982.

Crane, Howard. "Notes on Saldjūq Architectural Patronage in Thirteenth Century Anatolia." *Journal of the Economic and Social History of the Orient* 36 (1993): 1–57.

Cuinet, Vital. *La Turquie d'Asie*. Vol. 1. Paris: E. Leroux, 1890.

Cumont, Franz. *Studia Pontica*. Vols. 1–3. Brussels: H. Lamertin, 1903–10.

de Certeau, Michel. *The Practice of Everyday Life*. Translated by Steven F. Rendall. Berkeley and Los Angeles: University of California Press, 1984.

Der Manuelian, Lucy. "The Monastery of Geghard: A Study of Armenian Architectural Sculpture in the 13th Century." Ph.D. diss., Boston University, 1980.

DeWeese, Devin. *Islamization and Native Religion in the Golden Horde: Baba Tükles and Conversion to Islam in Historical and Epic Tradition*. University Park: Pennsylvania State University Press, 1994.

——. "The Mashāʾikh-i Turk and the Khojagān: Rethinking the Links Between the Yasavī and Naqshbandī Sufi Traditions." *Journal of Islamic Studies* 7, no. 2 (1996): 180–207.

——. "Sacred Places and 'Public' Narratives: The Shrine of Aḥmad Yasavī in Hagiographical Traditions of the Yasavī Ṣūfī Order, 16th–17th Centuries." *Muslim World* 90, nos. 3–4 (special issue: *Sufi Saints and Shrines in Muslim Society*, edited by Jamal Elias) (2000): 353–76.

——. "Yasavī Sayhs in the Timurid Era: Notes on the Social and Political Role of Communal Sufi Affiliations in the 14th and 15th Centuries." *Oriente Moderno* 2 (1996): 173–88.

Edhem, Halil, and Max Van Berchem. *Matériaux pour un corpus inscriptionum arabicarum*. Vol. 3, pt. 1, *Siwas et Divriği*. Cairo: L'institut français d'archéologie orientale, 1917.

Elias, Jamal. "Mawlawīyah." In *Oxford Encyclopedia of the Modern Islamic World*, vol. 3, edited by John L. Esposito. Oxford: Oxford University Press, 1995.

Emir, Sedat. *Erken Osmanlı mimarlığında çok-işlevli yapılar: Kentsel kolonizasyon yapıları olarak zâviyeler*. Vol. 1. Izmir: Akademi Kitabevi, 1994.

Erdmann, Kurt. *Das anatolische Karavansaray des 13. Jahrhunderts*. 2 vols. Berlin: Verlag Gebr. Mann, 1961.

——. "Seraybauten des dreizehnten Jahrhunderts in Anatolien." *Ars Orientalis* 3 (1959): 77–94.

Ettinghausen, Richard, and Oleg Grabar. *The Art and Architecture of Islam, 650–1250*. Harmondsworth, Middlesex: Penguin, 1987.

Eyice, Semavi. "İlk Osmanlı devrinin dinî-içtimaî bir müessesesi: Zâviyeler ve zâviyeli-camiler." *İktisat Fakültesi mecmuası* 23 (1963): 1–80.

Ferit, M., and M. Mesut. *Selçuk veziri Sahip Ata ile oğullarının hayat ve eserleri*. Istanbul: Türkiye Matbaası, 1934.

Fernandes, Leonor. *The Evolution a Sufi Institution in Mamluk Egypt: The Khanqah*. Berlin: Klaus Schwarz Verlag, 1988.

Gabriel, Albert. *Les monuments turcs d'Anatolie*. 2 vols. Paris: E. de Boccard, 1934.

Geary, Patrick. *Phantoms of Remembrance: Memory and Oblivion at the End of the First Millennium*. Princeton: Princeton University Press, 1994.

Göksel, Fikret. "Tokat'ta Osmanlılardan önceki Türk eserleri." Ph.D. diss., İstanbul Üniversitesi Edebiyat Fakültesi Sanat Tarihi Bölümü, 1969.

Golombeck, Lisa. "Cult of Saints and Shrine Architecture in the Fourteenth Century." In *Near Eastern Numismatics, Iconography, Epigraphy, and History: Studies in Honor of George C. Miles*, edited by Dickran K. Kouymjian, 419–30. Beirut: American University of Beirut, 1974.

Gölpınarlı, Abdülbâki. "Islam ve Türk ellerinde futuvvet teşkilatı ve kaynakları." *İstanbul Üniversitesi İktisat mecmuası* 2 (1948–50).

——. *Mevlânâ'dan sonra mevlevîlik*. Istanbul: Gül, 1953.

Grenard, F. "Sur les monuments du Moyen Âge." *Journal Asiatique* 17 (1901): 549–58.

Gronke, Monika. "Les notables Iraniens a l'époque mongole: Aspects économiques et sociaux d'après les documents

du sanctuaire d'Ardebil." In *Documents de l'Islam médié-*
val: Nouvelles perspectives de recherche: Actes de la table
ronde, edited by Yusuf Ragib, 117–20. Cairo: Institut
français d'archéologie orientale, 1919.

Hamilton, William J. *Researches in Asia Minor, Pontus and Arme-*
nia. Vol. 1. London: John Murray, 1842.

Hasluck, Frederick. *Christianity and Islam Under the Sultans*. 2
vols. Oxford: Clarendon, 1929. Reprint, New York: Octa-
gon Books, 1973.

Hill, Derek, and Oleg Grabar. *Islamic Archiecture and Its Decora-*
tion. London: Faber & Faber, 1967.

Hodgson, Marshall G. S. *The Venture of Islam*. Vol. 2. Chicago:
University of Chicago Press, 1974.

Hoexter, Miriam. "*Waqf* Studies in the Twentieth Century: The
State of the Art." *Journal of the Economic and Social His-*
tory of the Orient 41, no. 4 (1998): 474–95.

Holbrook, Victoria. "Diverse Tastes in the Spiritual Life: Textual
Play in the Diffusion of Rumi's Order." In *The Legacy of*
Medieval Persian Sufism, edited by Leonard Lewisohn,
99–120. London: Khaniqahi Nimatullahi, 1992.

Homerin, Th. Emil. "Saving Muslim Souls: The Khānqāh and the
Sufi Duty in Muslim Lands." *Mamlūk Studies Review*, pt.
3 (1999): 59–83.

———. "Sufism and Its Detractors in Mamluk Egypt: A Survey of
Protaganists and Institutional Settings." In *Islamic Mysti-*
cism Contested: Thirteen Centuries of Controversies and
Polemics, edited by Frederick de Jong and Bernd Radtke,
225–47. Leiden: E. J. Brill, 1999.

Huart, Clement. "De la valeur historique des mémoires des derviches
tourneurs." *Journal asiatique*, 2d ser., 19 (1922): 308–17.

Hüsameddin, Hüseyin. *Amasya tarihi*. Vols. 1–4. Istanbul: Hik-
met Matbaası Islamiyesi, 1911–35.

———. *Amasya tarihi*. Vol. 1. Translated by Ali Yilmaz and
Mehmet Akkus. Ankara: Amasya Belediyesi Kültür
Yayınları, 1986.

Inalcik, Halil. *The Ottoman Empire: The Classical Age,*
1300–1600. Translated by Colin Imber and N.
Itzkowitz. New York: Praeger, 1973.

Johansen, Baber. *The Islamic Law on Land Tax and Rent*. New
York: Croom Helm, 1988.

Kafadar, Cemal. *Between Two Worlds: The Construction of the*
Ottoman State. London: University of California Press,
1995.

Karamağaralı, B. "Şeyh Meknûn türbesindeki sgrafittolar." In *Türk*
Tarihinde ve Türk Kültüründe Tokat Sempozyumu, 2–6
Temmuz 1986, edited by S. Hayri Bolay. Ankara:
Gelişim Matbaası, [1987].

Karamustafa, Ahmet T. "Early Sufism in Eastern Anatolia." In
Classical Persian Sufism: From Its Origins to Rumi.
Edited by Leonard Lewisohn, 175–83. London:
Khaniqahi Nimatullahi, 1993.

———. *God's Unruly Friends: Dervish Groups in the Islamic Later*
Middle Period, 1200–1550. Salt Lake City: University of
Utah Press, 1994.

Kayaoğlu, İsmet. "Rahatoğlu ve vakfiyesi." *Vakıflar dergisi* 13
(1981): 1–29.

Kaymaz, Nejat. *Pervâne Muînü'd-dîn Süleyman*. Ankara: Ankara
Üniversitesi Basımevi, 1970.

Konyalı, Ibrahim H. *Konya tarihi*. Konya: Yeni Kitap, 1964.

Köprülü, Mehmet Fuad. "Anadolu'da islâmiyet: Türk istilâsından
sonra Anadolu tarih-i dinisine bir nazar ve bu tarihin
menbaları." *Darülfünün Edebiyat Fakültesi mecmuası* 2
(1922): 281–311, 385–420, 457–86.

———. "Anadolu Selçukluları tarihi'nin yerli kaynakları." *Belleten*
7 (1943): 379–458.

———. *Influence du chamanisme turco-mongol sur les ordres mys-*
tiques musulmans. Istanbul: Mémoires de l'Institut du
Turcologie de L'Université de Stanboul, 1929.

———. *Islam in Anatolia After the Turkish Invasion*. Translated by
Gary Leiser. Salt Lake City: University of Utah Press, 1993.

———. *Les origines de l'Empire Ottoman*. Paris: Boccard, 1935.

———. *Osmanlı imparatorluğunun kuruluşu*. English translation by
Gary Leiser. *The Origins of the Ottoman Empire*. Albany:
State University of New York Press, 1992.

———. *Türk edebiyati'nda ilk mutasavvıflar*. 2d ed. Ankara: Ankara
Üniversitesi, 1966.

———. "Vakıf müessessesinin hukukî mahiyeti ve tarihî tekâmülü."
Vakıflar dergisi 2 (1942): 1–36.

Kuban, Doğan. *100 soruda Türkiye sanatı tarihi*. Istanbul: Gerçek,
1970.

———. *Anadolu-Türk mimarisinin, kaynak ve sorunları*. Istanbul:
Istanbul Teknik Üniversitesi Mimarlik Fakultesi, 1970.

Kuran, Aptullah. *Anadolu medreseleri*. Vol. 1. Ankara: Türk Tarih
Kurumu, 1969.

———. "Anatolian-Seljuk Architecture." In *The Art and Architec-*
ture of Turkey, edited by Ekrem Akurgal. New York:
Oxford University Press, 1980.

———. *The Mosque in Early Ottoman Architecture*. Chicago: Uni-
versity of Chicago Press, 1968.

Lambton, Ann K. S. *Continuity and Change in Medieval Persia:*
Aspects of Administrative, Economic, and Social History,
11th–14th Century. Albany, N.Y.: Bibliotheca Persica, 1988.

Lefebvre, Henri. *The Production of Space*. Translated by Donald
Nicholson Smith. Cambridge, Mass.: Blackwell, 1991.

Leiser, Gary. *A History of the Seljuks: Ibrahim Kafesoğlu's Interpretation and the Resulting Controversy*. Carbondale: Southern Illinois University Press, 1988.

——. "The Madrasa and the Islamization of the Middle East: The Case of Egypt." *Journal of the American Research Center in Egypt* 22 (1985): 29–47.

Lewis, Franklin D. *Rumi: Past and Present, East and West: The Life, Teachings, and Poetry of Jalâl al-Din Rumi*. Oxford: Oneworld, 2000.

Lewisohn, Leonard. *Beyond Faith and Infidelity: The Sufi Poetry and Teachings of Mahmud Shabistari*. Richmond, Surrey: Curzon, 1995.

Lifchez, Raymond, *The Dervish Lodge: Architecture, Art, and Sufism in Ottoman Turkey*. Berkeley and Los Angeles: University of California Press, 1992.

Lindner, Rudi Paul. "The Challenge of Kiliç Arslan IV." In *Near Eastern Numismatics, Iconography, Epigraphy, and History: Studies in Honor of George C. Miles*, edited by Dickran K. Kouymjian, 411–18. Beirut: American University of Beirut, 1974.

Little, Donald P. "The Nature of Khānqāhs, Ribāts, and Zāwiyas Under the Mamlūks." In *Islamic Studies Presented to Charles J. Adams*, edited by Wael B. Hallaq and Donald P. Little, 91–105. Leiden: E. J. Brill, 1991.

Mélikoff, Irène. "Al-Baṭṭāl." In *Encyclopaedia of Islam*, 2d ed., 1:1103–4.

——. *La geste de Melik Dānişmend*. 2 vols. Paris: Dépositairea Maisonneuve, 1960.

——. *Hadji Bektach: Un mythe et ses avatars: Genèse et évolution du soufisme populaire en Turquie*. Leiden: E. J. Brill, 1998.

Ménage, V. L. "The Islamization of Anatolia." In *Conversion to Islam*, edited by Nehemia Levtzion, 52–67. New York: Holmes & Meier, 1979.

Mitchell, Stephen. *Anatolia. Land, Men, and Gods in Asia Minor*. Vol. 2, *The Rise of the Church*. Oxford: Clarendon, 1995.

Nafiz, Ridwan, and İsmail Hakkı Uzunçarşılı. *Sivas şehri*. Istanbul: Dergâh, 1928.

Numan, Ibrahim. "İlk devir Türk sufi merkezlerinin mahiyetleri ve mimarlerinin mensei hakkinda." *Vakıflar dergisi* 19 (1985): 109–18.

Ocak, Ahmet Yaşar. *XIII Yüzyilda Anadolu'da Baba Resûl (Babaîler) isyanı ve Anadolu'nun İslâmlaşması tarihindeki yeri*. Istanbul: Dergâh Yayınları, 1980.

——. "XIII–XV Yüzyillarda Anadolu'da Türk-Hiristiyan dini etkileşimler ve Aya Yorgi (Saint George) kültü." *Belleten* 55 (1992): 661–75.

——. "Emirci Sultan ve zaviyesi." *Tarih Enstitüsu dergisi* 9 (1978): 129–208.

——. *Islam-Türk ınançlarinda Hizir yahut Hizir-Ilyas kültü*. Ankara: Ankara Üniversitesi Basimevi, 1985.

——. *Kültür tarihi kaynağı olarak menâkıbnâmeler*. Ankara: Türk Tarih Kurumu, 1992.

——. "Les Menakib'ul-kudsiya fi menasib'il-unsiya: Une source importante pour l'histoire religieuse de l'Anatolie au XIIIe siècle." *Journal Asiatique* 267 (1979): 345–56.

——. *Osmanlı imparatorluğunda marjinal sûfilik: Kalenderîler (XIV–XVII. Yüzyıllar)*. Ankara: Türk Tarih Kurumu, 1992.

——. *La révolte de Baba Resul ou la formation de l'hétérodoxie musulmane en Anatolie au XIIIe siècle*. Istanbul, 1973.

——. "Zaviyeler." *Vakıflar dergisi* 12 (1978): 247–69.

Ögel, Semra. *Anadolu Selçuklularinin taş tezyinati*. Ankara: Türk Tarih Kurumu, 1966.

Öney, Gonul. *Anadolu Selçuklu mimarisinde süsleme ve el sanatları*. Ankara: Türkiye İş Bankası Kültür Yayınları, 1978.

Önkal, Hakkı. *Anadolu Selçuklu türbeleri*. Ankara: Türk Tarih Kurumu, 1996.

Oral, M. Zeki. "Durağan ve Bafra'da iki türbe." *Belleten* 20 (1956): 385–410.

Ramsay, William Mitchell. *The Historical Geography of Asia Minor*. London: John Murray, 1890.

Redford, Scott. *Landscape and the State in Medieval Anatolia: Seljuk Gardens and Pavilions of Alanya, Turkey*. BAR International Series. Oxford: Archaeopress, 2000.

——. "The Seljuqs of Rum and the Antique." *Muqarnas* 10 (1993): 148–56.

Riefstahl, Rudolf M. *Turkish Architecture in Southwestern Anatolia*. Cambridge, Mass.: Harvard University Press, 1931.

Rogers, Michael. "The Date of the Çifte Minare Medrese at Erzurum." *Kunst des Orients* 8 (1972): 77–119.

——. "Recent Work on Seljuk Anatolia." *Kunst des Orients* 6 (1962): 134–69.

——. "Waqf and Patronage in Seljuk Anatolia: The Epigraphic Evidence." *Anatolian Studies* 26 (1976): 69–104.

——. "Waqfiyyas and Waqf Registers: New Primary Sources for Islamic Architecture." *Kunst des Orients* 11 (1976/77): 182–96.

Savaş, Saim. "Tokat'ta Hoca Sünbül zaviyesi." *Vakıflar dergisi* 24 (1993): 199–208.

Schimmel, Annemarie. *I Am Wind You Are Fire: The Life and Work of Rumi*. Boston: Shambhala, 1992.

Sertoğlu, Mithat. "Eshab-i Kehf (mağara yaranı) vakıflarına dair orijinal bir belge." *Vakıflar dergisi* 10 (1975): 129–31.

Sinclair, Thomas Alexander. *Eastern Turkey: An Architectural and Archaeological Survey*. Vol. 2. London: Pindar Press, 1989.

Smith, Grace M. "Some Türbes/Maqāms of Sarı Saltuq, an Early Anatolian Turkish Gāzī Saint." *Turcica* 14 (1982): 216–55.

Sözen, Metin. *Anadolu medreseleri, Selçuklu ve Beylikler devri.* 2 vols. Istanbul: Istanbul Teknik Üniversitesi, 1970.

Stock, Brian. *The Implications of Literacy: Written Language and Models of Interpretation in the Eleventh and Twelfth Centuries.* Princeton: Princeton University Press, 1983.

———. *Listening for the Text: On the Uses of the Past.* Baltimore: Johns Hopkins University Press, 1990.

Tabbaa, Yasser. *Constructions of Power and Piety in Medieval Aleppo.* University Park: Pennsylvania State University Press, 1997.

Taeschner, Franz. "Beiträge zur Geschichte der Achis in Anatolien (14.–15. Jhdt.) auf Grund neuer Quellen." *Islamica* 4 (1929): 1–47.

———. *Zünfte und Bruderschaften im Islam: Texte zur Geschichte der Futuwwa.* Zurich: Artemis-Verlag, 1979.

Temir, Ahmet. "Die arabische-wogurische Vakf-Urkunde von 1326 des Emirs Seref el Din Ahmet bin Cakirca von Sivas." *Wiener Zeitschrift für die Kunde des Morgenlandes* 56 (1960): 232–40.

———. *Kırşehir emiri Caca Oğlu Nur El-Din'in 1272 tarihli Arapça-Mogolça vakfiyesi.* Ankara: Türk Tarih Kurumu, 1959.

Texier, Charles. *Description de l'Asie Mineure.* Paris: Typ. de Firmin Didot Freres, 1839–49.

Tilley, Christopher. *A Phenomenology of Landscape: Places, Paths, and Monuments.* Oxford: Berg, 1994.

Tournefort, Joseph Pitton de. *Relation d'un voyage du Levant.* Lyon: Anisson et pou posuel, 1717.

Trimingham, J. Spencer. *The Sufi Orders in Islam.* 2d ed. Oxford: Oxford University Press, 1998.

Tschumi, Bernard. *Architecture and Disjunction.* Cambridge, Mass: MIT Press, 1994.

Turan, Osman. "Celaleddin Karatay vakıfları ve vakifiyeleri." *Belleten* 12 (1948): 17–171.

———. "Le droit terrien sous les Seldjoukides de Turquie." *Revue des études islamiques* 16 (1948): 25–49.

———. "L'islamisation dans le Turquie du Moyen Âge." *Studia Islamica* 10 (1959): 111–36.

———. "Selçuk devri vakfiyeleri." *Belleten* 12 (1948): 17–171.

———. "Selçuklular zamanında Sivas şehri." In *Ankara Üniversitesi Dil ve Tarih Cografya Fakültesi dergisi,* 9:447–57. Ankara: Türk Tarih Kurumu, 1951.

———. *Selçuklular zamanında Türkiye: Siyâsi Tarih Alp Arslan'dan Osman Gazi'ye (1071–1328).* 5th ed. Istanbul: Boğaziçi, 1998.

———. "Selçuk Turkiyesi din tarih-dair bir kaynak." In *Fuad Köprülü armağanı,* 531–64. Istanbul: Osman Yalcin Matbaası, 1953.

———. "Les Seldjoukides et leurs sujets." *Studia Islamica* 1 (1953): 65–100.

———. *Türkiye Selçukluları hakkinda resmi vesikalar.* Ankara: Türk Tarih Kurumu, 1958.

Ülgen, A. Saim. "Kirshehir'de Türk eserler." *Vakıflar dergisi* 2 (1942): 253–62.

Ünal, H. R. "Az taninan ve bilinmeyen doğu Anadolu kümbetleri." *Vakıflar dergisi* 11 (1976): 136–38.

Unsal, Behçet. *Turkish Islamic Architecture in Seljuk and Ottoman Times, 1071–1923.* London: Tiranti, 1959.

Ünver, A. Süheyl. "Buyuk Selçuklu imparatorluğu zamanında vakif hastanelerin bir kismina dair." *Vakıflar dergisi* 1 (1941): 17–24.

Uzluk, Sahabettin. *Mevlevilikte resim resimde mevleviler.* Ankara: Türk Tarih Kurumu, 1957.

Uzunçarşılı, İsmail Hakkı. *Anadolu beylikleri ve Akkoyunlu, Karakoyunlu devletleri.* Ankara: Türk Tarih Kurumu, 1988.

———. "Kastamonu ve Sinop'ta Pervanezadeler." *Doğu mecmuası* 7 (1957): 27–31.

———. *Kitabeler.* Istanbul: Milli Matbaası, 1927–29.

———. "Sivas ve Kayseri hükümdarı Kadi Burhaneddin Ahmed." *Belleten* 32 (1968): 191–245.

Vryonis, Speros, Jr. *The Decline of Medieval Hellenism in Asia Minor and the Process of Islamization from the Eleventh Through the Fifteenth Century.* Berkeley and Los Angeles: University of California Press, 1971.

———. "The Muslim Family in 13th–14th Century Anatolia as Reflected in the Writings of the Mawlawi Dervish Eflaki." In *The Ottoman Emirate (1300–1389): Halycon Days in Crete, 1,* edited by Elizabeth Zachariadou, 213–23. Rethymon: Crete University Press, 1993.

———. "Nomadization and Islamization in Asia Minor." *Dumbarton Oaks Papers* 29 (1975): 41–72.

———. "Seljuk Gulams and Ottoman Devşirme." *Der Islam* 41 (1965): 224–52.

Watson, William. *The Art of Iran and Anatolia from the 11th to the 13th Century.* London: University of London, 1975.

White, L. Michael. *Building God's House in the Roman World.* Baltimore: Johns Hopkins University Press, 1990.

Wilber, Donald. *The Architecture of Islamic Iran: The Ilkhanid Period.* Princeton: Princeton University Press, 1955.

Wittek, Paul. "Deux chapitres de l'histoire des Turcs de Roum." *Byzantion* 2 (1936): 285–319.

———. *La formation de l'Empire Ottoman.* London: Variorum, 1982.

Wolper, Ethel Sara. "Khiḍr, Elwan Çelebi, and the Conversion of Sacred Sanctuaries in Anatolia." *Muslim World* 90, nos. 3–4 (special issue: *Sufi Saints and Shrines in Muslim Society,* edited by Jamal Elias) (2000): 309–22.

———. "The Politics of Patronage: Political Change and the Construction of Dervish Lodges in Sivas." *Muqarnas* 12 (1995): 39–47.

———. "Portal Patterns in Seljuk and Beylik Anatolia." In *Aptullah Kuran İçin Yazılar: Essays in Honour of Aptullah Kuran*, edited by Çiğdem Kafescioğlu and Lucienne Thys-Şenocak, 65–80. Istanbul: Yapı Kredi Yayınları, 1999.

———. "Princess Safwat al-Dunyā wa al-Dīn and the Production of Sufi Buildings and Hagiographies in Pre-Ottoman Anatolia." In *Women, Patronage, and Self-Representation in Islamic Societies*, edited by D. Fairchild Ruggles, 35–52. Albany: State University of New York Press, 2000.

———. Review of *The Evolution of a Sufi Institution in Mamluk Egypt: The Khanqah*, by Leonor Fernandes. *MESA Bulletin*, July 1992.

Yavi, Ersal. *Tokat (Comana)*. Istanbul: Güzel Sanatlar Matbaası, 1987.

Yazıcı, Tahsin. "Mevlānā devrinde semā'." *Şarkiyat mecmuası* 5 (1964): 135–59.

Yetkin, Suut Kemal. *L'architecture turque in Turquie*. Paris: G.-P. Maisonneuve et Larose, 1962.

Yinanç, Refet. "Selçuklu medreselerinden Amasya Halifet Gazi medresesi ve vakıfları." *Vakıflar dergisi* 15 (1982): 5–23.

Yücel, Yaşar. *Eretna devleti: Kadi Burhaneddin Ahmed ve devleti, mutahharten ve Erzincan emirliği*. Ankara: Türk Tarih Kurumu, 1989.

Yurdakul, E. "Tokat vilâyetinde bilinmeyen bir Selçuklu hanikâhı." *Önasya* 5, nos. 59–60 (1970): 9–10.

Zachariadou, Elizabeth A. "Co-Existence and Religion." *Archivum Ottomanicum* 15 (1997): 119–30.

Gök Madrasa (Sivas), 45–47, 46
 architecture, 63
 dervish lodge, 46, 47, 60, 61, 62, 70
 façade, 48
 waqfīya, 28, 44, 46, 61, 69
Gök Madrasa (Tokat)
 architecture, 63
 building complex, 113 n. 5
 dervish lodge, 50, 60–61, 61, 62, 113 n. 4
 interior courtyard, 67
 martyrs' remains in, 79–80
 site, 50
 tomb room, 79–80
Greek Orthodox Christians. See also
 Byzantine Empire; Christians
 in Anatolia, 7, 9
 churches, 8, 55, 56, 95
 converts, 81
 cultural production, 79
Güdük Minare tomb (Sivas), 47–48, 70
Gümüshlü mosque (Amasya), 58
Gurju Khātūn, 116 n. 5, 117 n. 18

ḥāfiz, 28
hagiographies. See manāqibs
Ḥājjī Bayrām Walī, 42, 51
Hamd Barūjirdī, 45
Hamilton, William J., 96
Hanafī school, 22, 109 n. 14
Hasluck, Frederick, 97
hospitals
 Seljuk hospital (Sivas), 35, 44, 45, 45
 tombs in, 34
Huart, Clement, 21
Ḥusām al-Dīn, 77
Hüsameddin, Hüseyin, 10, 58, 62, 96

Ibn ʿAli, ʿAlī ibn Sulaymān, 84
Ibn al-Jawzī, 24
Ibn al-Muḥyī, ʿAbd Allāh, 53
Ibn al-ʿArabī, Muḥyī al-Dīn, 5, 16, 62
Ibn Baṭṭūṭa, 30, 58, 77, 97, 99, 112 n. 36
Ibn Bībī, 10, 47
Ibn Cakirhan, Ahmed, 97
Ibn Ḥusayn, Shams al-Dīn, 51. See also
 Shams al-Dīn ibn Ḥusayn dervish
 lodge (Tokat)
Ibn Jubayr, 24
Ibn Lokman, 50–51
ʿAlī ibn Siyawūsh, 28
Khalif ibn Sulaymān, 51

Ibn Taj al-Dīn, Aḥmad Kujek, 58
Ibn Taymīya, 24–25
identity formation, 23, 37, 59
Iḥyāʾ ʿulūm al-dīn (al-Ghazālī), 80
Ilkhānids
 buildings, 48, 51, 58
 land confiscated by, 83
 ministers, 6
 officials as building patrons, 12, 45, 53
 rule of Sivas, 43, 46
 rule of Tokat, 53, 90
interpretive communities, 20, 23, 108 n. 20
iqṭāʿ (land grants), 25, 26
Iran
 dervish lodges, 18
 madrasas, 18
 Mongol incursions, 17, 18
 Seljuks of, 8, 11
ʿIrāqī, Fakhr al-Dīn, 14
 dervish lodges, 6, 12, 36, 37
 Lamaʿat, 36
 life of, 6
 relationship with Muʿin al-Dīn, 6, 36
Iskandarnāme (Niẓāmī), 80
Islam. See also Sufism
 conversions to, 1, 6, 74, 78–79, 93
 intellectual traditions, 5
 saints, 79
 Seljuk practice of, 80–81
Islamization, 5, 75, 102
ʿIzz al-Dīn Kay-Kāʾus I (Seljuk sultan), 8,
 17, 20, 49, 51, 62, 81

Jalāl al-Dīn Qarāṭay, 27
Jalāl al-Dīn Rūmī. See also Mawlawīs
 ancestry, 82
 biography (Aflākī), 19–21, 24, 36, 37, 77,
 78, 81, 82–83, 84, 85, 91, 100
 criticism of madrasa practices, 81, 100
 death, 37, 78
 dervish lodges, 21, 37
 descendants, 21, 82, 91, 105 n. 34
 disapproval of flamboyant rituals, 31
 followers, viii
 funeral, 78
 Greek and Chinese painter story, 80
 historical context, vii–ix
 interest in, vii
 in Konya, 20, 100, 113 n. 73
 Mathnawī, 37, 80, 116 n. 41
 migration to Anatolia, 16, 17

miraculous acts, 77
Muʿin al-Dīn and, 37
as Muslim, viii
relations with non-Muslims, 19, 78
relations with other religious leaders,
 18, 19
samāʿ performed by, 31–32
sons, 105 n. 34
successors, 90
tomb of, 37, 99, 116 n. 5
wives, 31, 82
Jews, relations with dervishes, 81
judges (qāḍīs), 24

Kafadar, Cemal, 92
Kamāl al-Dīn Aḥmad ibn Rāḥa, 47, 48
Karamustafa, Ahmet, 6
Kaykhusraw III (Seljuk sultan), 36
Kayseri, 48, 86
Khalif Alp, 56, 57
Khalif Alp Ibn Tūsī, Mujahid al Mubariz
 al-Dīn, 56, 57, 96
Khalif Ghāzī, 93, 95, 96
Khalif Ghāzī dervish lodge (Tokat)
 architecture, 63–65
 construction of, 26, 51
 façade, 68
 function of building, 76
 inscription, 76, 83, 87, 88–89, 90
 location, 52
 plan, 65
 tomb window, 33, 68
Khalif Ghāzī Madrasa (Amasya), 55, 57,
 93, 94, 95–96, 95
Khalwatī dervishes, 58
Khānqāh Mesʿūdī dervish lodge (Amasya),
 57, 95, 96–97
khāns, 44, 45, 70–71, 111 n. 22
Khidirlik bridge (Tokat), 97
Khiḍr Ilyās dervish lodge (Amasya), 97
Khiḍr Ilyās (Saint George), 74, 79, 97
Khwarzm-Shāh Turks, 55
Kırklar Kızlar. See Gök Madrasa (Tokat)
Kırklar Tekke dervish lodge, 79
Kirşehir, 27
Konya
 Christian residents, 78
 dervishes, 77, 113 n. 73
 dervish lodges, 37, 76
 madrasas, 110 n. 20
 Muslim scholars in, vii–viii, 18

Rūmī's tomb, 37, 99, 116 n. 5
Seljuk court, 8, 16, 20, 43
Konyalı, Ibrahim, 76
Köprülü, Fuad, 5, 6
Köse Dağ, Battle of, 11, 25–26, 46, 97, 100
Kuran, Aptullah, 62

Lamaʿat (ʿIrāqī), 36
land. *See also waqf* (pious endowments)
 confiscated by Ilkhānids, 83
 control by local elites, 25–26, 27, 46, 83
 iqṭāʿ (land grants), 25, 26
 mulk (ownership), 26, 83, 109 n. 14
 rents, 43, 59, 76
Laranda, 16
law
 education in *madrasas*, 9
 Hanafī school, 22, 109 n. 14
 Malikī school, 22
leaders, local. *See also amīrs*; elites;
 patrons
 relationships with *shaikhs*, 6, 26, 28, 38,
 42, 54, 82, 100, 101
 relations with resident groups, 27, 35–36

madrasas
 in Amasya, 55, 57, 67, 69
 audiences, 68–69
 in Cairo, 25
 churches converted into, 42–43, 55–57,
 94, 95, 96
 courtyards, 67
 criticism of practices, 24, 81
 decline of, 25, 63, 67
 dervish lodges associated with, 60–63
 education in, 9
 elites associated with, 9, 68–69, 100
 endowments, 25, 26–27, 69, 110 n. 20
 façades, 48, 67
 functions, 67
 in Iran, 18
 languages used, 9
 locations, 100
 lodging in, 20, 24, 110 n. 39
 officials' salaries, 110 n. 20
 patrons, 12
 portals, 48, 68, 95–96
 room layouts, 67–68
 in Sivas, 12, 45–47, 45, 48, 68
 Sufi view of, 100
 in Tokat, 49, 50

tombs in, 33, 34, 56, 57, 67, 69
Māhperī Khātūn, 83, 86, 89, 117 n. 19
maidān (halls), 4, 28–29, 30, 64
Malatya, 8, 16, 92, 93
Malikī school, 22
Mamlūks, 24–25, 36
Manāqib al-ʿārifīn (Aflākī), 19–21, 24, 36,
 37, 77, 78, 81, 82–83, 84, 85, 91, 100
Manāqib al-qudsiyye (Elwan Çelebi), 21,
 97
manāqibs, 19–21, 37, 79, 90–91, 102
Manzikert, Battle of, 7
Maqrīzī, Tāqī al-Dīn Abī al-ʿAbbās Ahmad
 ibn ʿAlī al-, 25
marketplaces
 dervish lodges located near, 2, 34–35,
 45, 47, 48, 54, 59
 khāns, 44, 45, 70–71, 111 n. 22
marriages
 between dervish and elite families, 82
 of Seljuk women, 86, 88
 of sultans, 74, 83, 88
masjids, 34, 71
Masʿud I, sultan, 55, 57
Masʿud ibn Sherifshah dervish lodge
 (Konya), 76, 115 n. 10
Mathnawī (Rūmī), 37, 80, 116 n. 41
Mawlawī-khān of ʿAlāʾ al-Dīn, 58
Mawlawīs. *See also* dervishes
 criticism of Seljuk practices, 81
 dervish lodges, 58, 96
 history of, 105 n. 34
 as interpretive community, 23
 in Konya, 113 n. 73
 leaders, 37, 77, 82
 origins, 6
 Rūmī's tomb and, 37
 social origins, 12, 78
Mehmed Dede, 58
merchants
 behavioral guidelines, 76–77
 contacts with dervishes, 34–35, 42, 71,
 74–75, 76–77
Merṣād al-ʿibād (Rāzī), 21, 75, 76–77
military patrons, 11–12, 57–58
minarets, double, 45–46, 48, 112 n. 25
Mithradates, 7
Mongols
 defeat of Seljuks, 11, 25–26, 35, 43, 100
 incursions into Iran, 17, 18
 Muʿīn al-Dīn Pervāne and, 36, 48–49, 85

rule of Anatolia, 56, 89, 112 n. 27
Monophysite, 9
mosques
 in Amasya, 55, 56, 58, 71
 churches converted into, 8, 42–43, 55,
 56, 96
 elites associated with, 100
 endowments, 26
 locations, 100
 in Ottoman period, 6
 Seljuk style, 17
 in Sivas, 44, 71, 78, 97
 in Tokat, 49, 71
 T-style (Bursa), 5
muʾadhdhin, 29, 110 n. 32
mudarris, 26–27
Muhammad, viii
Muhazzab ʿAli, 84
Muhlis Pasha, 57
Muʿīn al-Dīn dervish lodge (Tokat), 36,
 37, 50, 51, 113 n. 4
Muʿīn al-Dīn Pervāne
 as building patron, 12, 27, 50, 97
 daughter, 51, 83, 84–88, 90
 death, 36, 85
 dervish lodges built by, 6, 36, 37, 50, 51,
 57, 92
 descendants, 91
 Fakhr al-Dīn ʿIrāqī and, 6, 36
 as guest in dervish lodges, 30
 named in dervish lodge inscriptions, 88
 relationship with Rūmī, 37
 rise to power, 36, 85
 rule of Tokat, 36, 48–49, 50, 54, 90
 sons, 36, 58, 84, 85, 90
 wife, 117 n. 18
mulk (ownership), 26, 83, 109 n. 14
 amīrial acquisition of, 26
 transformed into wage, 26, 83, 109 n. 17
Muslims. *See* dervishes; Islam; scholars
 (ʿulamāʾ); Sufism
mutawallī (administrators), 28, 109 n. 16
mystics
 Christian, 74
 wandering (*fuqarāʾ*), 78

Nafiz, Ridwan, 47
Naṣīr (ʿAbbasid caliph), 21
al-Naṣīrī, 21, 77
Naṣr al-Dīn Ewliya, Shaikh, 79
nāzirs (officials), 26, 28, 109 n. 16